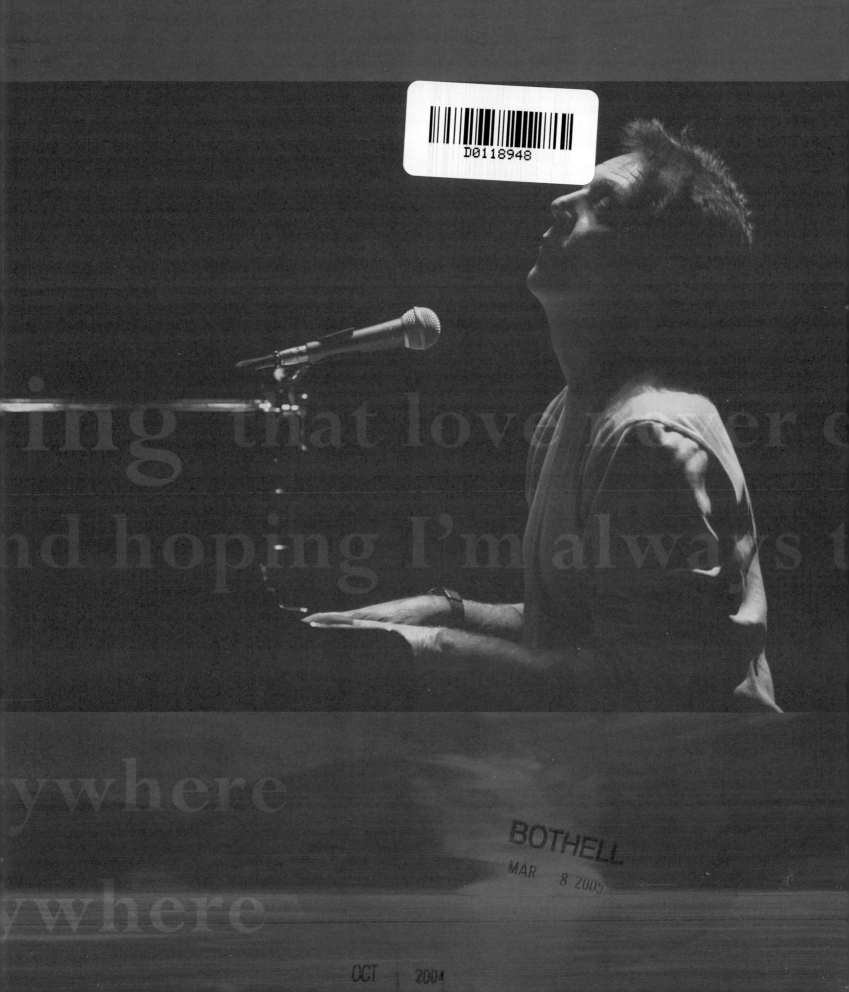

Each One Believing that love never dies
Watching her eyes and hoping I'm always there

To be there and everywhere
Here there and everywhere

Paul McCartney

On Stage, Off Stage, and Backstage

CHRONICLE BOOKS
SAN FRANCISCO

This book tells the tale of the **2002-03 Paul McCartney World Tour**. *The tour was the most successful of Paul McCartney's post-Beatles career, during which the man, who has successively changed the sound of music since the sixties, performed to two million people.*

While on tour, Paul McCartney came up with the concept to create a book that would reflect some of the energy and excitement of being on the road. This is the book that grew out of his concept. Writer and Art Director **Caroline Grimshaw** *selected, organized, and edited material extracted from film and interview transcripts of events that happened during the tour. She then designed the book, weaving these real-life stories around the incredible imagery supplied by* **Bill Bernstein**. *Caroline has worked on the creation of all of Paul's tour magazines since 1989. Thanks to* **Paul McCartney** *for allowing access to so much personal material.* **Roger Huggett**'s *input was invaluable as Creative Consultant. Roger has worked with Paul since 1969 as a design and print consultant.* **Robby Montgomery** *was the Publishing Consultant and* **Lilian Marshall** *the Project Manager. Thanks to* **Geoff Baker** *(Tour Publicist, pictured above with Paul) for supplying transcript material. Thanks also to* **Paul Du Noyer** *(Editorial Consultant),* **Lisa Dyer** *(Chief Sub), and all at* **MPL** *and* **Chronicle Books**, *especially* **Christine Carswell, Lisa Campbell, Steve Kim,** *and* **Vivien Sung**.

Scene Titles *throughout the book are fragments of lyrics drawn from the 40-plus songs that Paul McCartney sang during the tour's run (see page 207).*

Dialogue *is drawn either from transcripts of conversations filmed by New York director Mark Haefeli, aboard the tour to make two movies, or from tapes of many of the approximately 200 press, radio, and TV interviews that Paul McCartney conducted backstage. Due to the number of interviewers, space prevents listing every one. But we thank each and all for being players in the tour that they helped to make so special.*

Bill Bernstein *is a New York–based photographer who has traveled the world for such clients as* National Geographic TV, Time *magazine, and the band* U2. *His history with Paul McCartney began in 1989 with the first World Tour and has continued over the years. "The opportunity to photograph McCartney's entire World Tour and to be given such astounding access has been a high point of my career. Rarely is a photographer given such trust and free rein. These photographs are the result of McCartney's generosity and his unique ability to encourage fertile ground for creativity."*

Library of Congress Cataloging-in-Publication Data available.

ISBN 0-8118-4507-9

Manufactured in Hong Kong.

Distributed in Canada by Raincoast Books 9050 Shaughnessy Street Vancouver, British Columbia V6P 6E5

10 9 8 7 6 5 4 3 2 1

Chronicle Books LLC 85 Second Street San Francisco, California 94105

www.chroniclebooks.com

Contents

Never Quite Like This

The truth is, I said, "Just put a feeler out, will you? Like is there any, what do you call it, demand out there?" I don't get blasé, you know. So we started in the States and we stuck one show out—I forget where it was—and we sold out 15,000 tickets in 15 minutes. I was always imagining this very fast little lady doing the tickets. And when that news came back, we went, *"Ooo, 'ang on!"* And also you know that all the people at that show are really keen to see you. If they're that keen, then so am I. And then, well, I've also got a really good band.

When we started Wings, we had to overcome the shadow of the Beatles. So we couldn't do any Beatles songs. And that was difficult, that was more difficult than now. Now, well, I don't care, I'll just look at my whole career and just choose anything I fancy doing.

I do feel very, very lucky in a number of ways … with the band and getting the best tour of the year in America, you know. But that's life, isn't it? That's the magic of it. If you had said to me certain things, when I was a kid, that would be happening now … that I would be playing for the Queen in her garden, when I was nearly 60. *Unlikely*. But there I was, in the bloody garden going, "Oh no, dear me. What am I doing here?" *Loving it*. It's great. You know, it just keeps happening.

Then there we were by Lenin's tomb, in Red Square, in this sort of hallowed space for the Soviet Republic. You had the former head of the KGB, who is now democratically elected and liked by his people. Then there's Mikhail Gorbachev there of the old school, but the kind of cusp, you know the man who changed it all really. And here I was in this amazingly special place in time and space. And imagine then if I had been able to say to my dad, "Hey Dad, you know, I just had this premonition. I'm going to be in Red Square in front of the president, the ex-president, and by Lenin's tomb, and I'm going to have all these people listening to me. And I'm going to be singing to them all. And they're all going to dig it." He would have thought I was mad. But you know it has happened and I love to think of how proud he would have been. My mom and dad are no longer here. Just think how proud they'd be that something like that could happen in our family.

So, this book is a record of a very special tour. It's a record that hopes to communicate the excitement and feeling of being on that tour and being a member of such a great team. I hope it also shows something of how it feels to be lucky enough to be part of such a huge success.

Paul McCartney

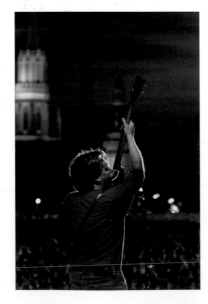

"AFTER A TOUGH FEW YEARS, I FEEL LIKE I'M BACK IN THE LAND OF THE LIVING. I'VE HAD MY LOW POINTS, BUT NOW I'VE GOT THIS GREAT BAND, HEATHER, AND MY FAMILY … WELL, THAT'S THE MAGIC OF LIFE."

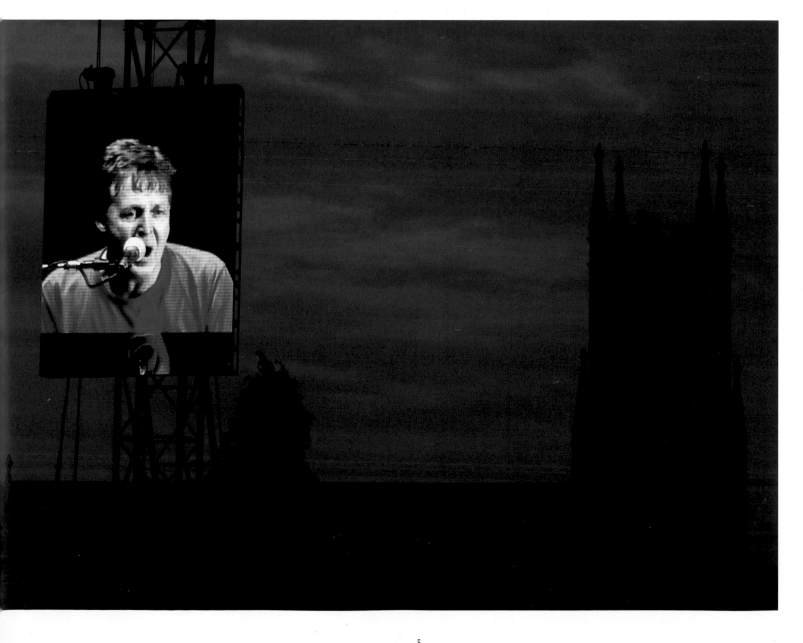

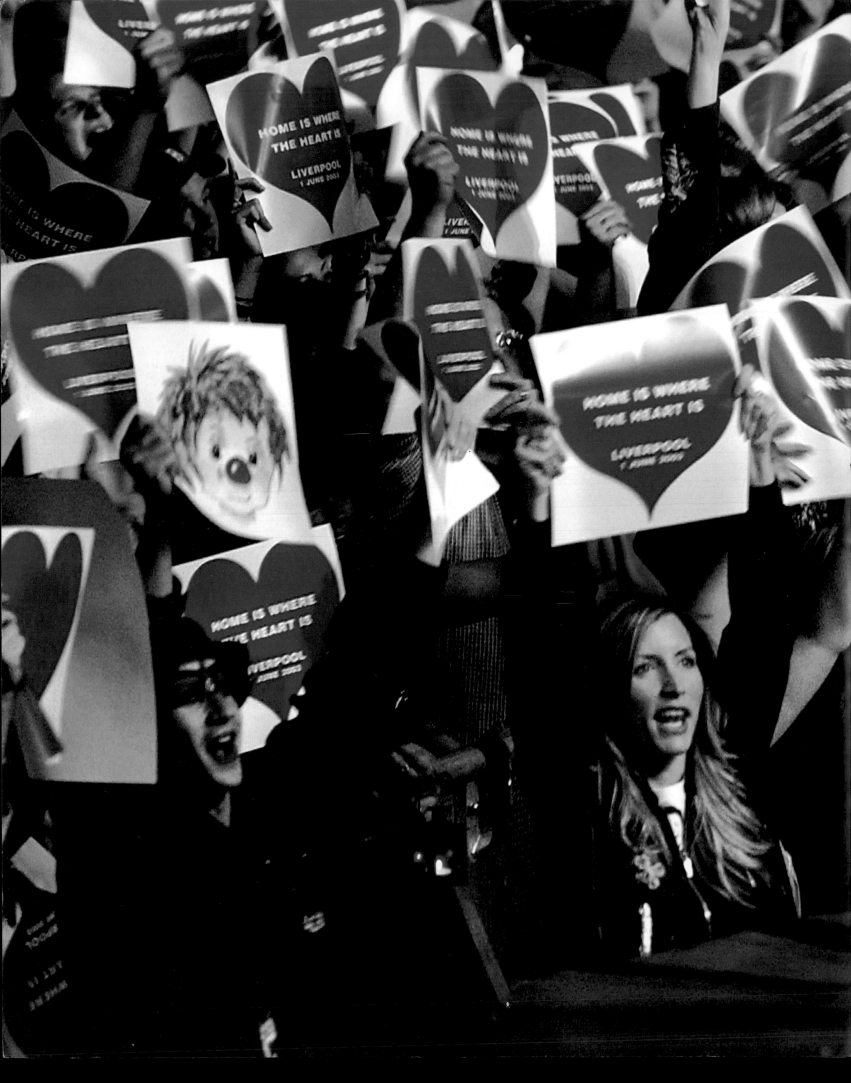

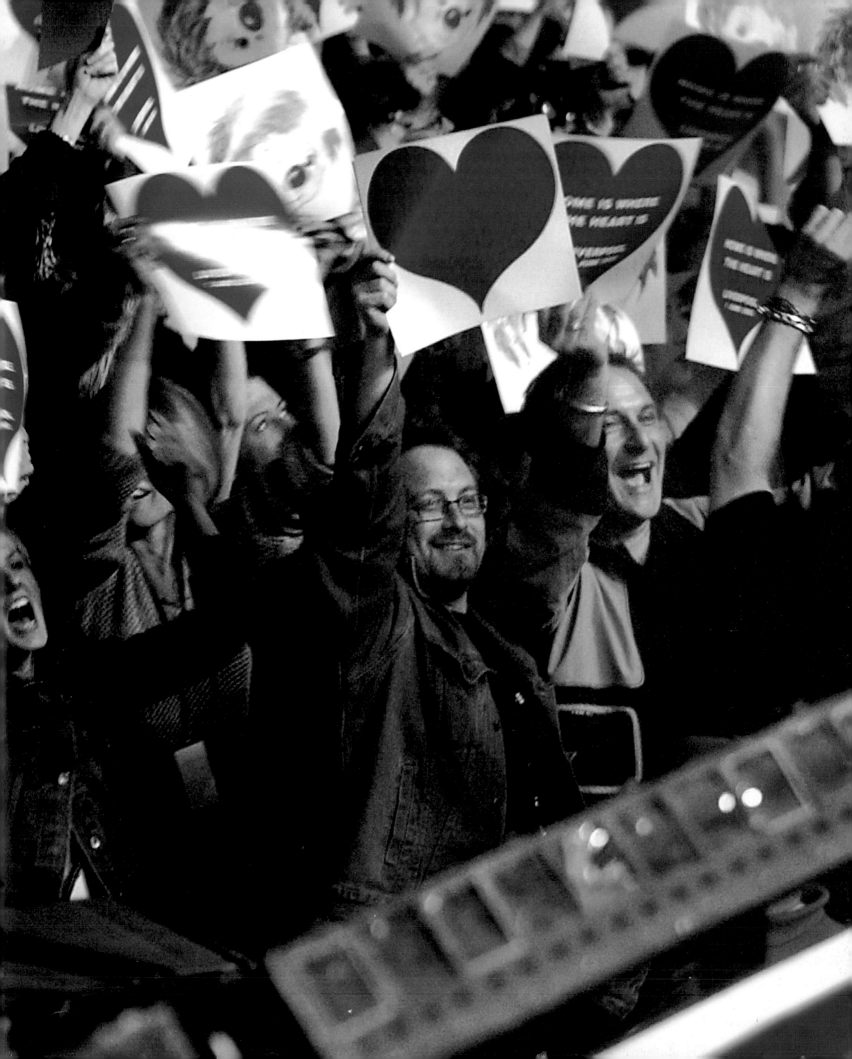

(Previous pages) "Home is where the heart is": family, friends, and fans become as one for the tour's emotional closing show in Liverpool.

(Right) Fourteen months after beginning what he intended to be "just a short, 15-date trip in the States," Paul McCartney brings on home to Liverpool the most successful world tour of his post-Beatles career, having slightly exceeded his initial expectations by performing 91 concerts of 36 songs in 16 countries to an audience of two million people.

"It is no surprise that Billboard *magazine —the music-industry bible—voted this the best tour of the year. His band are as polished an act as you will ever see. And McCartney himself remains the master showman ... No one does it better than the self-styled Scruff from Speke ... he's back on top of the world."*
Liverpool Echo

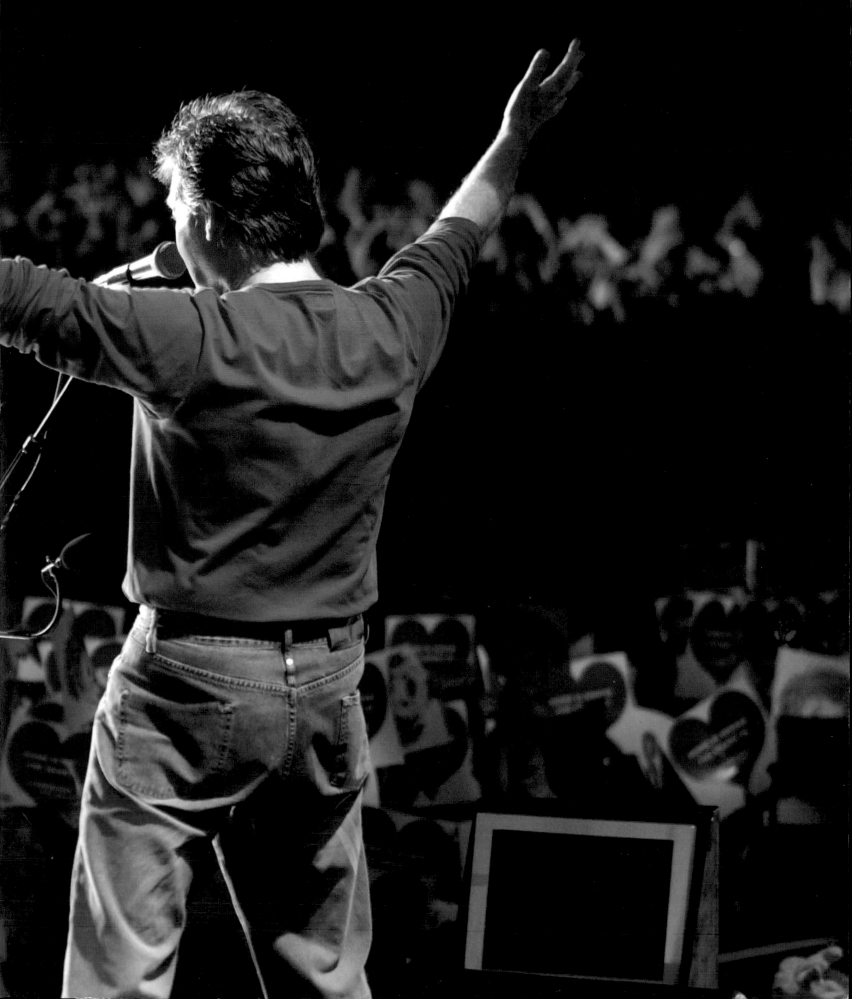

This Moment to Arise

Dipping his toe in the water

Paul: Having made *Driving Rain*, I was thinking of doing some live gigs and putting a band together. I was in New York, aiming to fly back to England with Heather and get together a gig in Russia, something like Red Square, 'cos I'd never played Russia and, having written *Back in the U.S.S.R.*, I wanted to go there and play *that*. That was the plan that day. We were on a plane on the tarmac at JFK Airport when they hit the Twin Towers. I saw them burning. After 9/11 it didn't make any sense to go and play in Russia, so we did the Concert for New York City. That was like dipping my toe in the water; I thought if I liked it, I'd think about going on tour … And I did; I really enjoyed it, and I got some clues off that concert of what I really wanted to do now. Like it was very emotional, seeing that sea of faces, a lot of firefighters in uniform, a lot of cops and families—so in some ways it sort of set the tone for how we would go out; that we'd try to do it from the shoulder, we wouldn't worry if it got a bit emotional. That's sort of how this show is, it's quite … sort of mature in that way.

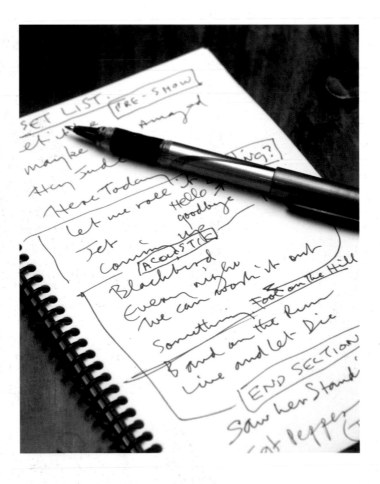

REHEARSALS: CULVER CITY, LOS ANGELES, MARCH 2002.
Reporter: Will this be a long tour?
Paul: No, not really. I don't want to tour for too long because there's summer coming up and I don't want to miss summer. Touring is not my life; it's just a part of it.

LIVERPOOL, ENGLAND, JUNE 2003.
Reporter: How long have you been on this tour now?
Paul: On and off, for about 14 months. We were having too much fun to want to stop.
(Paul did take a break during the summer—he had a wedding to go to!)

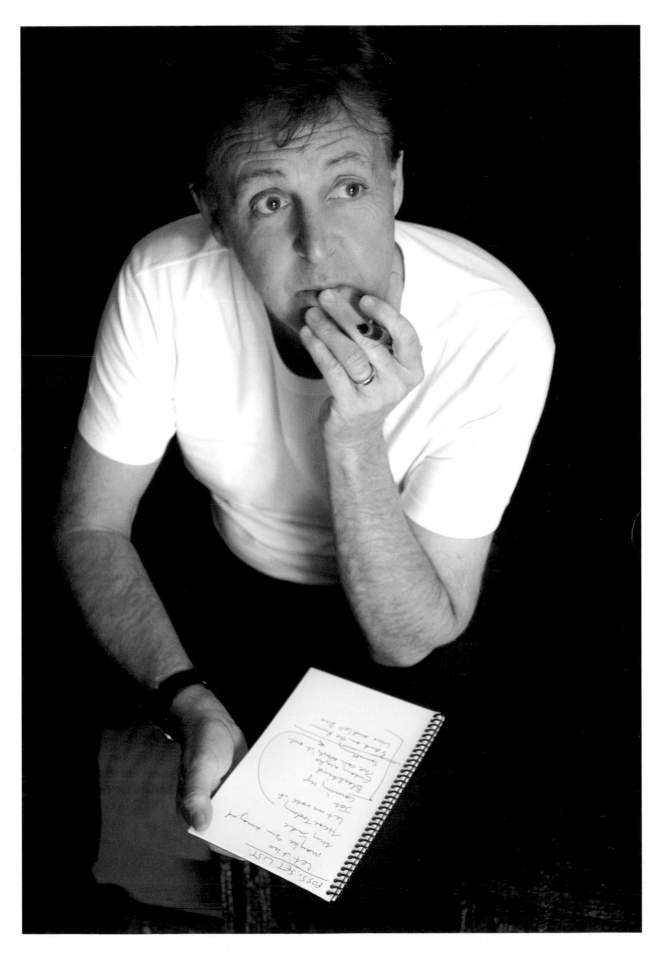

RESPONDING TO THE NEED TO RAISE MONEY TO AID THE FAMILIES OF THE VICTIMS OF THE SEPTEMBER 11 ATTACKS AND WANTING ALSO TO HONOR THE FIREFIGHTERS, POLICE, AND EMERGENCY WORKERS OF NEW YORK, PAUL ENLISTS IN THE ROCK-AND-ROLL ARMY THAT GATHERS AT MADISON SQUARE GARDEN ON OCTOBER 20, 2001. *The army includes Mick Jagger, Keith Richards, the Who, David Bowie, Eric Clapton, Elton John, Billy Joel, James Taylor, Buddy Guy, John Mellencamp, Kid Rock, Bon Jovi, Jay-Z, Destiny's Child, the Backstreet Boys, and Macy Gray. Also lending a hand presenting the musicians and hosting the show are Billy Crystal, Meg Ryan, Harrison Ford, Susan Sarandon, Jim Carrey, Mike Myers, John Cusack, Michael J. Fox, Halle Berry, Christy Turlington, Robert De Niro, Leonardo DiCaprio, Martin Scorsese, Woody Allen, Spike Lee, Jerry Seinfeld, Adam Sandler, Howard Stern, and President Bill Clinton. The six-hour show is televised worldwide through VH1.*

Paul closes the show with I'm Down, Lonely Road, From a Lover to a Friend, Yesterday *(unaccompanied), and* Let It Be *(very accompanied with all stars on stage). The benefit night— which raises more than $30 million—ends with the first public performance of* Freedom, *the song Paul purpose-wrote for the occasion in order to give the highly charged crowd "somewhere to put their emotions." This song provokes unprecedented scenes. Besides his co-stars gathering on stage to sing it, it also causes scores of firefighters and police officers to rush the stage and clamber up out of the audience, uninvited, and to sing along for the most rousing moment of the night.*

Paul: We ended up doing the New York gig and I ended up writing the song *Freedom.*
DJ, Washington, DC: Did you do that on the plane?
Paul: No, oh no. We got stopped from traveling and we were in the New York area for about a week and a couple of days after September 11. I then knew that I wanted to do a concert and I knew that, while some of my other songs would be appropriate, I wanted to have something really special, really appropriate. So, with Heather's help, I wrote *Freedom,* and wrote it as a really simple song, so that people in the audience would be able to pick it up immediately.

It's the first time I've ever really custom-written a song for an event. But it was great doing it—a couple of people thought that I was mad to try to do a new song on an event like that. But I just thought, "No, I just know it's going to work." So we did it and, sure enough, people sort of picked up the chorus— I mean, it's not a hard chorus … "FREE-DOM!" … kinda easy to learn. But it was great, a very emotional evening.
DJ: You got a great response when you played *Freedom;* it touched a lot of people.
Paul: Thank you. I tried to do it from the point of view of an ordinary citizen—"this is my right … don't mess with it"—it's very simple, it's just the right to live in freedom. 'Cos I was thinking that a lot of people in America, a lot of their ancestors, came here to escape that kind of thing. This is the "give me your huddled masses," where a lot of people came to get out of Hitler's Germany and places like that. It's very important everywhere, but perhaps at that time it was more important in America.

JACKIE LYNCH is the widow of Terry, who died in the September 11 attack on the Pentagon. She was among the families of the victims who were invited to see the show in Washington, D.C.:
"*We absolutely loved it. I remember almost every song from growing up with Terry in Ohio. Every one of the families had such a wonderful time; none of us could have asked for anything better right now. The men in our families are having a harder time dealing with it all than the women, losing their wives. One friend of mine who was there last night, I've seen him crying a lot—but last night he was smiling and clapping, he was happy. You have made a lot of people very, very happy. Thank you for that.*"

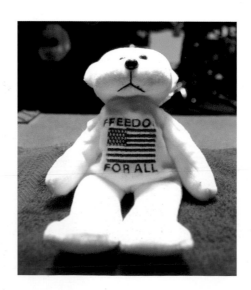

(Left) Early in the tour Paul was presented with the Freedom Bear, a toy mascot symbolizing American feeling in the 9/11 aftermath. (Opposite) In the show, during the performance of Freedom—*the protest song Paul wrote following the 9/11 attacks—a 50-foot banner would fall from the rigging and dominate the stage. The banner, depicting the Statue of Liberty, was a replica of a work created by New York schoolchildren.*

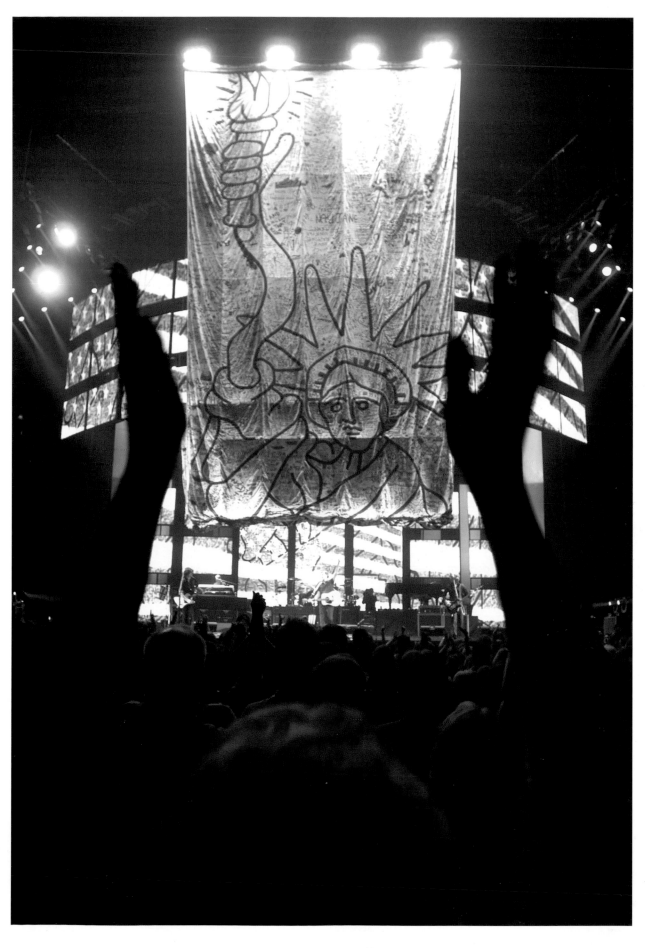

Easy Game to Play

Inside the massive hangar, keeping it fresh, and the biggest buzz

IN PUTTING TOGETHER THE TOUR BAND, PAUL BETS HIS INSTINCT AGAINST LONG ODDS. *Paul has toured only with Paul "Wix" Wickens before. Brian Ray and Abe Laboriel Jr. have toured with each other, but not with Paul, Wix, or Rusty Anderson. Rusty has never toured with any of the other four. Brian has only ever played one song with this band—*Freedom *at the Super Bowl. Also, Brian has to deputize for Paul on bass when Paul is on guitar or piano during the show, but Brian has never played bass live on stage. Inside the massive hangar of a sound stage at Sony Studios, Culver City, Los Angeles, where part of* The Wizard of Oz *was once filmed, Paul gathers the band for just 10 half-days of rehearsal in March 2002.*

Paul: Sometimes you think the equation is that if we have a lot of rehearsal, we'll be great. But sometimes you have a lot of rehearsal and you get a little bit bored, and the rehearsal is more fun than the gigs. So I just thought, "I know this band, and I know they're all great musicians, so we should just go and rehearse for about two weeks and then really try to have fun with it on the road. As long as we know what chords we're playing and when we're all coming in ..." These guys don't need overrehearsing and so I thought maybe I don't either.

"WE REHEARSED FOR JUST ENOUGH, AND THEN WE WENT AND HAD FUN ON THE ROAD."

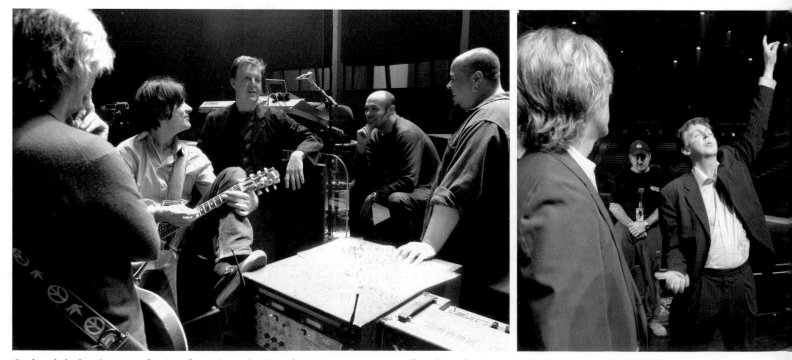

Paul and the band convene for their first rehearsals. More than one commentator will acclaim this lineup as Paul's best group since the Beatles.

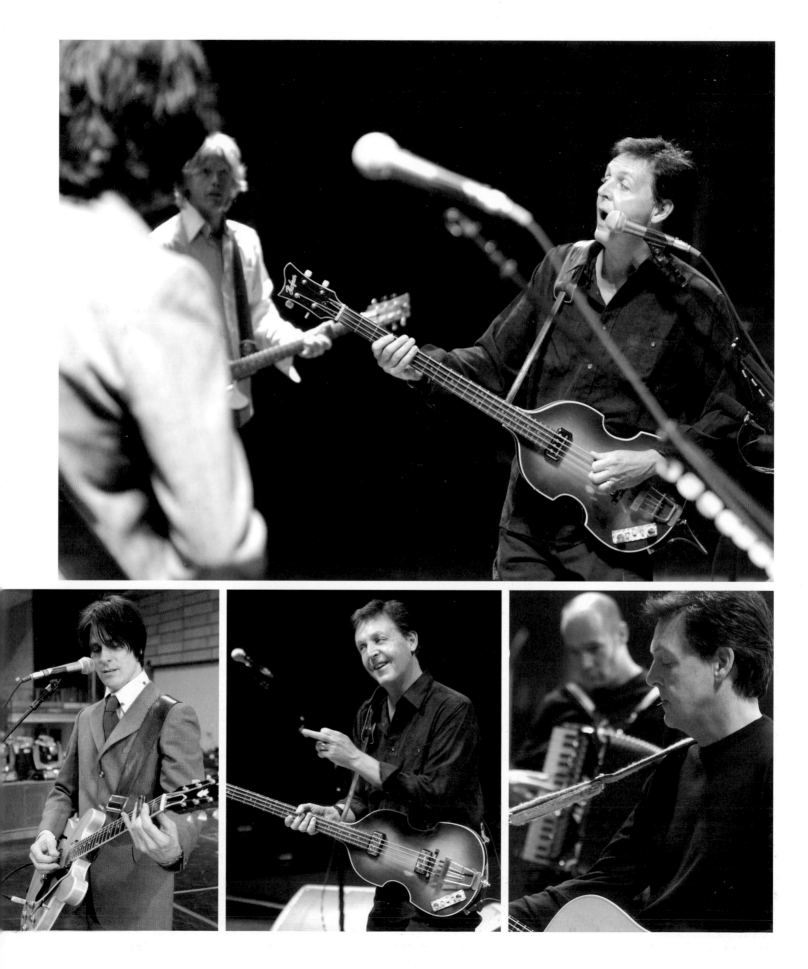

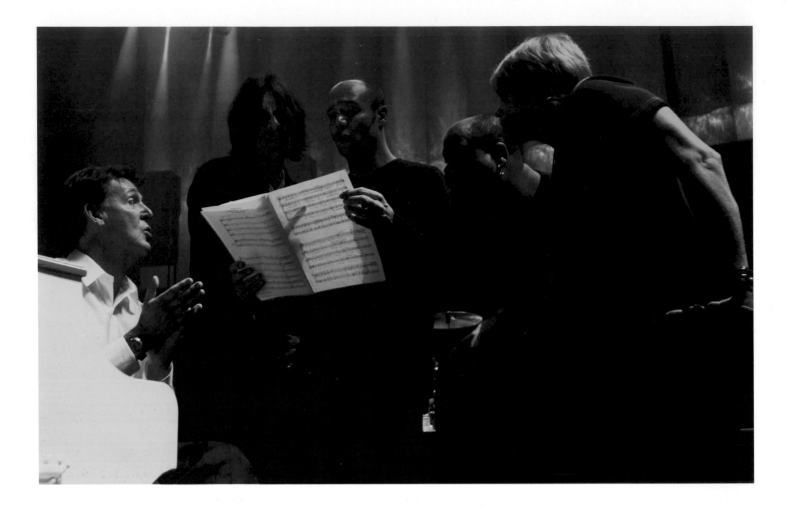

THE NEWLY RECRUITED MUSICIANS MUST ADJUST TO THE EXPERIENCE OF PLAYING WITH A MAN THEY'VE WORSHIPPED FROM AFAR FOR MOST OF THEIR LIVES.

While the Englishman Wix has played for many years with Paul and acts as the Band's musical director, Americans Rusty, Abe, and Brian consider their new positions with a mixture of elation and trepidation. In every case, though, their anxieties are allayed. In the rehearsal studio at Culver City, they chat and unwind.

Rusty: I was talking on the phone to David Kahne—we'd done recording together in the past, a lot of times—and he said, "I think I'm producing the new McCartney record." I was so happy for him; he's a great producer and it all made sense, you know. And he said, "I might need some guitar playing on it," and I was like, "I'm your man." Then a few months went by and I kept on not wanting to jinx it, to make sure that it really was gonna happen, so I didn't tell too many people. And then it did … it was February 2001. I walked into this studio and it was just kinda like "Where is he?," and looking around I finally saw him. We just shook hands and I said, "Hi, I'm Rusty, it's

good to meet you, Paul." He said, "Good to meet you," and it was, OK, that's done. I probably said, "Hi, my name's R-r-r-r-rusty, hi P-p-p-paul," you know, but that was OK. It was sorta like, "It's actually going down, so this is good." And then we proceeded to record three songs that day, which is amazing 'cos no one works that fast.

Abe: Meeting Paul was slightly surprising because I hadn't slept probably for the week before, knowing that it was coming. And I'd anticipated so much of, "Oh, my God, what's it going to be like?" Then I shook his hand and it was the most generous handshake—and just very "Wow, I am glad you are doing this," and "This is gonna be fun. C'mon, let's go make some music." And within five minutes of meeting him we were just communicating the way I think every musician wants to, which is just to go and do it. I don't know what I was thinking it was going to be like, but I was so relieved and so excited that he was really just one of the guys.

Brian: I was at home one day, picked up the phone, and it was a guy who introduced himself as David Kahne and explained that he was the producer of Paul's new record. He said, "Hi, I'm

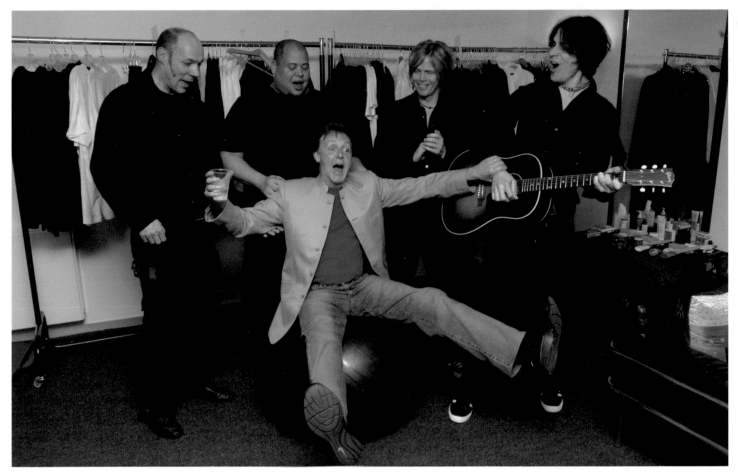

(Left to right) The ball of sound. Paul "Wix" Wickens, Abe Laboriel Jr., Paul McCartney, Brian Ray, Rusty Anderson.

calling you in regards to Paul McCartney," and my heart just kinda froze. He said, "Would you be interested in doing the Super Bowl with us?" I said, "Hell, yeah," and he goes, "We need a bass player; we're doing one song at the Super Bowl. Can you come down to my office and meet with me in an hour?" It was really relaxed, in a studio; I sat on the couch, just hung out with him. He handed me a guitar and just kind of watched me. Then he handed me a bass, again just kind of watching me, and then he called me later that night and said he had a good feeling about this. I didn't know he had called three or four other guitar players, but in any case, a day later I was on a plane to go and meet with Paul McCartney at the Super Bowl—which was my audition. I was nervous, I was *really* nervous. I mean, you've got to understand I was of an age when the Beatles came out, and it was huge for me, it was just huge when they came blasting out of the TV that night on Ed Sullivan. So I flew to New Orleans, really nervous—I think I walked around New Orleans for about an hour and a half just to burn off some extra energy. Anyway, we were at a private dinner at the hotel, and I remember I had my back to the door. I was talking to Abe and

some people and I noticed everyone's face changed, and I knew that Paul had just walked in behind me. I just slowly turned around and he came up to me and said, "You must be Brian." So we did the Super Bowl; we only did the one song, *Freedom*. We hadn't had a chance to really sit down and play or sing together, but at the end of that Super Bowl weekend, at the bar at the end of the game, he was saying good-bye and he said, "Welcome aboard. Stick with Abe and Rusty and they'll show you the ropes." And I was like, "Did I hear that right, you guys? Did he just, like, welcome me aboard?" And soon after that I started getting e-mails asking about my gear and what my shoe size was, and it was like, "Oh, my God, I'm going on the road with Paul McCartney!"

Rusty: There had been some mention of touring. There was talk about it because the *Driving Rain* record was supposed to be released in September, but I guess because Europe shuts down in August or something, they couldn't pull it off. We were supposed to play all these gigs around the world, you know, like really random, like the Colosseum and the Budokan, but all that changed because the record release date got pushed back

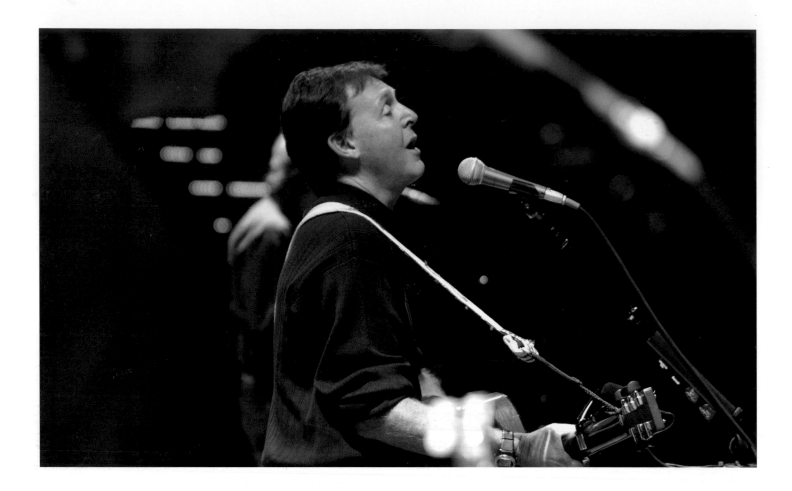

and so they were then talking of doing Red Square in Russia, in October. But then that didn't happen because September 11 *did* happen, and then it was sort of, "Let's go and do this gig at Madison Square Garden," the Concert for New York City. That was extremely surreal because all my heroes were there playing: David Bowie, the Who … and we were going on last! We'd only rehearsed a couple of times; we'd done one four-song gig at the Beverly Wilshire months and months before for Adopt-A-Minefield, and then, out of the blue, we're doing this gig. You know what I'm saying? When we rehearsed for that, it was like being in a sort of classroom, when you're in at school at nine in the morning and you have to recite something … All the houselights were on and there's Roger Daltrey and Pete Townshend standing around the stage, and Elton John's there playing.

The most surreal thing was being backstage and seeing all the stars come in and go out … And then President Clinton comes in and it's, "Hi, Bill, I'm Rusty," you know? And the next thing was the Super Bowl and then the four of us—Abe, Wix, Brian, and myself—got together and started going over material for this tour.

Wix: I came out to Los Angeles and had to meet with the guys before Paul came in for rehearsals. I came out so I could give them the angle about what he was about live and the little things he might want different. It was new for me, figuring people out that I had never worked with before. Until the first rehearsals we hadn't played a night together, so that was a new experience and challenging … frightening.

In 1989 we had five months to get it together, but this time I had like three weeks. So it started out as dread. There was a lot of work in the preparation stages, but it turned into a completely joyful experience.

Brian: Between the Super Bowl and the first day of rehearsal I had five weeks to get my head around this thing. Thank God, I was pretty prepared by then, and by the time Paul arrived we, as a band, had rehearsed for five days together.

Rusty: Paul came in, I guess, about five days later, and we did a week together, the five of us, and then we did production rehearsal for another, like, less than a week, and that was pretty much it. We'd just sort of raced through it. I think Paul really doesn't like to overdo stuff. He likes to keep it fresh. But it worked out.

Wix: I think everyone brought their humor; everybody in this Band has got their own particular sense of humor and everybody had a vibe they brought with them. The humor is important; warped or otherwise, it's what helps keep you on a roll.

Abe: You definitely feel a musical communication; it's an unspoken language, if you will. It's very intuitive. We just understand where each other is going to go.

Wix: I said to the guys at the first gig, "This is going to be the biggest buzz you are ever going to have." The first time you go out and do that in front of people, *these* songs with *this* guy, the right voice, singing those songs, and you are all part of it. And they are all loving it. It is just like *whew!*

"THIS IS GOING TO BE THE BIGGEST BUZZ YOU ARE EVER GOING TO HAVE."

Paul McCartney's equipment includes: Hofner 500-1 violin bass; Gibson Les Paul Flame Top electric guitar; Martin D28; Martin J18; Epiphone Texan acoustic guitars; Petersen classical guitar; Gibson ukulele (a gift from George Harrison); Boogie Bass amp and speaker cabinets; Vox AC30 guitar amp and speaker cabinets; Kurzweil PC2X keyboard and Yamaha DC-5 Pro. Piano.

Paul "Wix" Wickens has worked with Paul McCartney since 1989 on two previous World tours and five albums. His equipment includes: Kurzweil PC2X Controller keyboard; Yamaha Motif 7 keyboard; Studiologic SL-MP113 MIDI Pedal board; Opcode Studio 5 MIDI interface; Roland JV-5080 synth module; Akai S5000 sampler; Yamaha VL70m Physical Modelling synthesizer; Novation Nova synthesizer; E-mu Custom Proteus synth module; Yamaha 01V digital Mixer; Macintosh PowerBook G4 titanium laptops for programming system and softsynths; custom Hohner Student V accordion; custom Allodi accordion;

Gibson Emmylou Harris model acoustic guitar.

Abe Laboriel Jr.'s equipment includes: Drum Workshop drum set, consisting of a 28 bass drum, 15, 18 toms, and black brass snare drum; Paiste Signature and traditional series cymbals; drumheads by Remo; sticks by Vic Firth.

Rusty Anderson's equipment includes: Gibson 335; Gibson SG; Gibson Les Paul; Gibson J160; Gibson Chet Atkins; Gretsch Corvette; custom Cummings Firebird guitar; Dave Freidman custom guitar effects rack; Divided by Thirteen amp and speaker cabinets.

Brian Ray's equipment includes: '57 Gibson Les Paul; Gibson Chet Atkins; '59 Gretsch Double Anniversary; Duesenberg guitars; Patrick James Discus; '63 Gibson Dove; Taylor 12-string acoustic; '70s Guild M-85 bass; Fender Precision bass; Ashdown bass amps and speaker cabs; Electroplex amps; Line Six gear and various effects.

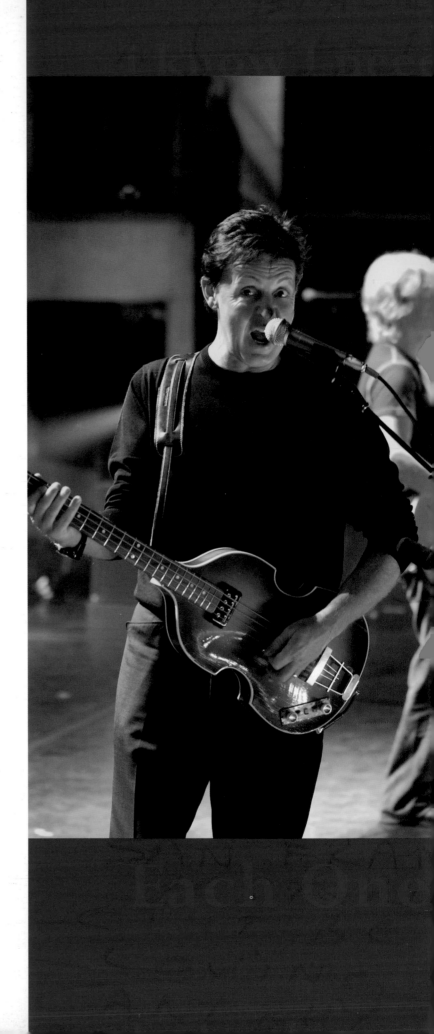

Rehearsals and a production meeting in London prior to the European leg of the tour.

TO PAUL, THE BAND IS OF HIGH IMPORTANCE. *Whereas some big-name acts may consider their bands as backing players, for Paul the fun is in performing as a unit.*

Paul: This is a band that I can sit back and watch. I like them as people, and I like playing with them because they make it feel easy. The thing about this band is that they've got great attitudes; they come to play and it is not "ego time." With some bands you can get big egos and you know you can get all sorts of funny stuff going on. But it feels great with this band, and I'll tell you how I know. We were rehearsing in Los Angeles, and we have all these big screens so that people at the back of the auditorium can see, and you're not some spot on the horizon. I didn't quite know how it all looked, so I asked the band, "Do us a favor—would you play the whole set without me, so I can see?" So there would be no bass, no piano, no vocals. I said just play all of your parts. They are such cool musicians they could do that, and I just sat out front and looked at the show. And you know then that they are a great band. I just liked the noise they made, and they sing great harmonies. I was really happy with it, then someone said, "It's even better with you!" We are having a really good time together.

Having being "reviewed" by Paul in rehearsals, Wix, Abe, Rusty, and Brian nervously face the critics proper. They are dazzled by the reaction: "It's a crack band," writes the San Francisco Chronicle; *"an exquisitely Generation X band," records the* Chicago Sun-Times; *"The songs were played to perfection by a whip-smart crew of young Turks he's assembled into a band," writes the* Boston Herald; *"an amazing band," says* New York Newsday; *"a wonderful, energetic group," writes* Rolling Stone, *"the outfit has a youthful energy that suggests the cellars of Hamburg"; "The Band played with razor-sharp execution," comments the* Los Angeles Times. *The British press is no less enthusiastic: "The Band is top-notch," writes the* Daily Mirror; *"much credit belonged to his extraordinarily versatile band," writes* The Times; *"The band is incredible," says the* Liverpool Echo; *"an airtight quartet who rip through the songs and make radiant magic," writes* The Observer. *And Billy Sloan of the* Mail on Sunday *speaks for many when he opines, "The band is fucking fantastic."*

Little prepares Wix, Abe, Rusty, and Brian for Howard Stern's reaction after the New York show: "The band! The band was better than the Beatles!"

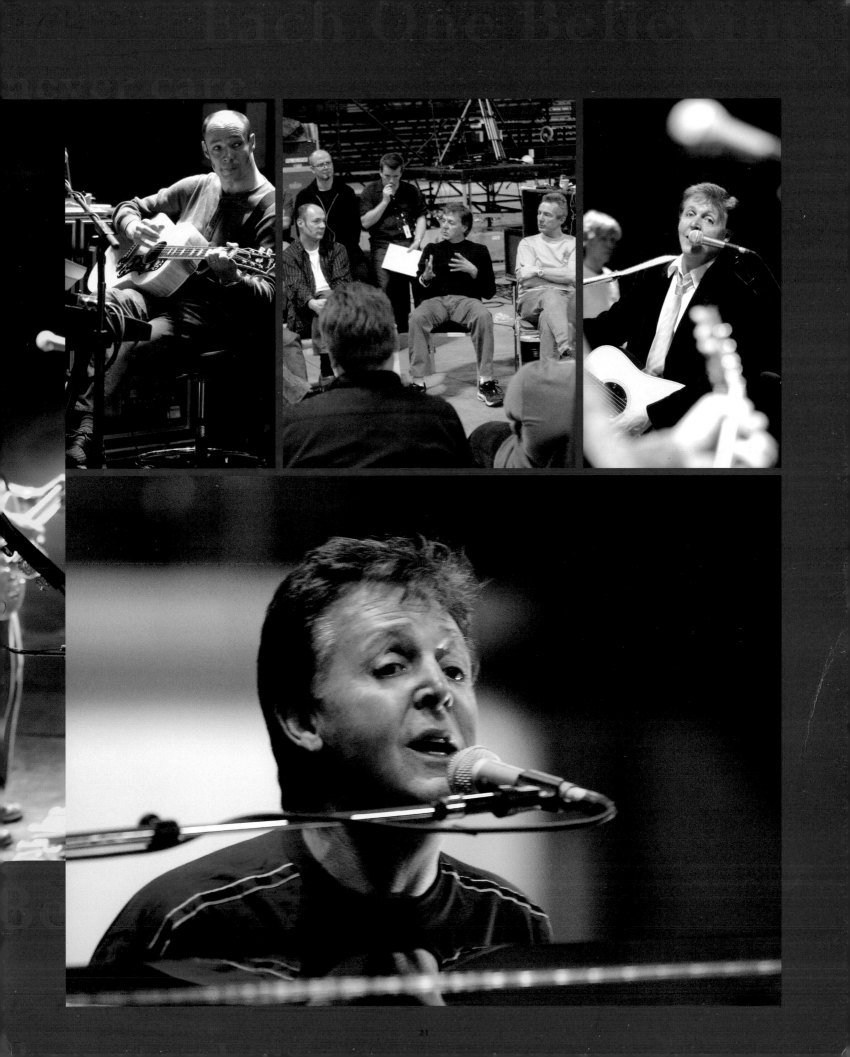

We Could Always Sing

Freedom, madness, and original keys

**INTENDING TO "GIVE YOURSELF A BREAK, MAN,"
PAUL INITIALLY AIMS TO SELECT ENOUGH SONGS FOR
A 90-MINUTE SHOW.** *But his enthusiasm for the back catalog and
an eye to crowd-pleasing ensure that it doesn't quite work out like
that. The set list is discussed in interviews before, during, and after
the tour …*

DJ, Culver City, Los Angeles: I've heard that the show is going to
be 36 songs. Is it really that long?

Paul: Yeah, I think so. I didn't come to it thinking that. There's
a play in London called *Art*. It's quite a little play, a funny little
play, but the great thing that everybody said about it was it's
short! So you go, "Wow! A short play, wow!" That really is,
like, a bonus, you know. You don't have to sit in a theater that
long; it's not like a three-hour epic. And with that in mind I
thought, "Well, if people really are sort of pleased that this
show is short, maybe I don't have to do as much as I was
intending to do," or as much as you feel you have to give the
audience. So I came with the intention of doing an hour and a
half. I thought that would be it—top whack. That's a long play.
Sometimes you can get too long. With the Beatles we only used
to do half an hour, or 25 minutes if we were angry. So I thought
we'd have a little bit of an introductory thing, a little bit of a
support thing—this Pre-Show idea. And then what I did was, I
imagined myself sitting in the audience and thought, "OK,
what would I like to hear him play?" So I'd want to hear some
Beatles … *Hey Jude,* that'd be good, *Eleanor Rigby, Let It Be,
Here There and Everywhere,* yeah, I like those. And something
rocky, *I Saw Her Standing There, Lady Madonna.* And maybe
some songs I've never done before, *Hello Goodbye.* Then I'd
want to hear some Wings stuff, *Band on the Run, Maybe I'm
Amazed, Jet* … And then some of the stuff from the solo period;
I want to do *Here Today,* for John—I've been doing that on my
poetry readings—and I'd like to try that live. And I'd want to
hear some songs from the new album; *Lonely Road* would be
good to do. And I just got this whole list of songs together.
Then I talked to the band and Rusty said he really fancied doing

Getting Better. I've never done that live before so, OK, add that.

Anyway by the time we came to rehearsals, I sat down with
Wix, who's like our musical director, and we tried to cut the
list down to one and a half hours. We started looking at the
numbers and thought, "Oo, I like that one … oh, that one's
good … oh that sounds good … *err,* we can't leave that one
out." We just made a set list up and the original list didn't get
cut much. We said, "OK, let's do that set and see how it goes
… we'll probably change it on the road." But we never did.

DJ: So now your show is around two and a half hours long.

Paul: Exactly …

DJ: You've done some songs that aren't real obvious; it's not just
the obvious hits … things like *The End.*

Paul: Yeah, well in one way I wanted to give the audience what
I thought they'd like, because I like that when I go to a show. I
do like to hear what I consider to be the best songs of the
people I'm coming to see. I don't think there's much point in
hearing their worst stuff just because they don't feel like
playing their best stuff. But at the same time it's kind of
interesting not to always do the obvious. You see my problem
is—and it's a great problem to have—I'm basically doing my
songs spanning my whole career. And I'm lucky to have a lot of
songs to choose from. A lot of people love the Beatles. And then
a whole new generation loves Wings.

DJ: You've had a lot of hits with Wings.

Paul: I've heard a lot of people, particularly people in their 30s,
thirtysomethings, say, "I like Wings better than the Beatles."
Which, you know, is kind of surprising; that's always surprised
me. I was talking to some guy from *Rolling Stone* once … I was
saying, "And, you know, *Sgt. Pepper* … and, you know, *Sgt.
Pepper* … and, wow, *Sgt. Pepper,*" and he said, "I hate to tell you,
man, but my one of those was *Band on the Run.*" It's like a whole
different generation and what does it for them. So what I did is
that I just really looked at a list of what I'd written with the
Beatles and decided to learn them up with the guys. And then I
looked at a list of what I'd written with Wings and since then,
and just thought, "Out of all of those, if I was going to this guy's

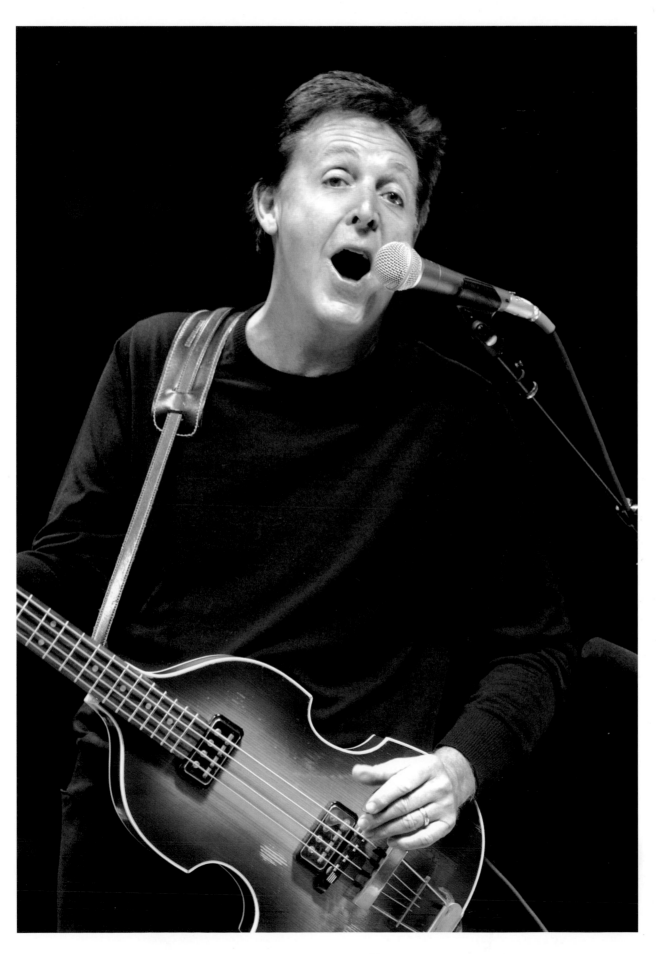

"I'M LUCKY TO HAVE A
LOT OF SONGS TO CHOOSE FROM."

concert, what would I really want to hear? What couldn't he leave out for me?"

DJ: That gets you a lot of songs right there.

Paul: That gets you a lot of songs right there. It's a great problem to have. So I'm thinking, "*Maybe I'm Amazed,* I really would like to see him do that … *Hey Jude*, because it's *his* song and *he* does it." And then I'm thinking on some of the not-obvious stuff, like *Let Me Roll It.* "I really would like to hear him do that, love that guitar riff." And I love playing it. So that came in. *Vanilla Sky* came in because of the Oscars; it was a current song at the time, which I'd had to learn for the Oscars.

DJ: Are you doing *Freedom* again?

Paul: Yeah, we're doing *Freedom*. It'll be interesting to see what will happen with *Freedom* in other parts of the world. In America we'll certainly do *Freedom*, there's no way around it. And they like it.

(Paul opens a box of chocolates.)

Paul: You want one of these?

DJ: No, I'm diabetic, thanks.

Paul: Well actually, interestingly enough, they're sugar-free.

DJ: Oh, OK. Cool. Thank you, sir.

Paul: Hey, that's the first interview you've had where your dietary needs have been taken care of. *(Laughs.)*

DJ, Chicago: So, you're doing *Getting Better* for the first time in the show; is there something symbolic about performing that song at this point in your life?

Paul: I certainly didn't sit down and look at any of the symbolic meanings of any of the songs. But the funny thing is that with this show there's a lot of that happening, where I'm hearing lyrics and thinking, "Well, I certainly didn't mean that when I wrote it." *Yesterday,* for instance, *all my troubles seemed so far away now it looks as though they're here to stay*—that wasn't about any of my troubles that I've had recently or about any of the troubles that America has experienced recently. But that's what it seems like when I sing it in this context, at this point in time. *Getting Better* was just a song, just an idea that I had, but singing it now, there is another kind of symbolism that takes over—

because of where it is and the time. One strange little thing: I do *Jet*—the old Wings song—and that's fairly straightforward, and when I rehearsed it, I didn't think anything of it. But when I came to do it, the first or second night, *Jet … I remember their funny faces that time you told them that you were gonna be marrying soon … And I was gonna be marrying soon*. So there have been a lot of those funny little coincidences happening on this tour. They weren't intentional. But that makes it even better.

DJ, Cleveland: Unlike some of your peers, you are still able to sing songs in their original keys. To what do you attribute your brilliant vocal ability?

Paul: Madness. It's madness. He does not know any better … He just assumes he can do it … No, you know what, it's a funny thing I first noticed this time out when we did the Concert for New York at Madison Square Garden. I thought I'd like to open with something kind of rocking, but I didn't want it to be too sort of happy, because of the events of 9/11. So I thought *I'm Down* might be good, because it's up and it's rocky, but it's saying "I'm down." So I got the record and refreshed myself as to how it went and how I sang it—because it was a long time ago … I needed to think, "Oh, yeah, I sang it like that." And so we did it, just like the record. And only afterwards I thought, "Wait a minute, that's in the original key"—which was very high then, and it's now a number of years later, and we're doing it in the same key!

But it really is that I kind of assume that it'll be there. And I touch wood and just think it'll probably be OK. Psychologically the approach is … *Yah!* It's a very positive approach. Any singing teacher will tell you—not that I've ever had a lesson, but I've heard what they say—that it's a mental thing, singing. I heard that somebody—Elvis Costello's dad, actually—said that if you're going for a high note, look down on it. It's a question of not intimidating yourself with a high note. You look at it and think, "Yeah, it's high, but looking at it from here it looks quite low to me." You persuade yourself that you can do it. Somewhere in the middle of all that rubbish I've just said is why I still do the songs in the original keys!

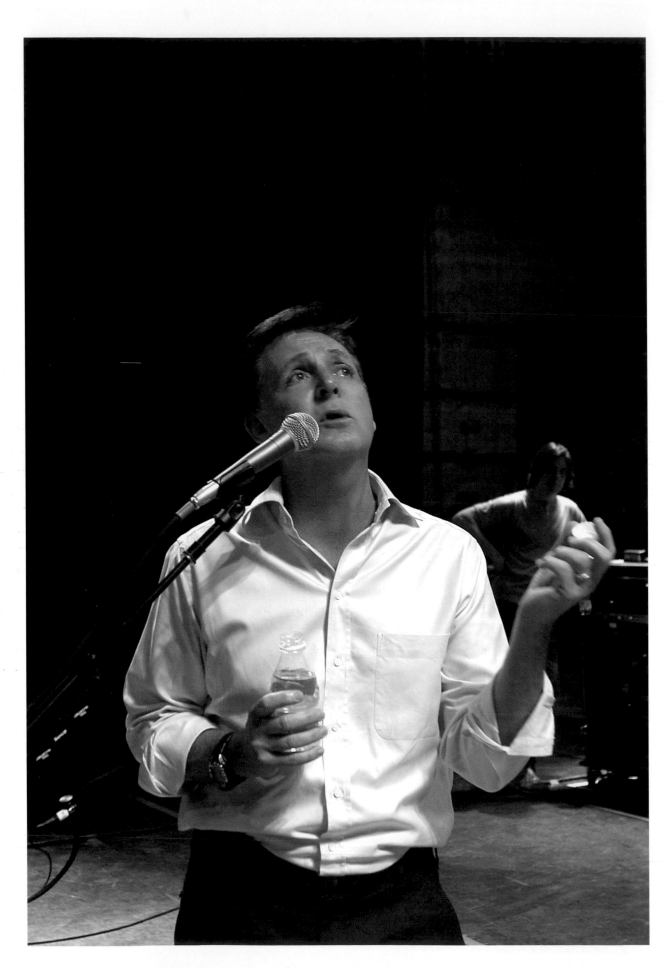

"I WROTE *YESTERDAY* WITH THE WISDOM OF AN OLD MAN, BUT I WAS QUITE A YOUNG MAN. SO NOW, ONCE YOU HAVE ACTUALLY LOST FRIENDS AND LOVERS, THEN IT REALLY IS KIND OF ... IT MEANS MORE."

PAUL MAKES SOME CHANGES TO THE ORIGINAL SET LIST.
On the opening night of the second leg and later on in Chicago, he discusses some of these changes.

Reporter, Milwaukee: How did you decide which songs to put in this set and which ones had to go?

Paul: There were a couple of numbers ... for instance, something like *Vanilla Sky* was a song from a film that's a been and gone kind of thing, you know ... So at the time it was topical because of the Oscars, and Cameron Crowe had cut a real nice little video for us. But I just felt that it had had its moment, and that was an opportunity to include something else. Then we dropped another little acoustic number that I was doing, *Mother Nature's Son,* a Beatles number. I actually just wanted to drop a couple, just to keep it a little bit fresh for us, so there would be a couple of numbers that we'd be looking forward to because they were new. There was another one—*C Moon.* We were enjoying doing it, but I think, 'cos there are so many hits in the show, there were a couple of lesser hits which I'd put in, on purpose actually, to give people a chance to go get a beer and take a pee. So now ... there's no chance! We've filled all the leaks, the ship is now watertight! *Nahh,* there were just a few songs that in talking to the guys we thought, those don't quite go down as well as the others. We were happy with them at the time, but I thought I'd like to try to find a couple to switch. So that's what we did; we just pulled those three out and put three others in.

DJ, Chicago: You've added *She's Leaving Home* to the set. An interesting choice, and I imagine that when you recorded it in 1967 you never imagined doing it live because the technology was so limiting then.

Paul: Yeah, that's right ... well, actually, a mellotron would just about have covered it—the early mellotron, which was the forerunner of the synths. It wasn't so much not imagined doing it, it was just that I never got around to it. So it was a record for me, it wasn't like a kind of live song. It just existed as a record. Doing this tour and doing *Hello Goodbye* and *Getting Better* in the set, was just a really cool thing. I thought, "Wow, there must be quite a lot of Beatles songs that I've never done with the Beatles." 'Cos you can't do 'em all. Especially in the Beatles days, before '67, you know, we didn't used to play that long; you could only get a few songs in the set, and half of them were John's anyway. So it's just a thrill to be playing things like *Getting Better,* 'cos you're rediscovering this interesting song, and it's almost like you didn't write it, it's so long ago. It's like, "Hey, this is a cool song; I wonder who wrote this?" *She's Leaving Home* is certainly like that; it's really lovely to do and sort of rediscover the lyrics. And also, like a lot of my songs, they've got a new resonance because I'm older. These songs about family sadness or losing people, like *Yesterday,* reverberate more now. They seem to mean more now, 'cos I was like 24 or something when I wrote *Yesterday.*

I was writing with the wisdom of an old man, but I was quite a young man. So now, once you have actually lost friends and lovers, then it really is kind of ... it means more.

Although the show essentially stayed the same throughout the tour, Paul changed songs at times to keep the set fresh to play. Among the additions were Calico Skies, Two of Us, Let 'Em In, Michelle, She's Leaving Home, *(and for Liverpool)* Maggie Mae *and* I Lost My Little Girl, *and (Toronto only)* Mull of Kintyre.

See the World Spinning

Paul and the Band on iguanas, nightmares, and dreams

HANGING OUT TOGETHER FOR DAYS, THE BAND HAVE TIME TO GET TO KNOW EACH OTHER'S WAKING AND SLEEPING THOUGHTS. *As they sit around comparing dreams, a few surprising facts emerge. Rusty is probably not the only musician to dream he's been invited to play with the Beatles, though he's one of the few to see the fantasy made real. But even Paul, it seems, has his Beatles dreams.*

Brian: I got woken up last night by the alarm clock, at six o'clock in the morning. And I realized I'd been having this dream. You know how all of a sudden you get thrown out of it, and I was having this dream that I had to take care of every single animal that I've ever owned. I had seven iguanas and I was taking care of them. Things were crawling all over me.

Paul: There is this nightmare that I have, and which I particularly used to get in the Beatles, where I'm playing to an audience and they start walking out. And in my nightmare, I'm thinking, "Do *Long Tall Sally*" … and they're still walking out. So I think, "Do *Yesterday!*" … and they're still walking out, in droves. It's a performer's nightmare.

Rusty: When I was a kid, I was like seven or eight, I had dreams that the Beatles would come to my door with their guitars and stuff and say, "Hi! You wanna play?" And I'm like "Yeah!" And I'd wake up and be sad because it was only a dream. And then we were in the studio recording, and toward the end of that Paul says, "Hey, man! I had a dream about you last night." You know? And that was like *Chrrr!*

Abe: When I'm up on stage I am not thinking about the show. I'm almost in a transcendental meditation or something. I feel like I kind of leave and observe the whole time. I am staring at faces and definitely feeling the audience. And it's beautiful.

Wix: You get flashes of "Am I doing this? Am I really only just me?" You know, "I am still me inside of me—and I just happen to be here." And I permanently live with the fear that I am going to get found out one day.

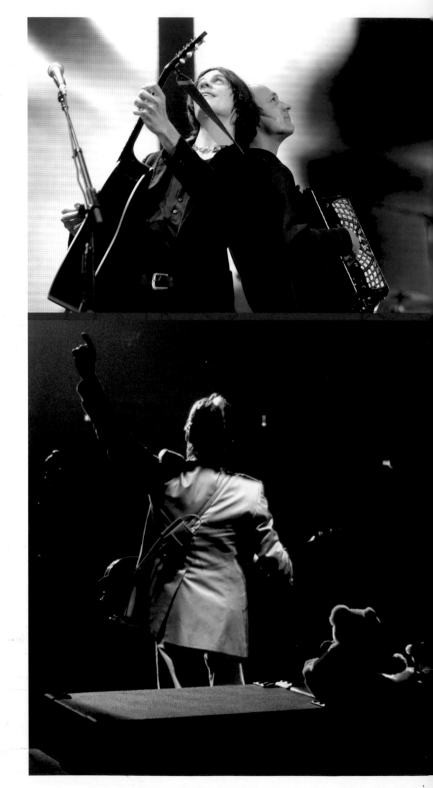

"WHEN I WAS A KID, I HAD DREAMS THAT THE BEATLES WOULD COME TO MY DOOR WITH THEIR GUITARS AND STUFF AND SAY 'HI! YOU WANNA PLAY?'"

Rusty Anderson

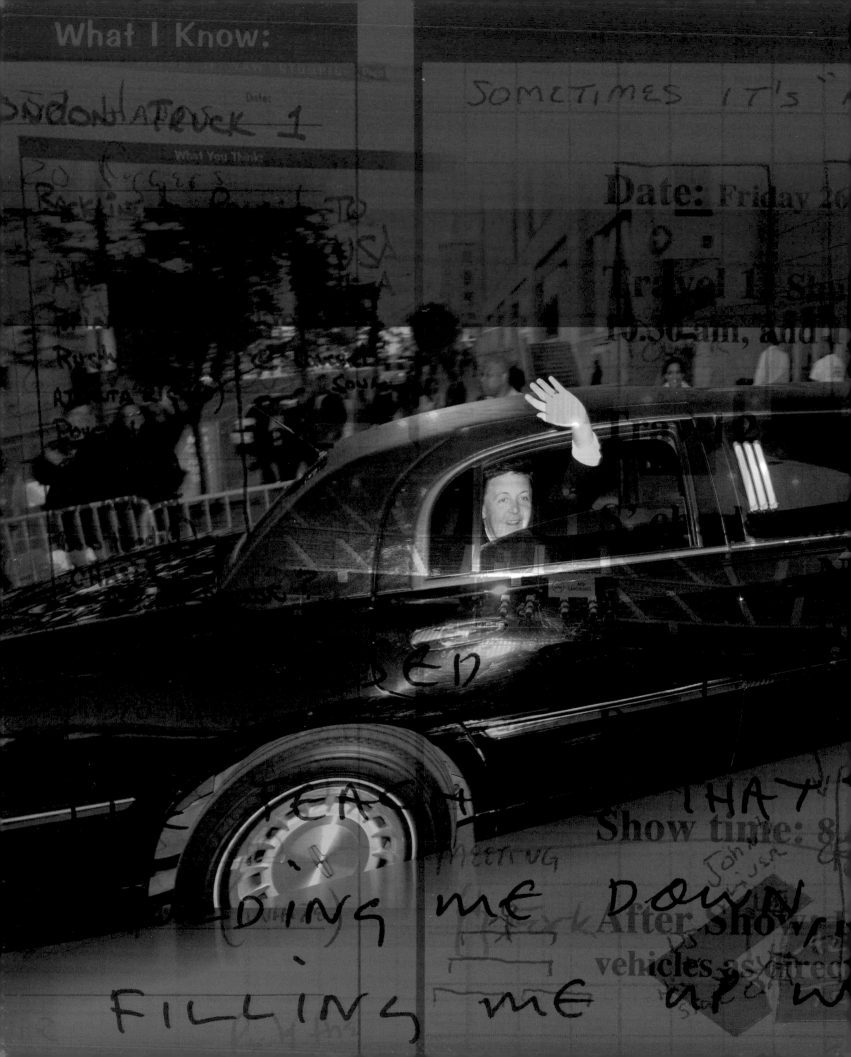

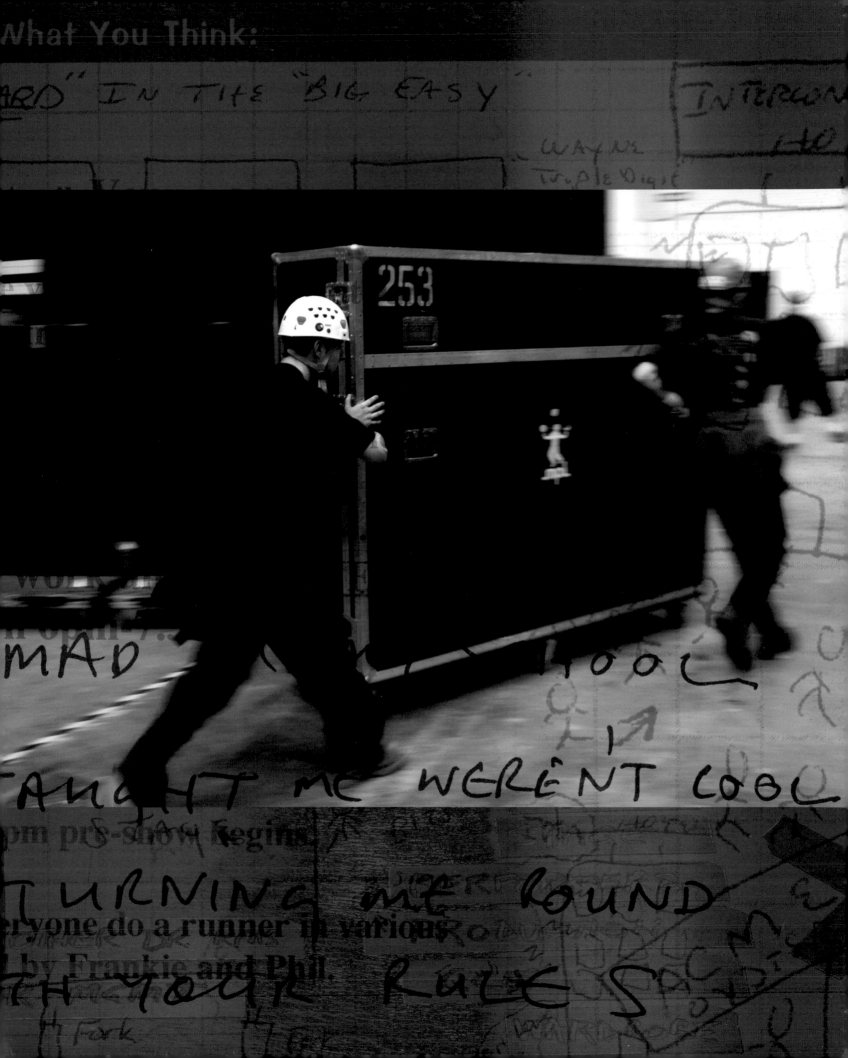

Filling Me Up

The ultimate truck fan's shot, the three-minute rule, and keeping it edgy

A PLAN IS HATCHED FOR SOME SPECTACULAR SHOTS THAT WILL CAPTURE THE DRAMA AND ROMANCE OF A MAJOR ROCK-AND-ROLL TOUR. *Twelve trucks travel 115,000 miles in the course of transporting the bits and pieces of the tour. Paul sits down with his tour publicist and official photographer to envision a picture that will encapsulate the scale and grandeur of it all.*

Paul Freundlich, Tour Publicist: Apparently the truck tops are Plexiglas, so they have to actually somehow do this differently in terms of how they lie the logo on them ...

Paul: They're Plexiglas, that means you can't paint on them?

Paul F.: No, you can't paint on them.

Paul: Can you stick on it? I thought you might just get them to stick it on it.

Paul F.: Do you want the lettering ... do you want it to be "Paul McCartney's Driving USA"?

Paul: Depends what they've got room for. Maybe they should tell me what they've got room for. How many trucks have we got?

Paul F.: There are 12.

Paul: Well, cool. I'd imagined them actually sort of coming under a bridge ... don't know how they'd do that. It might have to be early in the morning.

Paul F.: What they were thinking was it would take some time to create what goes on top of the truck ...

Paul: Yeah, OK.

Paul F.: So what they were thinking was they would have it ready by Tampa.

Paul: Yeah.

Paul F.: There's an off day right after Tampa where they could shoot at that point. And I was saying really the best way to get it done is either going to be in a small craft or a helicopter.

(Right) Although the computer-imaging option would have been easier, in keeping with the "no faking it" policy of the tour, Bill Bernstein shot this photograph from a helicopter high over the Florida Keys as the trucks sped to the last shows of the first leg, in Fort Lauderdale.

Paul: Well, I know that's the best way, but you know we were hoping for something simpler. I was hoping for like a bridge that they drive under ... Mr. Bernstein will tell you how to set that shot up. I was just thinking that if all the trucks were coming side by side, taking up three lanes or something, and there was like a lot of them, and you could just sort of see "Driving USA." They don't all have to have that written on the top, in fact. I'll show you what I'm thinking of doing. I mean, I'm making this up now. What else is new, huh? Here we'll make a bridge. *(He starts to draw.)* That's a bridge. And let's say the trucks are coming toward you ... terrible perspective drawing *(laughing)* ... really crummy. And see you've got these big trucks coming toward you, big red trucks, and they're all sort of a convoy, like this. And you know, then, it might just sort of say "Driving USA" ...

Paul F.: Umm, hmm.

Paul: ... It might just say "Paul McCartney."

Bill Bernstein, Tour Photographer: You could put that on the image afterward, too, you know. You could use Photoshop.

Paul: If it's the only way to do it.

Bill: Easily.

Paul: That is sort of what I was thinking. It's just an army of trucks, it's like a roar, you know: the ultimate truck fan's shot.

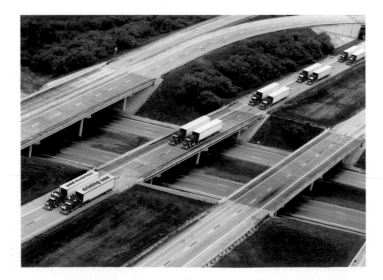

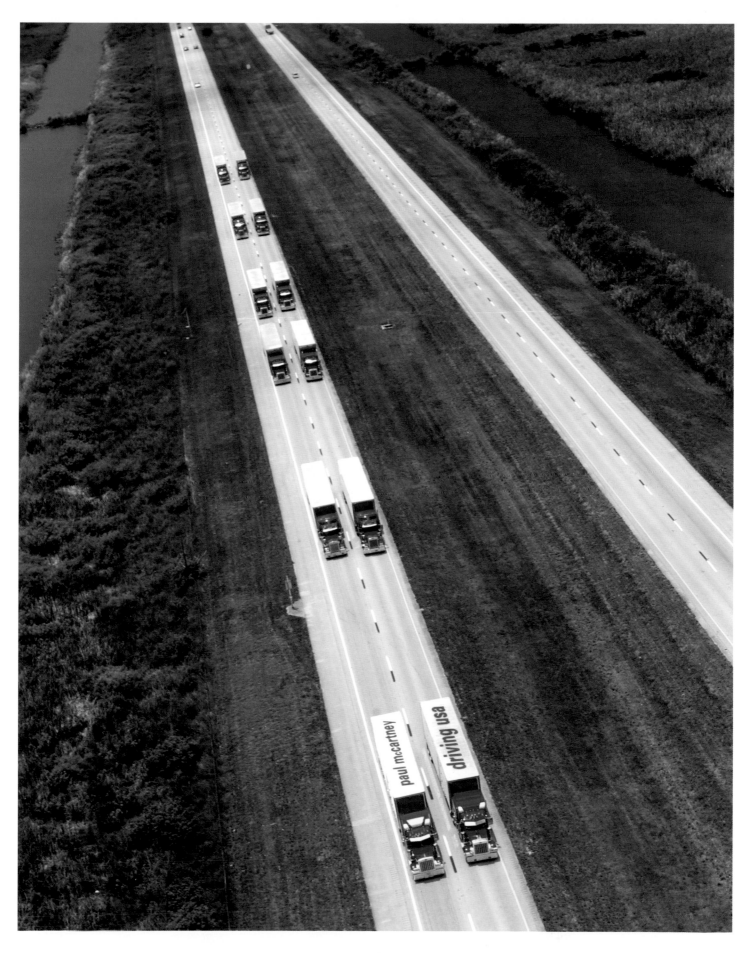

AROUND 140 PEOPLE TAKE PART IN THE ELABORATE CONSTRUCTION OF THE STAGE, PREPARING THE EMPTY SPACE FOR THE MAGIC OF THE NIGHT'S SHOW.

THE BEAUTIFUL ILLUSION OF A BIG ROCK SHOW IS THAT THIS EVENING'S MAGIC IS SPONTANEOUS AND UNIQUE. BUT THAT ILLUSION MUST BE RE-CREATED EVERY NIGHT OF THE TOUR. *Responsible for stage building, lighting, sound, and transportation, the crew members collaborate in a collective enterprise of staggering proportions. The show's very existence depends upon the speed and efficiency of their largely unseen labors.*

Mark Haefeli, Film Director / Producer: What does a stage manager do on this trip?

Scott Chase, Stage Manager: On this tour, and any other tour,

I get the show into the building. I take it all off the trucks. I get my crew to work with the local crew, make sure everybody plays together nice, and then we get it going. I get sound check going on time, I get the show going on time. And then I have to load out at the end of the night; I take a whole other crew, get them together, and get out of there as fast as we can.

Mark: What does it take to load a show in? How many people do you have? How much equipment comes into the building?

Scott: We have got 12 trucks on this tour; 12 big, heavy, full trucks. I have a crew of 60; they travel with us. And then I use another local crew of close to 80 when we get to the venue.

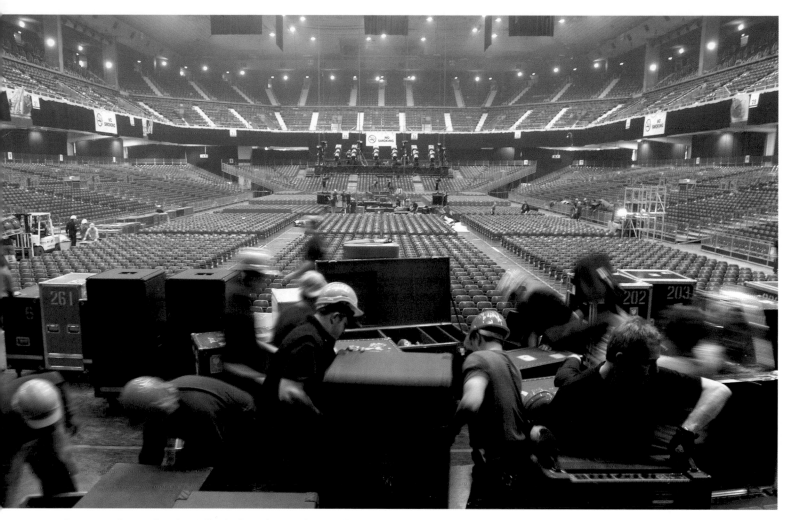

Setting up the London show. The clock is always ticking and screwups are not an option.

Everyone has a department, everyone knows what they are supposed to do, and I just give a certain amount of guidance to each department and then they continue with their task.

Mark: You make it sound so easy, yet you're building a whole stage in an empty arena in less than a day.

Scott: If it's all done in the right position, then it all goes up right. If anybody screws up during the day, well then, things can go wrong. Everything depends on everybody else to make sure everything goes right—starting with the rigging. As long as the rigging goes up quick, then everything can slide underneath it and we can proceed. If we get held up, then everything gets backed up in the course of the day.

Mark: Give it to me step by step.

Scott: The trucks pull up to the docks. I organize the local crew. Get my guys out of bed. Get them into the venue. The riggers go out. The riggers lay out the points on the floor, send their team up, and unload the trucks. We start unloading the rigging motors, the lighting truss, working our way into sound and

video. Our backline truck with the instruments will be the last truck in. The rigging goes up; the lighting comes in underneath it. As the lighting goes up, the stage is being built at the other end of the venue. Once the stage is up and the lighting and video walls are up in the air, we roll the stage in underneath with all the band gear already set up on it. Then we do the final touches, do the line check, ready for sound check.

Mark: How do you break it down?

Scott: At the end of the night, at the end of the show, as soon as Paul has left, I give them the three-minute rule—which is that nobody gets to charge on stage until three minutes after Paul leaves. Because he should get that respect. Once that has happened, I take the local crew and they are all given colored wristbands so that they each know which department they're in. They are sent to each crew chief and then, starting with the backline gear, we strip the stage. Whatever we can get off quickly gets off the stage. Then the stage is pushed back out to the front of the house. And then things start coming down and

going back in the trucks. There are teams of loaders out there and it just gets fed out; a production manager fires it out to me, and me and my guys get it into the trucks.

Mark: How long does it take?

Scott: It takes us about six hours to be show-ready, and at the end we can get out of there and be back on the bus in two and a half hours.

Mark: What's the tour been like for you?

Scott: It has been a long time since I've worked with a rock band, you know; I've been doing a lot of pop acts for the past five or six years. Paul is good to work with; everything he wants, you get and you give it to him. Everybody's happy and it's smooth, smooth sailing. The show itself is good, we watch the show. I like the fact that he can change his mind anytime he wants. You know, it's good working with him. Overall, I have a great crew; everybody does their job really well. We had a few casualties, people who couldn't cut it, but other than that the whole crew and the whole tour are really cool.

Mark: Lighting plays a major role in any concert, particularly this one. It's *ahh*—I am not going to describe it. How about you describe it?

Wally Lees, Lighting Director: The lighting has to complement the video, because the video is a big part of the show as well. So when Randy and I were programming it, we wanted to make sure that the lighting didn't become a more powerful aspect than the video. And in the same way, we had to make sure that the video didn't overpower the lighting. I think Paul wanted an edgy show—somewhat edgy, in keeping with the tune of his vibe on stage as well, without getting too out of control. And that is basically where we started with the lighting and this is where we ended up. I think we did the job pretty good. We are pretty happy with it.

I'm trying to keep it as even as I can every night. You know, Paul would probably do a show with the houselights on if he wanted to. But what we are trying to do is get a feel for every song. We're trying to choreograph the lighting to the music. And between songs, we just try to vary it so that nothing looks the same twice—that way no one gets bored. We're aiming to keep everyone interested till the last song.

Mark: Everybody takes something away or home from the tour. What is that thing you will take home with you?

Wally: What I will take home with me will be the feeling I had before the show the first night it opened. In twenty years I've never felt so pleased. It was great. But even now I can think about it because it was so much fun. It was so much fun, the

anticipation and then the nervousness. There was nervousness and I often don't feel nervous anymore. It was a thrilling experience. And then again, the audience, to see the audience watching a Beatle on stage. For me that was great, it doesn't get any better. Since that night the shows have progressed; the shows have probably become neater. And everything is tighter than it was the first night. But for me I will never feel the same way I did the first night. That was incredible.

Paul "Pab" Boothroyd, Front of House Sound Engineer: What will I take away with me from this tour? *Ahhh,* the wages. Then the per diems … and all the things I have stolen … the whiskey out of Paul's dressing room. *(Laughs.)* But seriously, it's always a privilege to tour with Paul McCartney. The sound crew are great, the ideas, groundbreaking. The sound system for the tour is a combination of new and old technology. Some are so new that they have not been applied in touring situations before. The tour is also being catalogued and recorded, so a fully functional recording facility is incorporated into the front of the house sound mixing area. Not only is the live sound being mixed for the show, but it is also being multitrack recorded at the same time! This really is historical!

All the world's his stage: Stage Manager Scott Chase (above, opposite, and below center) and some key collaborators, including Monitors Engineer John Roden (below left), Front of House Sound Engineer Paul "Pab" Boothroyd with Abe (below), and Production Director Gerry Stickells (bottom row, second from right).

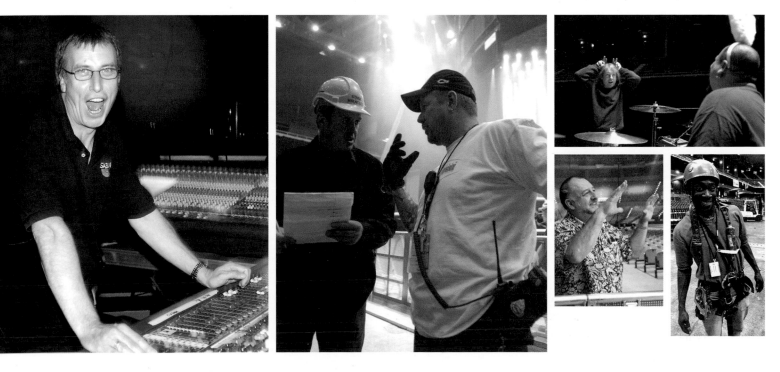

Out of Sight

On premature ejacu-landing and underwear

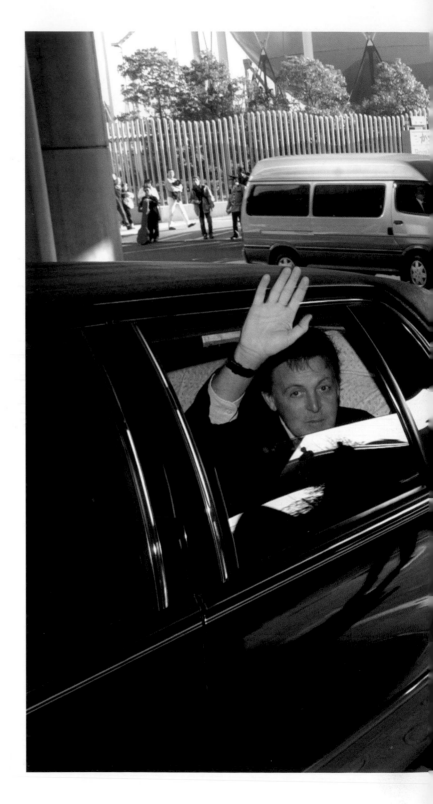

TYPICALLY PAUL'S ARRIVAL AT A VENUE INVOLVES A CONVOY OF UP TO 20 VEHICLES, SPEEDING INTO THE BACKSTAGE AREA TO THE SOUND OF SIRENS. *The flagship of the fleet is a limo carrying Paul and Heather; the band rides in another. There will be 2 security town cars, between 4 and 12 police motorcycle outriders, 2 police squad cars, and a luggage van. Backstage in Columbus, Ohio, on October 10, 2002, some of Paul's entourage await his arrival at the sound check.*

Paul Freundlich, Tour Publicist: Hey, Phil! What time's the boss due?

Phil Kazamias, Tour Manager: Did you read your day sheet?

Paul F.: Uhhh, yeah.

Phil K.: Then you'll know what time he's coming, won't you?

Paul F.: Err, yeah, but what time he's meant to come and what time he arrives …

Bill Bernstein, Tour Photographer: He'll be anything but early.

Paul F.: Sound check is at 5:30.

Robby Montgomery, Creative Consultant: The plane could be early …

Geoff Baker, Press Officer: He could have a—what did Macca call it?—a *premature ejacu-landing.*

Robby: Who said that?

Geoff: Paul. That's what he calls it when the plane gets in early. Call up Brian— see if he's heard anything.

Paul F. (speaking into the radio): Hey, Swally Man, you out there? Hey, Brian, come in.

Phil K.: He's not on your channel; go to 12.

Paul F. (speaking into the radio again): Hey, Swally …

The voice of Brian Riddle, Security: Who's calling Swally?

Paul F.: Brian, it's Freundlich. Have you got an ETA?

The voice of Brian Riddle: No.

Robby (to Geoff): What are you doing with that sign?

Paul F.: Yeah, what's with the sign?

Geoff (affixing gaffer tape to the back of a large piece of cardboard): It says "ten." It means we've broken another house record. Ten house records in a row.

Robby: We bust the record in St. Louis?

The tour's main man arrives at the next venue—in this instance Osaka, Japan—within the convoy of limousines and police escorts that is integral to the tour routine.

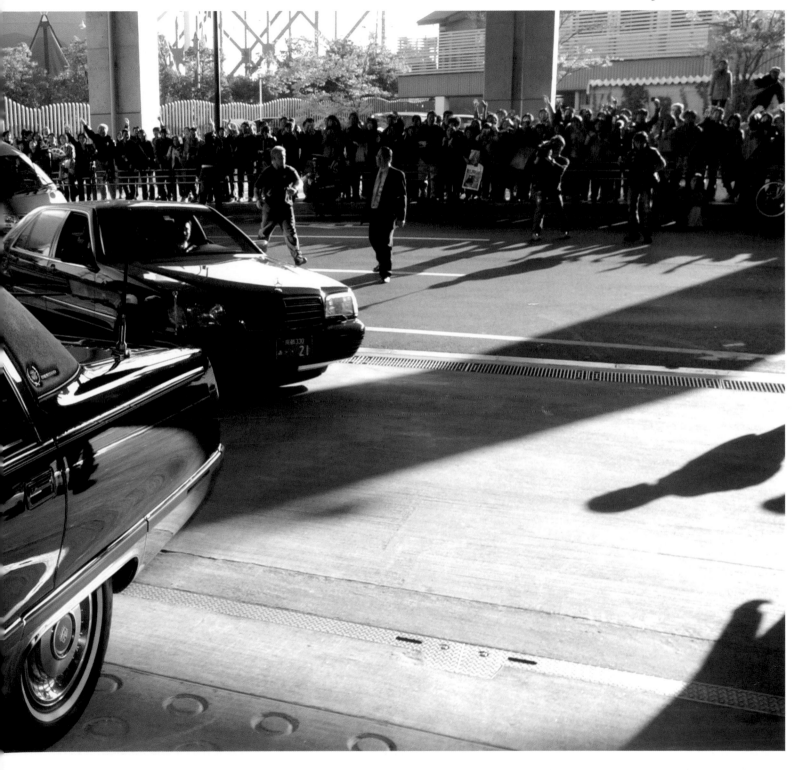

During the early days in the Beatles—before the arrival of the mania that necessitated the band be transported to concerts in armored trucks—Paul, John, George, and Ringo would ride from gig to gig in an old, unheated Bedford van. When the bitter cold of English winter became too much to bear, the group would try to keep themselves warm by making a "Beatle Sandwich," piling on top of one another in the back of the van with just their body heat and a communal bottle of whiskey to stave off hypothermia.

(Right) Paul arrives at the sound check; highly trained monkeys keep watch in the band's dressing room; (top right) Paul Freundlich and Geoff Baker, equally well-trained publicists, confer; (center) Abe exchanges grooming tips with Pre-Show performers; elsewhere all is pep talks, phone calls (two at once, in Robby Montgomery's case), and the constant checking of watches. Show time approaches …

Geoff: Yeah … smashed it.

Bill: So what's with the sign?

Geoff: Just a little game … to let him know when he arrives. Helps the vibe.

Bill: Who held the record before?

Geoff: U2.

Bill: Cool. So that's ten records in a row? That's cool, man.

Geoff: Fucking cool … a perfect ten. We are the Bo Derek of rock-and-roll.

Robby: What were the reviews like?

Paul F. (reading the Tour Newsletter aloud): "McCartney rocks the Savvis Center crowd … a hit-packed musical bonanza … backed by a crack four-piece band, he drove the crowd crazy."

Bill: Cool.

Paul F. (still reading): Hey, what's this? "He drove the girls wild" … and Geoff's added, "which presumably accounts for that underwear getting thrown at the stage." What underwear? They threw underwear? Girls' underwear?

Geoff: Yeah.

Paul F.: Where was I when they were throwing underwear?

Robby: Do we throw it back? Where's the underwear? Do we keep it?

Geoff: Brian catches it.

Paul F.: Why do they throw it?

Geoff: I guess they're feeling gruntled.

Robby: Gruntled! What the fuck is gruntled?

Geoff: It's Zach Niles' term for the effect of this feel-good factory. Didn't you hear him on the bus? He said, "Is there such a word as canny, like the opposite of uncanny?" He said he only asked 'cos this tour was making him feel very "gruntled" right now. Cool word, eh?

Robby: How do you get to be gruntled?

Paul F.: Be here now.

The Tour Newsletter was inaugurated by Paul in 1989 as a means of keeping tour personnel informed on the progress of the tour and as a digest of tour reviews, news, and gossip. The newsletters are written by Geoff Baker.

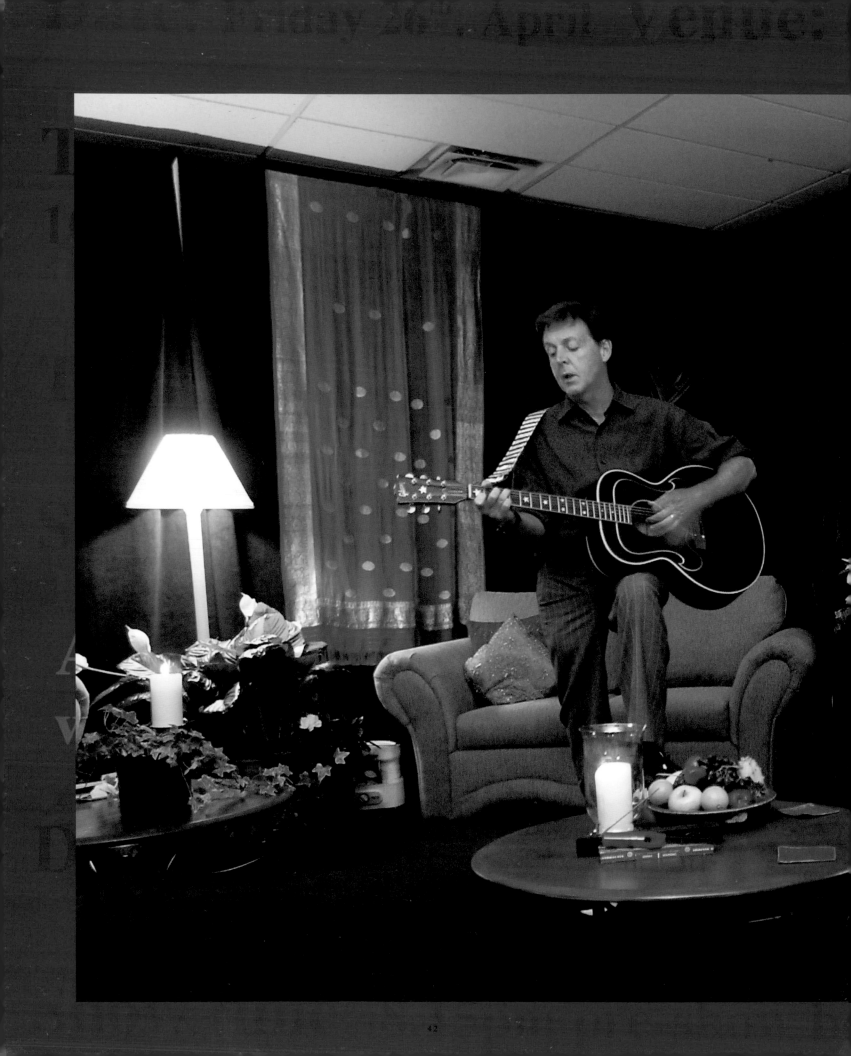

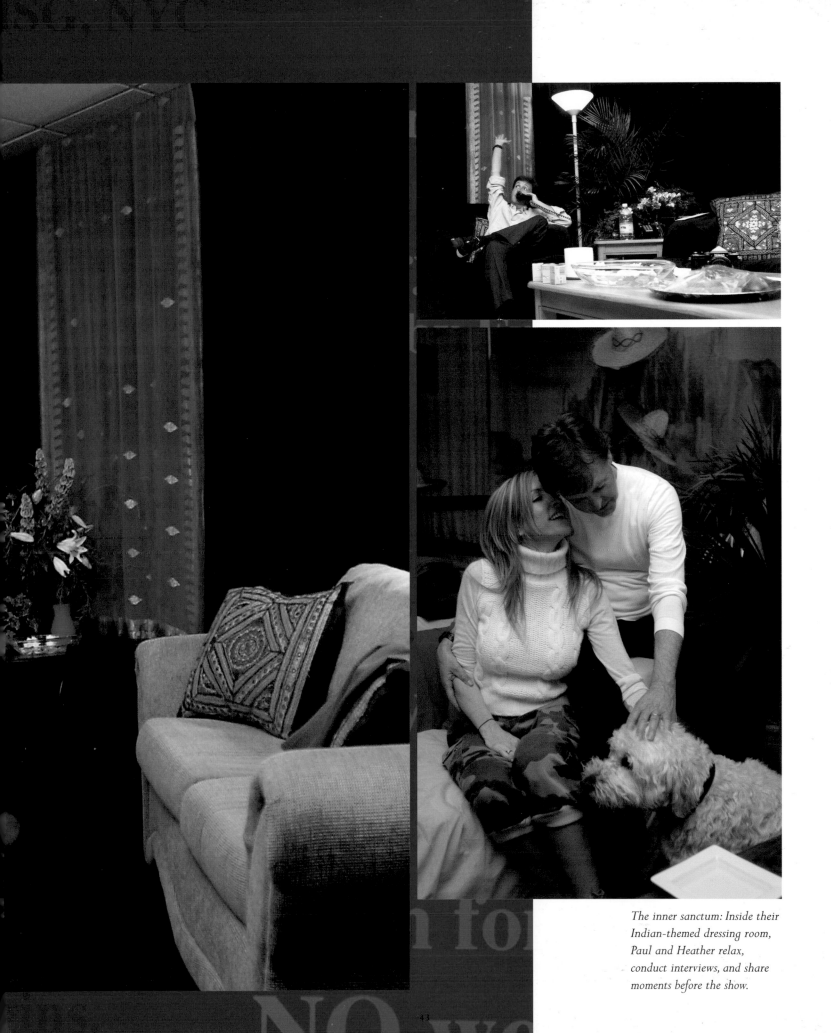

The inner sanctum: Inside their Indian-themed dressing room, Paul and Heather relax, conduct interviews, and share moments before the show.

Unpack My Case

On monster guitars, catching guitars, and confidence

PAUL McCARTNEY HAS USED HIS HOFNER VIOLIN BASS DURING EVERY CONCERT OF HIS LAST THREE WORLD TOURS. *He bought his first Hofner when playing in Hamburg with the Beatles in the early sixties; he made the model iconic, right up to the group's final appearance on the Apple rooftop in 1969. Paul's current Hofner has served him for 40 years, including the 300-plus shows he has played since 1989.*

Reporter, Antwerp: Here's a question from a bass-playing friend of mine. On this tour you only use the Hofner for bass, whereas, if I'm right, there are only three songs in the set which were recorded with that guitar or that type of guitar. And the rest were all Rickenbacker—which, he thinks, would be a more suitable sound for a bunch of the songs. So is it just for the image or the love of the Hofner?

Paul: Well … let him come and play the bass with this band, then. He's got to sing all the songs, though … No, you know what? I just like the Hofner and I like playing it and I don't like fussing around—I've already got enough changes, you know. I change to electric guitar to acoustic guitar to piano to ukulele to bass, so I wouldn't wanna be changing between the Hofner and the Ricky. You know, the Rickenbacker's a good bass, but at the moment I just like the Hofner. It's very light, and you know that may not seem like an important factor, but it is actually … it changes how you play it. A light instrument is easier to move about with. I've got a Wal, a five-string, you know, a really big, sort of heavy guitar with the big bottom note.
Reporter: Great sounding.
Paul: It's a great sound, so it's good for studio and stuff, but it's a monster to carry around. It's like having a big heavy suitcase. So, no, please tell your friend I'm happy with my Hofner!
Reporter (laughing): I'll tell him.

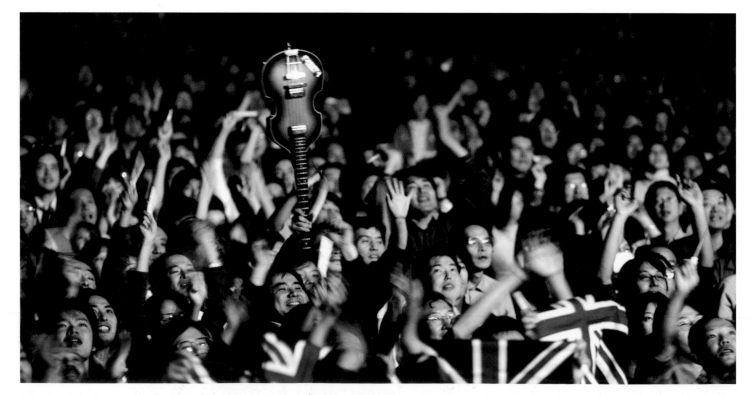

Proudly aloft, the iconic Hofner guitar that says "McCartney" all the world over.

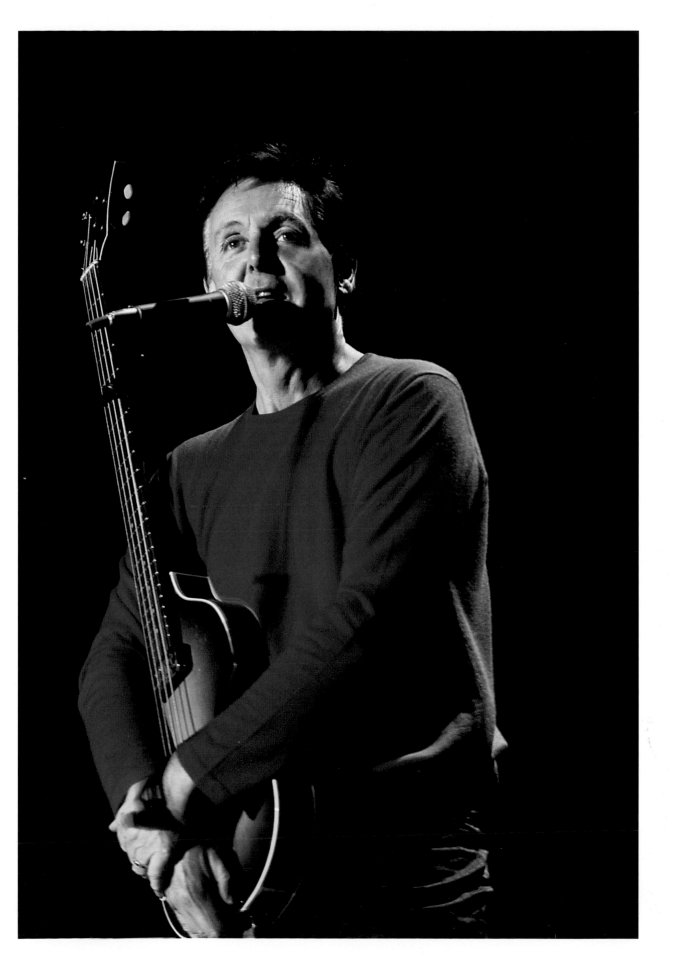

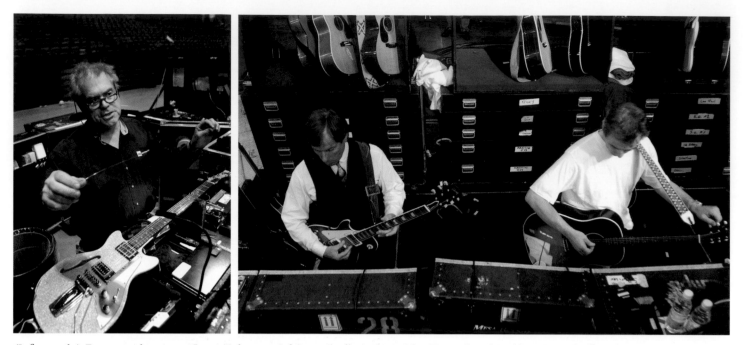

(Left to right) Zing went the strings. Guitar Technician Sid Pryce, Paul's Assistant John Hammel, and Backline Crew Chief Keith Smith.

EVERY NIGHT, THE GUITARS PAUL PLAYS ON STAGE PASS THROUGH MORE THAN ONE PAIR OF HANDS. *But keeping strings at the correct tension can be a pretty tense affair.*

Geoff Baker, Press Officer, London: John, why do you say that Paul's Hofner bass is the most iconic guitar in the world?

John Hammel, Personal Assistant to Paul McCartney: Just because of the shape of it; it doesn't matter which way around you play it, it looks the same. And that's why Paul originally bought it—being left-handed. In fact, I think the original one he bought was left-handed. This one he uses now is left-handed, because Hofner made it especially for Paul. It's iconic because it's so recognizable. It doesn't matter where you go with it, people recognize it. Even in its guitar case people say, "Oh, there's the Hofner." I think Paul reinvented the Hofner when he began playing it again in '89, and all of a sudden Hofner started making the new ones again. Since the '93 tour he's not played another bass on tour, because of the Hofner's lightness and easiness to use on stage. On the '89–'90 tour he used the Wal five-string bass and used the Hofner for a couple of numbers. But the Wal is heavy; it's like carrying a large piece of wood.

Geoff: There's a moment in the show, at the end of *I Saw Her Standing There,* where Paul throws the Hofner for you to catch, a risky business with an expensive guitar. How did that begin?

John: It just started. One night Paul just threw it at me, and I just caught it. He just threw it out of the blue—*bang!* And I caught it. And gradually that's become part of the show.

Geoff: Did you ever think you'll drop it?

John: Well yeah, but you don't. You can't drop it.

Keith Smith, Backline Crew Chief: But he doesn't just neatly lob it to you. On one occasion he hurled it in the air and spun it at the same time.

John: Yeah, and I nearly fell over Rusty's amps catching it.

Geoff: I remember watching that with a friend and we both went, *"fuck-ing hell!"*

John: Yeah, well, I went *"fucking hell,"* as well. No, the worst one for me, my one real bad catch, when I missed it with one hand but God was on my side, was when I just caught it with my left hand about two inches off the ground. It was just insane.

Keith: You say it's a light guitar; what would happen if it hit the floor?

John: Oh, it'd crack. It's a 40-year-old guitar. It is its 40th birthday this year—40 years after the Royal Variety Show of 1963. We'll have to send the Hofner out on tour for its

Paul first bought the Hofner because it was cheap and he was poor. Back in 1960 a Fender bass retailed at around £100, way beyond the pocket of Paul, whose £2.50-a-day deal had only allowed him to save about £30, the price of a Hofner. However, for left-hander Paul, the guitar had the advantage of twin-sided cutaways, making it easier to play, and—having to be restrung upside down—"it looked less daft because it was symmetrical." In recent years, John Hammel has taken the Hofner to a bass specialist in New York for upholstering on the frets, correcting a problem that was throwing the instrument out of tune.

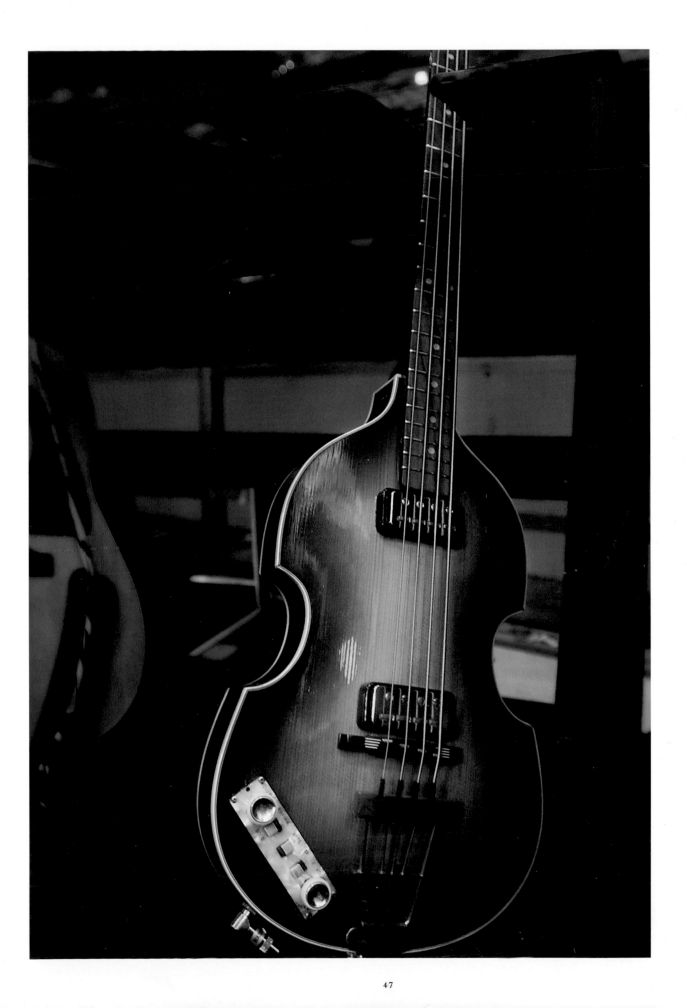

John Hammel (above) and Keith Smith (right) have numerous duties, including ensuring that guitars and other instruments are precisely tuned and ready the moment the player needs them.

anniversary. In a pink Cadillac, like Elvis did.

Geoff: Midway through the first leg in America you said this was the best tour you'd ever been on. Why was that?

John: Because Paul was the most relaxed I've ever seen him. He has a great band behind him and, to me, they support him like no other band has. They support him like we all support him, like they are part of the team. Paul is the guy everyone is coming to see, and he needs the whole team of people to produce this for him to perform like he does on stage—with the lights and the screens and everything else, PA, monitors, the whole thing. He needs everyone to do it. And for me, with this band, there's been no ego trips; they just back Paul brilliantly. They worked out the tunes brilliantly, and they just make it easier for Paul to play on stage; he's not having to worry about someone playing out of tune or out of time.

Geoff: So what's a typical show involve for you?

John: We arrive at the gig for the sound check and the first thing is I'll tune the bass. Paul will do a few numbers on the bass, and while he's doing that, I'll tune the electric guitar. Then when he goes onto acoustic guitar or piano, then I'm restringing the Les Paul.

Geoff: Why restring it?

John: I restring it every night. Every night his acoustic guitar and his electric guitar get new strings.

Geoff: Why?

John: Because Paul could break a string playing it the second time around, and you don't want breaking strings on stage because it's not good for him. He's still got to play his chords, and if his E string or D string's gone, then he's not comfortable. So I restring them every night and then there's no excuse for a string breaking. We've not had one broken string on this tour.

Geoff: Wasn't there one gig when he had to tune the guitar in the middle of the show?

John: That was on the *Yesterday* guitar. Someone in the crowd threw a flower up on stage, and Paul put it in the guitar and he knocked the machine head out as he put it in. He knocked it out of tune. It would have been the bottom E that was tuned to a D.

Geoff: So, during the show, you're basically tuning guitars the whole time?

John: Pretty much, yeah. My hardest part of the show is up to after *Band on the Run*. After that it gets a bit easier because Paul does three piano numbers then, and I can chill out for a bit. But up to then I've got different tunings; I've got tuning with *Michelle*, and I've got the ukulele. Paul's so open out there on stage, and knowing a lot of it's being recorded, I've got to have it right. You can't have it not sounding right. It's a pressure, but you've got to do it.

Geoff: So do you get to watch and enjoy a show?

John: I never get to watch the show; I'm just focused on Paul.

Geoff: What have been the principal gigs from your point of view?

John: Madison Square Garden was one of my favorites because the way Paul sang *Here Today* was probably the best ever. It just came out of him, the vibe was there, and he sang it absolutely beautifully.

Geoff: That's been one of the highlights of the whole tour, *Here Today*.

John: Yeah, that's one of the most nerve-wracking moments of the gig for me. I do a guitar change there because he comes off the Magic Piano, he talks to the audience, and he doesn't check the guitar; he just goes straight into that first chord. That first chord is very important; it pitches him and everything. So it's got to be spot on. And he's got the audience holding up these signs saying "I Love John"; there's a lot going on in his head at that moment. And it's so quiet at that point, the audience is silent and you could hear anything if it's not right.

Geoff: I thought that a couple of times that song got to him and he choked.

John: Oh yeah, you can see that sometimes.

Geoff: Besides doing all that you have to do, you appear to be Paul's point man during the show.

John: Yeah, he'd talk to me about certain things that might bug him, like the bouncers in the audience. Paul will notice stuff, like the local bouncers being a bit over the top. And I'd pass it out to get sorted.

Geoff: And of course your job doesn't stop with the end of the show.

John: Yeah. When we're doing "the Runner," I'm the barman on the bus, mixing Margaritas and pouring champagne.

Geoff: So do you and Keith talk a lot during the gig?

John: Not a lot, because we're busy. Although Keith will be getting text messages every five minutes.

Keith Smith, Backline Crew Chief: Well, yeah, Chloe, my daughter, decided halfway through the tour that it'd be a good time to text me in the evening.

Geoff: What's your normal day like, Keith?

Keith: My day starts way before sound check; 7:30 in the morning I'll get up. We'll have a 9:30, 10:00 call to be at the venue. I go to the production office to check out what's going

"Backline" describes all the instruments and equipment on stage actually played by the band (this differs from everything else on tour because it is not rented but usually owned by individual members of the band). The "Backline Crew" are responsible for setting up and looking after this equipment before, after, and, most importantly, during the show.

on. At that time the stage is usually still being built out at the front of the house.

Our backline call is usually about 11:00, 11:30, when we can actually get our stuff up on the stage. We'll then build the backline, and then around 1:00, 2:00-ish, if we're lucky, the stage will be moved into its final position, if there are no hold-ups. If we're really unlucky, it's not until 3:00 or 4:00 in the afternoon, and that screws us completely because of sound check. Nothing actually works on the stage when it's being built out in the middle of the floor, because there's no power, so once we've got it underneath the trusses and the lighting, that's when everything gets powered up and John Roden, the Monitors Engineer, is usually running around doing all his checks. I'll go through every little bit that we set up, one by one, to make sure it works, instrument-wise and amp-wise. And then we do a check with John Roden and Pab [Paul Boothroyd] doing the monitors for the acoustic stuff. And that usually takes us up to sound check, when Paul arrives. I'm usually just sticking down the set lists on the floor when Paul walks in.

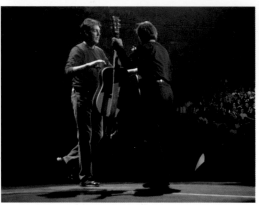

Geoff: John was saying that he restrings Paul's guitars each night, but Rusty doesn't appear to even change his guitar.

Keith: He plays the same guitar for about 80 percent of the set. He loves that guitar.

John: The 335.

Keith: I'll change his strings every day. If you change the strings, they'll last the whole show.

Geoff: So it doesn't need detuning?

Keith: No, because he only has one detuned song, where he plays slide on *Band on the Run.* But that's on another guitar. He started off the tour playing a little white Gibson SG, then he went to the great, fabulous, wonderful Californian-made fake Firebird. And then he turned to the 335. He's got two. The blond one is beautiful. Lovely guitar.

John: The blond one plays beautifully.

Geoff: When Paul started throwing the Hofner to John, did you think he'd catch it?

Keith: Yeah, well he has to. I've seen Paul do that with John before, in rehearsals, and on the odd occasion in the studio. Once, when we were recording, he turned around and lobbed it and didn't realize it was me and not John behind him.

I caught it, but the look on his face! You could see he didn't mean to do it to me. But he's got 100 percent confidence in John.

Geoff: What's all that running about that you do on stage, Keith?

Keith: I never run on a stage.

Geoff: Well, scampering, then. At one point in the show you're up on the side of the stage going on and off.

Keith: Oh, that's during *Sgt. Pepper.* You know Paul, Rusty, and Brian go center stage in the middle of the song, trading little four-bar solos. Rusty has this really bizarre setting on his pedal board, and because they take it in turns on the solos, Rusty just wants one of his solos on this reverse pre-setting. Really bizarre. Just on one of the solos, but he doesn't want to walk away from the center spot to go back to his pedal board, hit it, and walk back. So he said to me would I do it? I put it off for weeks. I kept saying, "Nah, you're all right, Rusty, you don't need to do that," because I knew it'd involve me having to go up and press this pedal board and then get off again. But I do it.

Geoff: What do you think of the standard of guitar playing on this tour? Paul seems to be playing a lot more electric guitar.

John: Paul's got a lot more confidence in his playing.

Keith: Also, the sound of his guitar seems to be getting better and better.

John: Yeah, we've got a good, nice sound going with the fuzz pedal that he's using.

Keith: And that really encourages him.

John: If you've got a great sound behind you and the guitar sounds great, then you play great.

Keith: And also we've modernized. We upgrade at every opportunity with Paul's gear. We try new stuff out all the time. We just try to keep ahead of the game, or if not ahead, at least up to speed. Because if you don't tour for five or six years, technology races past you.

John: One thing you've got to remember with Paul is that years and years and years ago in Liverpool he was playing guitar, and he went to do a solo and it all went horribly wrong. And he lost his confidence for years.

Geoff: That was in the New Clubmoor Hall, when he started out playing with the Quarry Men.

John: But so many years on now he's playing guitar better than he's ever played.

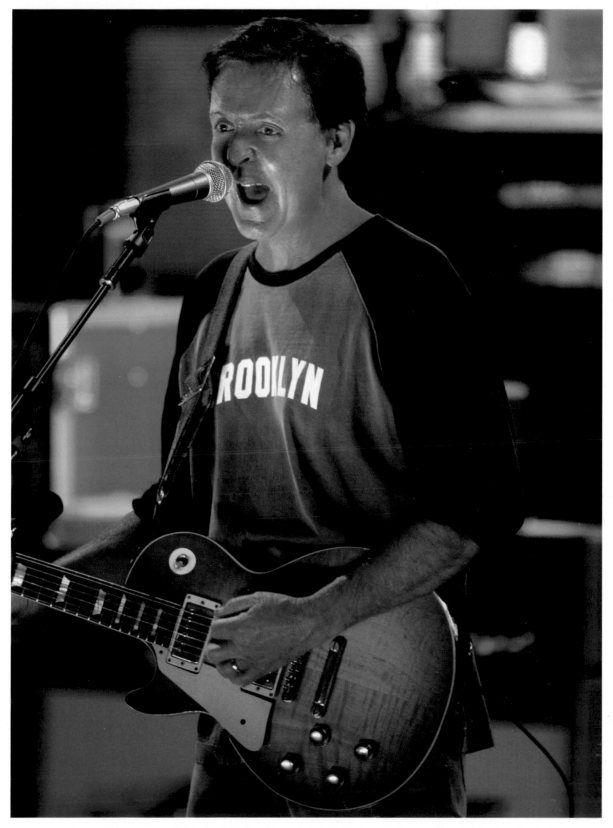

(Opposite) Paul switches to his Yesterday *guitar.*

Three to four hours before every show, Paul and the band will sound check the hall. Although ostensibly created to literally check the sound on the instruments and microphones, sound check invariably turns into an audience-less gig—with Paul singing a number of songs from the show for over an hour, mainly playing personal favorites such as Matchbox, Midnight Special, Bring It to Jerome, *and various impromptu jams, such as the Gerry Stickells' Song—"written" in honor of the Production Director, whose frequently hapless task is to get the sound check over so that the doors can open for the audience in time. Sound check usually begins with* Coming Up *and ends with* Lady Madonna, *the crew's cue to rush to Catering and the media's cue that one-on-one interviews with the star are about to begin.*

Always There with a Smile

The best restaurant, 70 pounds of potatoes, and black jeans in ever-increasing sizes

THEY USED TO SAY THAT AN ARMY MARCHES ON ITS STOMACH. A PAUL McCARTNEY TOUR IS NO DIFFERENT.
The tour's team of nine caterers is one of the busiest departments—always up early to cook breakfast for the crew and always finishing late after everyone else has eaten dinner. Although they work the longest hours, there is never a frown seen in Catering. Every show day, the chefs prepare a total of more than 250 organic vegetarian meals—a choice of six hot courses for lunch and eight for dinner, plus a dozen salads, soups, and vegetable dishes. That's not to mention the all-important selection of at least six desserts for those who have not quite doubled their body weight through the daily temptations on offer. Although Italian, Mexican, Japanese, and other specialities are regularly created, there is always a groundswell of English traditionalism to cook for—egg and chips with HP sauce "sells out" almost within minutes of appearing on the menu. During the tour, the chefs will create more than 20,000 meals for the band and crew. In addition, Catering provide a total of more than 8,000 speciality sandwiches and "take-away" meals to sustain the Pre-Show performers and crew during overnight bus rides from gig to gig. But of the nearly 30,000 meals that will be cooked in total, Paul gets to enjoy very few. He does not like to feel full before a show, so despite hiring the best all-around vegetarian catering in the world, the demands of his gig mean that Paul is confined to a diet of still water and (the aptly named) macadamia nuts.

Geoff Baker, Press Officer: So what's on the menu today?
Mat Jackson, Catering Crew Chief: Good question. So far we've made baked cheese ravioli in a tomato sauce; we've got a polenta stack with roast vegetables; we have udon noodles that will be served with Asian vegetables; penne with chili, sun-dried tomatoes, and pesto; asparagus; and garlic mashed potatoes … and there's a lot more to come.
Geoff: So this is not typical tour catering because there is no meat or any kind of fish?
Mat: Nothing with a face. Basically we are trying to cook great vegetarian food for meat-eaters. I think we've probably got only 10 actual vegetarians on the tour, but I'm glad to say

While Paul will content himself with just a cuppa (opposite), Mathew Jackson, Sarah Swain, and Pam White (left, top to bottom) prepare the hundreds of daily servings at "the best restaurant in town." Meanwhile, Paul and Heather (below) contemplate a dip inside the best cookie jar in town.

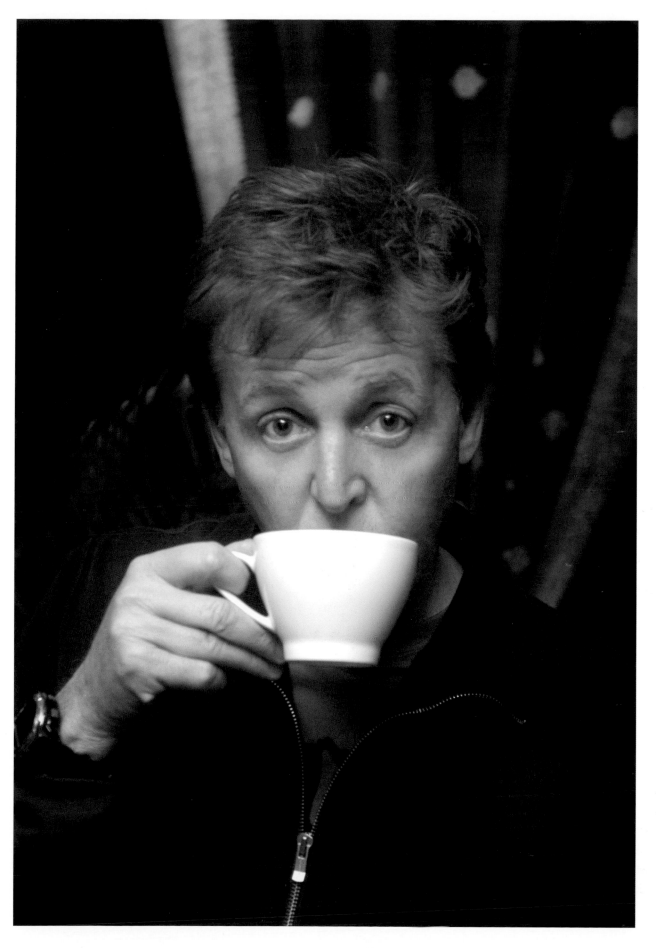

everyone seems happy with what we're serving.

Geoff: Did you have to study up on vegetarian cooking before the tour began?

Mat: A little bit, but not much. I'm a meat-eater, too, but I love cooking vegetarian food. It's not difficult, but you have to be more creative, look for more variation, try new things.

Geoff: How do you make a quality level?

Mat: Set your own standards. Also, you're only as good as your chefs, and we've got a fantastic team here. People have said that what they produce is a variety that rivals restaurants—and that's done just from us all putting our heads together and banging ideas off each other. We're carrying around 20 cookbooks with us, and we have yet to open one of them.

Geoff: How do you shop for the food, and what sort of volume are you buying?

Mat: We only buy organic, so every morning we go to the whole-food market, getting in there at 7:00 in the morning. I've got two hours to get around the supermarket, spend a certain amount of money, and get back for the team to prepare it. In terms of quantity, we're usually buying 70 pounds of potatoes, carrots, garlic, onions, and celery each day—just to provide the general base of things. We'll generally go through about 30 pounds of pasta a day.

Geoff: How many people do you feed on average?

Mat: About 125: 40 for breakfast, 60 for lunch, and 125 for dinner.

Geoff: When you go to these supermarkets, are you pushing a cart like every other shopper?

Mat: Yeah, only I've got seven or eight carts at a time.

Geoff: And are they surprised when you say you want 70 pounds of carrots?

Mat: No, they are more surprised at who we are shopping for. You know, it's a shame, but when you say Paul's name, everyone is there for you. Suddenly you can get exactly what you want.

Geoff: Do you get special requests from anybody?

Mat: Little things like Pab's baked beans—Pablo [Paul Boothroyd] cannot live without his baked beans, his eggs, beans, and chips. Most of the dietary requirements are not hard to deal with. Some people can't have dairy, and we make a lot of the sweets without sugar—people come on tour to lose weight, but at the end of it, you get blamed if they're five pounds over.

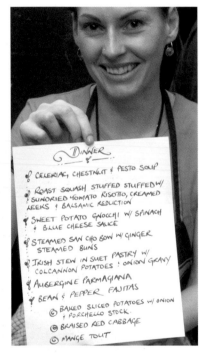

A BRIEF DIGRESSION CONCERNING PIZZA. *Somewhere in America, aboard the Band Party bus, an intellectual debate is raging.*

Bill Bernstein, Tour Photographer: Anyone want pizza?

Paul Freundlich, Tour Publicist: Are you fucking mad?

Bill: Mad? Me? Why? I'm not mad …

Geoff Baker, Press Officer: You're insane!

Bill: Why am I mad?

Paul F.: 'Cos you're offering us fucking pizza!

Bill: It's good pizza, man; you wanna try some?

Geoff: Uh-oh … here we go.

Paul F.: I can't eat pizza! I can't eat a fucking thing. If I eat a fucking nut, I'll explode!

Bill: You allergic to nuts? No nuts in this pizza. C'mon, man, try some. It's really good.

Paul F.: You don't get it, do you? This tour is making me swell up like a blowfish! Catering is so fucking good, I'm putting on pounds! I'm not even a vegetarian, and I'm running out of clothes, man. Nothing fits me 'cos all we do is eat this great food. I'm going to fucking roll off this tour.

Robby Montgomery, Creative Consultant: Paul's right, man. Fucking Catering; it's just too good. They should hire new cooks, get 'em in from a hotel … 46 dollars for a fucking pot of coffee and some eggs. What the fuck is that about? I don't even know who the fuck it is looking at me in my mirror anymore. All I'm doing is eating 72 meals a day in Catering and buying more and more black jeans in ever-increasing sizes. I just go in Catering for a fucking coffee and that fucking smell just hits you, man, and you've gotta eat. Don't wanna eat, but the smell just gets you.

Mark Haefeli, Film Director/Producer: Great fucking smell. You get the pumpkin ravioli tonight?

Robby: Nah, I had some wild mushroom pasta.

Bill: Oh yeah! With the sauce, the sage sauce? Fucking A, man.

Robby: Yeah, it was fucking A … A for *Another* larger size of jeans I'll be needing.

Mark: The ravioli was excellent, wasn't it?

Bill: I didn't get the ravioli.

Paul F.: Obviously … which explains your current fetish for pizza.

TOURING HOLDS NO TERRORS FOR THE LONG-DISTANCE VEGETARIAN. *McCartney's dietary regime may be one of the secrets of his onstage dynamism. But he also suspects that touring itself can whip you into shape.*

Paul McCartney: Our Catering is superb; we often say it's the best restaurant in town. But I never really get to try it. I don't like to really eat much before a show, so I just munch on nuts and annoy the radio guys who are interviewing me by talking with my mouth full.

DJ, Culver City, Los Angeles: Could the secret of your stamina be in your veggie diet?

Paul: You know, it could be something to do with it. I've been veggie now for over 25 years and, you know, I feel great. I don't know if it's to do with that; I would suspect it probably is. It's what most doctors will tell you is a pretty healthy diet. I eat a lot of good food, I stick to vegetables, and I love fruit. It's not out of any sort of health kick. It just feels good to me. I eat what feels right. I just don't eat meat, fish, or anything that has a face—so it could have something to do with that. I think another thing with stamina—again, touch wood, 'cos this stamina could just *(snaps his fingers and whistles)* any minute— but I think it's because the Beatles worked so hard in Hamburg, then we came back to England, then we toured America, and then we toured the world. We were working then 360 days a year, certainly 350. We never had much more time off than that. It was because we loved it, we were hungry to be famous. We wanted to accept any gig they threw at us. Our manager kept us working, and I think that this was a pretty good aerobic workout. Like every night you're *(starts breathing heavily, as if working out),* and if you play somewhere like Denver, and you've got to sing something like *Long Tall Sally,* the Little Richard number—you know *Long Tall Sally (singing and acting out of breath)*—without knowing it, you're getting fit. It's a workout, you're sweating, you're getting the heart rate up, the blood's certainly pulsing around. You're thinking on your feet for a good part of the year.

Rosy and cozy aboard the chartered tour jet: nonstop traveling and top-notch catering are the keys to Paul's on-tour health routine.

Très Bien Ensemble

The three-minute walk, tight tummies, medals, and mayors

WHEREVER PAUL'S TOUR GOES, IT IS SURROUNDED BY A WHIRLWIND OF ORGANIZED CHAOS. *The Pre-Show is perhaps the most eloquent expression of this heightened reality. While the backstage environment may be a scrum of film crew, media interviews, and celebrity meet-and-greets, the Pre-Show performers invest each evening with an overture of graceful strangeness.*

Paul: What happened was we weren't going to have a support act, and I just got this idea that when you begin the night, when you come out of the traffic, and you come off the streets into this place, instead of just coming into a big, cold shed and then waiting for the show, it might be nice to sort of settle you down so that you felt like you were in a sort of a club. I thought we'd get some special lighting, play a little bit of music, and make it all a bit theatrical. So I did a mix of some music with a friend of mine, and then we put the idea together of having some characters in there, and it'd be like they'd just landed out of time and they didn't quite know why they were there. It was just to sort of entice the audience into the show, get them off the street, and get their imaginations going a bit, and then, suddenly, we appear.

Jenni Bolton, Costume Designer: When I saw that the green-faced Indian Kathakali dancer, Marie Antoinette, and Magritte were part of Paul's inspiration for the Pre-Show characters, I realized that all the other characters had to be strong and colorful to work with them. Creating characters and costumes from across the nations and throughout history to stand up to those colorful and strong silhouettes was a joyful experience. I had costumes made in England, America, and India. The Indian

(Above and opposite) Tonight's the night and we got a show. Backstage the cast get into character, trouping the smiles, and Paul gets a visit from Twiggy (middle left, above).

Paul did not want a support band because of the time it would take to derig their kit before setting up Paul's own. He equally didn't want an audience walking in cold from the turnstiles. He aimed to set a mood of theater for the audience, easing them out of reality and raising a feeling that something special was about to begin. Inspired partly by sights that he and Heather enjoyed on

vacation in India, Paul conceived the Pre-Show as a little dream sequence. "It's something different," he explains, "just because I'm interested in being different." Exotic characters meander through the crowd to the accompaniment of 17 minutes of ambient trance music, composed for the purpose by Paul and Youth, his friend and collaborator on the spacey musical side project The Fireman.

(Above left) Heather with her sister Fiona, a valiant Pre-Show volunteer. (Above right) Abe and Brian discuss aesthetics.

Kathakali costumes were hand delivered by one of India's premier Kathakali dancers, who showed me the four-hour ritual of being made up and dressed in the Kerala tradition. That then had to be reduced in a way that didn't detract from the look to 40 minutes, to work on the road. A little bit of theater meets rock-and-roll.

DJ, Atlanta: Is the Pre-Show supposed to have another meaning? Like about "performing man" through the ages?

Paul: It's … well, the thing is with deeper meanings, who knows, you know? People can draw connections, which I quite like anyway. What I like is that we're having fun and a lot of nice little things happen. With the Pre-Show, we have a thing with balloons before the show and people walk out into the audience like Pierrot clowns with these huge balloons. Normally we get volunteers to do it in each place. So Heather's sister, Fiona, was doing the balloons, with our accountant and our travel and ticket ladies. But they're all getting nervous about it. They're all, like, amateurs, but wanting to be very professional. They were more nervous than we were. They were terrified out of their wits!

NOT ONLY ARE THE BAND MEMBERS MUSICALLY TALENTED, THEY ALSO SHOW ADVANCED AESTHETIC TASTE. WELL, IN A SENSE … *It was Brian Ray who perhaps best summarized the initial impact of the Pre-Show on the Tour Party when a magazine writer in New Orleans asked him, "Is there anyone out there whose ass you admire?" Deadpan, Brian replied, "Have you seen the Pre-Show yet?"*

Band Member 1: Did you hear that part of being in this troupe is not to get involved in any relationships involving the band members?

Band Member 2: Oh …

Band Member 3: You think so?

Band Member 1: Yeah …

Band Member 4: I'm kinda hoping they don't—except for Carol, though.

Band Member 1: They were told to be seen, not heard.

Band Member 4: There's the two that hang out together all the time that are just awesome. That one, *err* … she's South American.

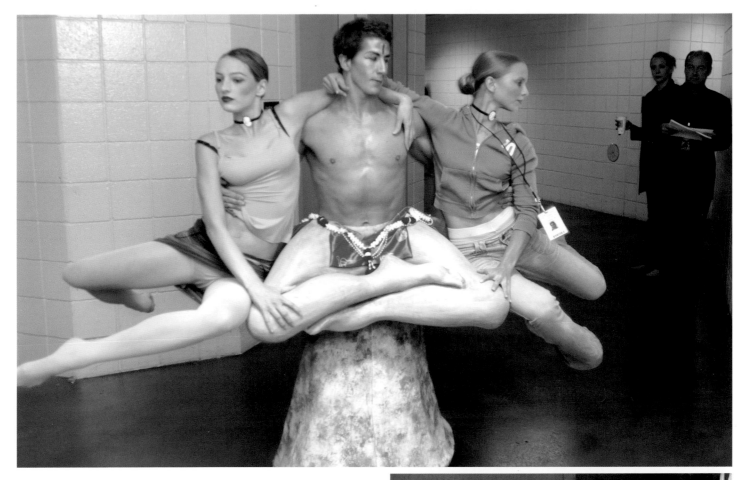

Band Member 4: And then her friend with the blonde hair … they both have the tiniest little butts and the tightest tummies. It's just like …

Band Member 2: I don't know what you're talking about …

Band Member 4: It's just like … unbelievable!

Band Member 2: I have no idea what you are talking about …

Band Member 3: Watch it—man with a video. *(Mark Haefeli, Film Director/Producer, appears from nowhere.)*

Band Member 4: Oh no! This isn't going to get used, is it? Oh no … I'm selling myself down the river right now.

Band Member 3: We're only admiring the talents of our fellow performers. It's not necessarily incriminating …

Band Member 4: Yeah! Like he has a very nice ass, too …

Band Member 2: Nice try, nice try.

WHAT'S IT LIKE TO PLAY WITH PAUL McCARTNEY? *This is a question the band members are asked repeatedly. In searching for an answer, the musicians reflect on their leader's unparalleled career.*

Rusty: What can I tell you about Paul? Oh man, I mean I don't know where to start with him, you know … I think first of all you have to realize that his life is not normal. He's been a super-mega-star since he was what, 20 or something. And so most of his life has been spent in his own category that sort of defies the normal limits of fame; it's like beyond there. And yet he is such a normal, regular guy. When he's in a room with people, you know, he makes everybody feel very welcome, and I think that he is very obviously aware of his own situation, so he is in a constant state of diffusion, diffusing everyone's need for an autograph or need to touch him or need to ask him some dumb question. I think the problem is that, when you're famous, everybody sees you but you don't see them, so they all assume they have relationships with you. So I really think that he has to include all that all the time in his everyday way of life, but having said that, he really does go the extra mile for people.

The other thing I noticed pretty quickly was that he's like an open book, you know. You feel like he's learning, like he still keeps absorbing, absorbing knowledge all the time. And as a musician, well, it's like God said, "OK, I'm gonna give 50 talents and put them into this one person. There you go. *Boom!*" So you have all these talents thrown into one guy and it's really mind-blowing, you know? It's mind-blowing. But yet, at the same time, the way he applies his musicality to each instrument is like … it feels natural, you know. I think that's the reason, one of the reasons, he's been so successful—because it's such a flowy event. He's really good at just keeping it fresh, keeping the rhythm comfortable for everybody.

Wix: I am always amazed how much he is into playing and singing music. You know, he has done everything you could possibly want to do in the music business, and films and the rest of it. And he is still fired up by it; he really loves playing and singing and that is where he started. And when he plays and sings, especially when he plays bass, he is like two people. He's this great bass player and this great singer. I've seen it a lot, and I am still amazed how into it he is.

Brian: Wow! He had us over to his house in the Hamptons a couple of weeks back for a couple of nights, and we were having a barbecue. He was chopping up all these vegetables and preparing veggie-burgers, and I told him that I'd always prayed that one day I'd be able to be on a tour where I could really rock out and have a great time and be surrounded by very cool people. I said that on this tour that prayer came true for me. And that's the truth. I really did have that wish, you know. He's a dream guy.

Abe: He lives his life to the full, with a lot of joy but with great observation. He has an amazing memory for minutiae, for very small details. He makes small details as important as they should be. I think all of that translates into these songs. Like the ability to take a very typical everyday phrase like, "She loves you," and turn it into a song of decades. I think it's a reflection

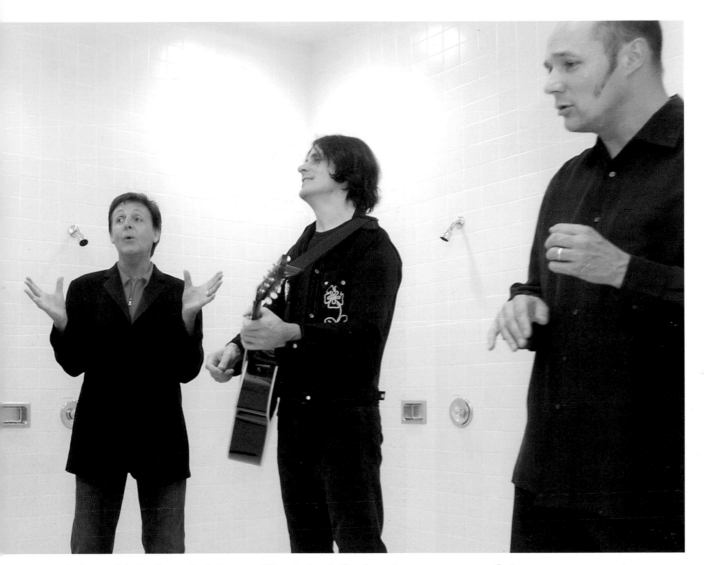

(Left to right) Abe, Brian, Paul, Rusty and Wix: the band often favor shower-room acoustics for last-minute warm-ups.

of life and the way he lives it. And musically—*ah, man*—it is great to see someone who has done so much and has written so many songs and has done so many gigs and broken so much ground, still be excited to do what he does. You know it's very easy for people to get complacent and to feel jaded, but he doesn't have any of those affectations. He's still just as happy and still feels as excited as if he's 16 years old and playing his first gig.

Reporter, New York: You have a kicking little band and some of them are pretty young. It must be a blast for them to be up on a stage with a guy who wrote some pretty decent songs?
Paul: Yeah, it must be. I wish I was them. *Nah,* you know, they'd love you to believe they're young but, actually, some of them aren't as young as they look. But that would be giving the game away. No, you know what? It's not to do with age, it's … yeah, it's exciting for them playing some of these Beatles tunes because there's a nice structure there, there are nice licks to play, there are nice chords. It is exciting, yeah … they will say that in conversation. Rusty says this thing, "Wow, I had this dream once when the Beatles all came to my door and said, 'Hey, do you want to play, man?' and I said, 'Yeah, sure,' and we were just gonna go out and play, and I woke up and I was really sad because it was just a dream." And then he said, "And when we were making *Driving Rain*, Paul came in one day and said, 'Hey I had this dream last night, Rusty, and you were in it,' and that was like *Wowww!!!*" So from that point of view it is, like, far out—but it's that way for all of us, in a way. I mean, I'm enjoying playing with them just as musicians. You don't have to have a track record, or as big a track record as mine, to enjoy it.

AS THE TOUR'S SUCCESS FURTHER BUOYS SPIRITS, PAUL ALLOWS A FILM CREW TO RECORD NOT ONLY THE SHOW, BUT ALSO, AND FOR THE FIRST TIME IN HIS SOLO CAREER, ALL OF THE ACTION AND ANTICS BACKSTAGE AND OFF STAGE. *Director Mark Haefeli is told that no area is off-limits, even inside the dressing rooms. Haefeli gleefully begins shooting in every corner of the tour for a project that will become the* Back in the U.S. *"rock and road movie," but only after he is firmly told that he cannot shoot the show in any orthodox way.*

DJ, St. Louis: You've got a DVD and a TV special of the tour coming out. I understand that features more than one show?

Paul: Yeah, it's a lot of shows. It's really good, actually. What happened was that the tour was nice and we were enjoying it, and then it started to become more than nice; it started to become special. The audiences were really getting intensive, there was a lot of warmth; I thought the band was really kicking and I was enjoying myself. It was like, "Wow! Here we are, it's America, it's great, there's goodwill, and it's a good show, great screens and that … we've gotta capture this." So we started to just have one or two cameras around, recording bits and pieces, and then the guys started saying, "Hey, we should really do this properly, like this is good enough to really do well for a movie or something, a big production." I said, "Yeah, but the only thing I really don't want to do, seeing as we're all having such a good time, is have that kind of horrible night when they say you're being filmed tonight and you go *'arrrghhh, no!'"* That's when you see all these cameras swooping over the audience, the audience is being filmed, and it changes the whole thing.

DJ: I would think you'd be immune to that at this point in your career.

Paul: Ah … I can do it. But I don't like it. It changes the event … and it's never quite as good a gig as the night before it. You freeze up, everyone freezes up, the audience freezes up a bit, so you don't quite get the show you wanted to film. So, they said, "Well, we've got to do it like that." I said, "No, you won't." I've spent all my life kicking over the traces. So I said, "Find a way, guys." When you say that to my kind of guys, they're really

good—they go, *"Oh, Shit! Shit! … Repair to the bar … Shit! How're we gonna do it?"* So I just said, "Look, I don't mind if one night I've got a different T-shirt on and the next number I look a bit different. I don't mind that; we're just trying to capture the show." That's how we did it. We just kind of filmed a lot of the shows and a lot of the numbers, and so it's like as if we've got a 52-camera shoot. We've got angles from everywhere. Whereas if you've had 14 cameras, you've still only got 14 angles.

DJ: Is there wedding footage in your tour film?

Paul: No. There's a number of songs in it from the show; we filmed a lot of shows. And the crew's very good; there's film of like a lot of very interesting people. So the film's got a lot of background stuff—like this interview, which you'll notice the guys are filming. So you see what we do when we're not doing

Paul takes time out to film some interview footage for the DVD.

the show: traveling, on the plane, in the dressing rooms, chatting, joking, me and Heather goofing around. Whatever goes on. But I decided against the wedding footage. Somebody asked for that, but I said no because there are some things that are kind of private. The tour is the tour, it's not private. This isn't private. If someone walks in now, I don't mind because I'm quite open about all this. I was thinking about that, actually, when I had a little sail on Lake Michigan today, and I was thinking about filming that, a private moment. But then I thought, well, it wouldn't be private, would it, if you shared your private life with everyone? Why isn't there private stuff in the film? Because it wouldn't be private, simple as that. It's sort of like me saying, "Well, let's see what you and your wife get up to." I don't know if you're married or not …

DJ: Yeah.

Paul: Well, let's see what you and your wife get up to tonight in bed. You'd go "fuck off!" Because it's private, man. And I say "Oh, OK—but why?" Because it wouldn't be private if we showed you and told you. Anyway, that's it. I have a private side, like anyone, and I keep a good balance to my private side.

On release, the Back in the U.S. *DVD becomes the fastest-selling music DVD ever and achieves more than 500,000 sales. A TV version of the film is screened around the world, taking the tour into the living rooms of many millions.*

*Following its success, another concert film by director Mark Haefeli—*Paul McCartney in Red Square—*is globally broadcast. In Russia, the Red Square film is watched by almost a quarter of the nation's vast TV audience.*

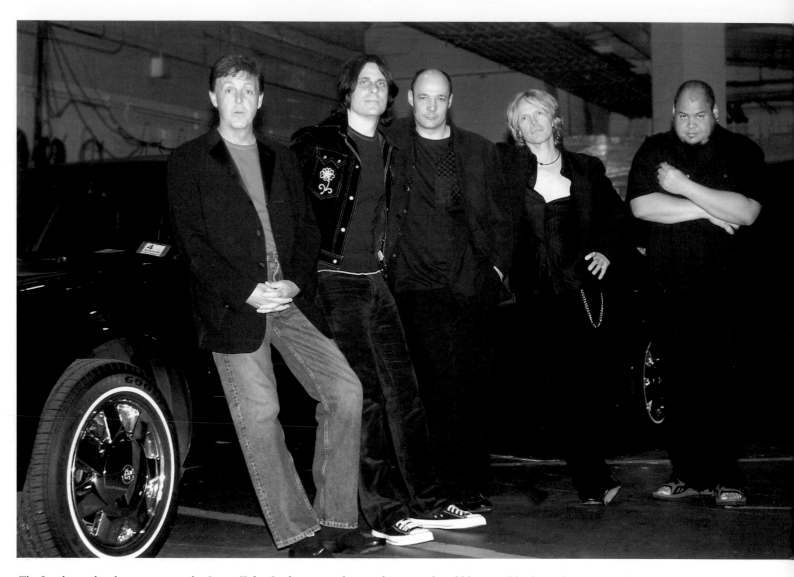

The Beatles used to line up to meet the Queen. Today Paul generates his own lineup, and could be visited backstage by a mayor who makes his own music, film stars, friends, presidents and ex-presidents, and even animals.

THE MEDIA CIRCUS THAT ACCOMPANIES THE TOUR CAN SOMETIMES SEEM AS SURREAL AS THE PRE-SHOW. *Paul and his band must learn to assess the unlikeliest lines of questioning.*

Reporter: What's the best thing about being on tour?

Brian: That someone said we were playing better than the Beatles.

Reporter: What's the most interesting thing you've had from a fan in the mail?

Rusty: I got a bra on stage. It came through the air, by air mail.

Reporter: Who is the hands-down ladies' man on the tour?

Band (in unison): Mark Hamilton [the Security Director].

Reporter: When is the best time to go naked?

Brian: In the shower.

Rusty: I like to be naked under my clothes.

Reporter: What do you know about Paul that the world doesn't know?

Abe: That he's the silliest gentleman you'll ever meet.

Reporter: Is there a prankster on this tour?

Wix: No, it's a very prankless tour. It's a prankless task, but someone's got to do it.

DJ: Paul, please don't get fed up, I have to ask you this because not many people get to do what I'm doing, but why do you talk to people like me? You really don't have to. You've done things and you continue to do things. Why talk to me?

Paul: I really don't know and after this interview I am beginning to question why I talk to people like you. I mean, you're just an ordinary guy. Why am I talking to you? I'm, like, this really incredible person and you're just, like, nothing. You know what I mean? I don't want to put you down, but ... (Much giggling.) But seriously, you know why? 'Cos when you come to a town, not everyone gets to see your show, and I kind of like reaching out to the people who listen to the radio, and

I like talking to DJs and seeing, you know, where it's all at and where it's up to. And I like people, I suppose. Although I really am beginning to question why ... why somebody chose you. I think I see a sacking on the horizon ... heads are gonna roll over this one. (Chuckles.)

DJ: On behalf of everyone who doesn't get to talk to you, thank you for everything. Err ... there aren't many heroes in the world of show business. I think of a hero these days as a Rudy Giuliani or a Jimmy Carter, but I know you do a hell of a lot for people besides just this, and so ... I say ... thank you.

Paul: Hey, thank you. Seriously, a big hi to all your listeners. And thanks for your compliments and stuff—it's been fun.

IN THE PAUSE THAT SEPARATES SOUND CHECK FROM SHOW TIME, THERE ARE BUSINESS MEETINGS TO BE HELD AND DIGNITARIES TO MEET. *In a tradition stretching back to the earliest days of the Beatles fame, Paul is regularly sought out by the great and the good of each locale he visits. In town for his historic Colosseum shows, Paul makes time to meet the mayor of Rome (below) and his family.*

Paul: Thank you for your help.

Mayor: It's my job. It's my pleasure.

Paul: Good. Good move.

Mayor: This is my daughter.

Paul: Hello. What's your name?

Natalia: Natalia.

Paul: Very pretty name.

Mayor: And my wife.

Paul: Hi, and what's your name?

Clavia: Clavia.

Paul: Claudia.

Clavia: Clavia.

Paul: OK. How are you?

Mayor: Yes, thank you very much. I'm

very happy that you're here. How was it playing inside the Colosseum?

Paul: Very special.

Mayor (through a translator): He thought, we all thought, that the best venue for music, your music, Beatles music, would be the Colosseum.

Paul: Oh that's weird … Did you know that Federico Fellini was asked to do a video idea and he thought we should do something in the Colosseum?

Mayor: Yes, yes, yes.

Translator: The mayor used to be the minister for cultural affairs here in Italy, and when he was minister for cultural affairs he wanted to call you so that you could play Pompeii.

Paul: Oh, like Pink Floyd did?

Mayor: Yes, Yes.

Paul: They beat us to it. Would you like a photograph, Mr. Mayor?

Mayor (Translator): Yes, of course. Yes, yes. Thank you very much.

Paul: Vote for me. Not him. Vote for me. *(Laughs as the photograph is taken.)* Is it difficult being mayor of Rome? Is it a hard job?

Mayor (Translator): It's very nice. It's the nicest thing he ever did.

Paul: When you see the city itself, it speaks for itself.

Mayor (Translator): Archaeology and the mother of the Adriatic Sea. It's a very open city with no racism. It's very open. It's a city that's difficult to manage and govern, but it's the nicest thing that ever happened.

Paul: Beautiful. Do you get to meet the Pope?

Mayor (Translator): The Mayor awarded the honorary citizenship award to the Holy Father. And he prays to the Holy Father to make sure there will be no rain today.

Paul: And there isn't. Of course. He's got the power alright.

(Mayor hands Paul a framed picture.)

Mayor (Translator): Well, we brought to you City Hall and the Capitoline Hill, since you couldn't go to see it personally.

Paul: Beautiful. And this is an old print. Excellent. Look at that. Thank you very much.

Mayor (Translator): And then the most traditional gift. It is the medal … And this medal has become … And this gift has been given four hundred years ago, so that's the medal celebrating this anniversary.

Paul: Wow.

Mayor (Translator): But the most important gift of all … is a record, a CD.

Paul: It's not your band, is it?

Mayor (Translator): It's his own. It's his CD. Yes, it is.

Paul: You trying to get a record deal?

Mayor (Translator): Yes.

Mike Wally, Travel Director, enters: Too much time?

Paul: Oh, no no. We're fine, thank you. Yeah. Yeah.

Mayor (Translator): This CD was made for charity to build wells for water usage. And five water wells were dug thanks to the proceedings of this. So giving this CD to Paul McCartney as a gift, it's perfect for this.

Paul: Have we got one of my CDs around, guys?

Geoff Baker, Press Officer: Yeah we do.

Paul: In a minute I'll give you one of mine.

Mayor (Translator): He was already given one.

Paul: Oh, you've been given one already? OK, great. This is good. Well thank you very much.

Mayor (Translator): Thank you. All the best.

Paul: Thank you. Excellent, Mr. Mayor.

(Far right, third from top) Sir George Martin pays Paul a supportive visit.

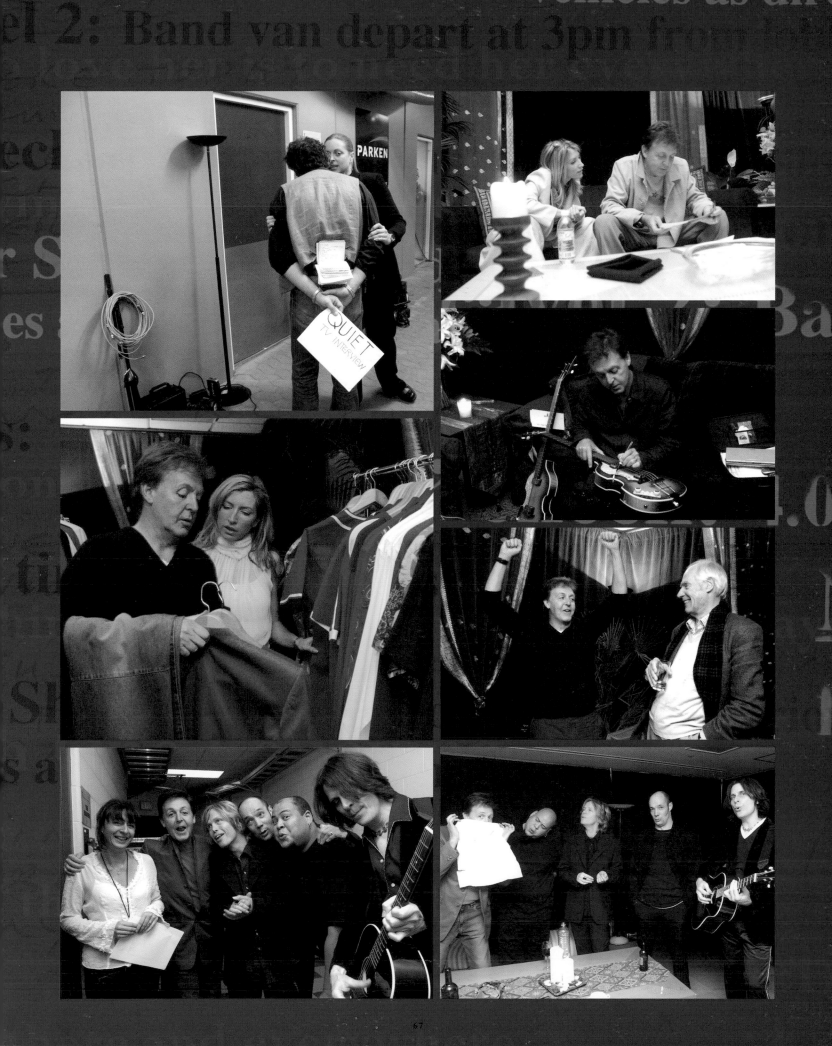

Funny Paper

It's communication: "priviet Maskvichi," "aolghg" …

DESPITE SINGING 36 SONGS PER NIGHT AT THE SAME SPEED AND IN THE SAME KEY AS HE WROTE THEM, PAUL'S ENTHUSIASM FOR ENTERTAINING HIS AUDIENCE PROMPTS HIM TO FURTHER EXTEND HIS VOICE BY SPEAKING TO THE CROWD AT LENGTH IN THEIR OWN LANGUAGE. *Wherever English is not spoken, Paul spends at least an hour with a translator, learning a variety of phrases that the showman in him uses to chat to the crowd. During the tour he learns Mexican Spanish, French, German, Catalan, Dutch, Flemish, Hungarian, Norwegian, Swedish, Russian, Italian, and Japanese for numerous phrases, such as, "And now I'd like to introduce my fantastic guitarist Rusty Anderson," and "I'd like to dedicate this next song to my beautiful wife, Heather," and "Do you want to rock some more?" Just 30 minutes before the Dublin show he decides that he rapidly needs to learn some Gaelic. Although this "homework" is not easy, Paul's method is simple—a translator repeatedly pronounces the requested phrase, Paul gets his ear around it and writes the translation phonetically on cue-sheets that Keith Smith then tapes at the feet of his microphone. The results impress even the critics; after the Budapest show one tabloid writes, "A long-held dream came true last night as Paul McCartney sang for the first time in Hungary … He spoke Hungarian almost continuously all night … " Paul always wants his translators to give him a phrase in street-speak, and he eagerly takes tips from any source—including, in Moscow, a translation lesson from President Putin.*

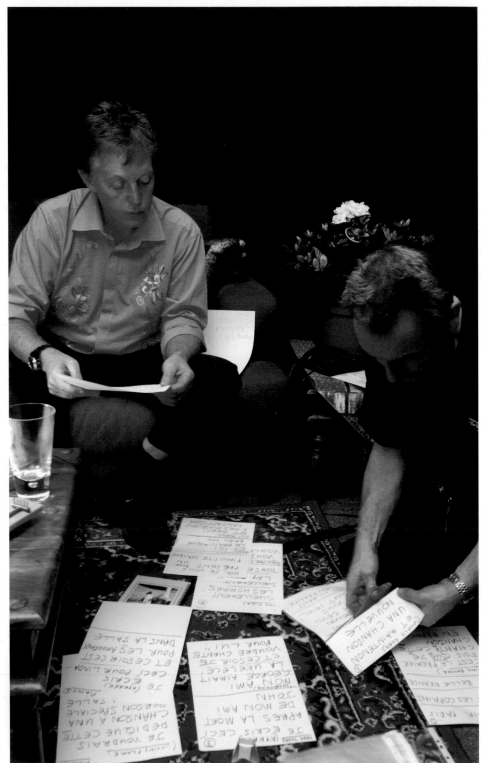

Paul: OK, let's press on with this, we haven't got much time.

Russian Translator: I can't believe we'll do this—a whole Russian lesson in less than …

Paul: I like languages. In school I learned Latin and German. When we come here I have very good translators who I work with. They tell me the things to say and I write them down and just learn them. I was on a bike and I met a bunch of Japanese school boys with uniforms on, and I said, "aolghg," and they loved it. It's communication. It's all right, we'll do it … Keith, have you got the translations from the last show? Where was that?

Keith Smith, Backline Crew Chief: Hamburg. It's all in German.

Paul: OK, lay 'em out. Right, what do we want to say? *Umm,* what's simple? Something like "Good evening, Moscow" or "People of Moscow." Something like that. But not formally. How would the ordinary guy say it?

Russian Translator: OK … you could say "dobriviccha Maskvichi" or "priviet Maskvichi."

Paul: Priv … ee … et … Hang on, I've just remembered something. I was with Putin this afternoon; you know, he invited me and Heather to the Kremlin. I was telling him I like to speak to the crowd, and I said I was going to say that "privyet Maskvichi …"

Russian Translator: Priv-ee-et …

Paul: Yeah, but he said, "Don't say that, say, 'priv-ee-et ribiata.'"

Russian Translator: Oh … that's good.

Paul: Yeah. I said, "What's that mean?" and he said, "It means 'hi guys.'" He said it's much cooler.

Russian Translator: It is. It's more laid back.

Paul: It's wild, man … talk about things have changed, you know. For years the Kremlin wouldn't let you sing in Russia, and now they're coming to your gig and they're giving you language lessons on the side. I love it … "priv-ee-et rib-ee-ata."

Russian Translator: Perfect!

Paul: Spaziba.

Japanese Interviewer: Are you going to use Japanese words on your stage tonight?

Paul: Yeah, we have a very good translator. His wife is Japanese so he understands the language very well. He teaches me things to say, and when we went to Kyoto, he taught me slang. The other thing we have is a translation device, so when I talk in English, it is translanted on the screen. This is the first time in Japan that this has ever been tried in a music concert. They've used it in opera, but those words are set and don't change every night. Mozart's words stay the same … *unfortunately* … That's a joke, just a little one! I can say anything I want. I can say "My dog eats bananas," and they put it up on the screen.

Japanese Interviewer: Really!

Paul: We have a team. Two translators and six typists—big team. The audience likes it because it's a very good way to communicate. I think a lot of people in Japan understand English anyway, but the little bits they don't, they can just look up on the screen and check. It's a very new thing, and we're excited about it.

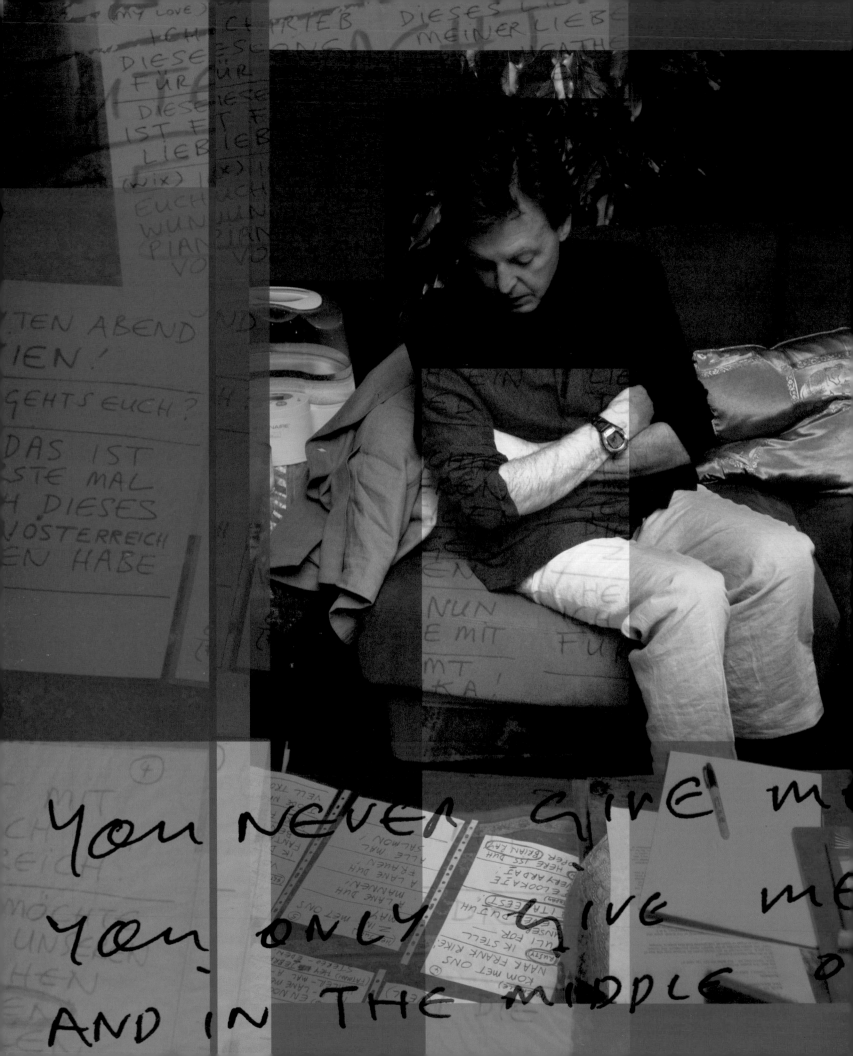

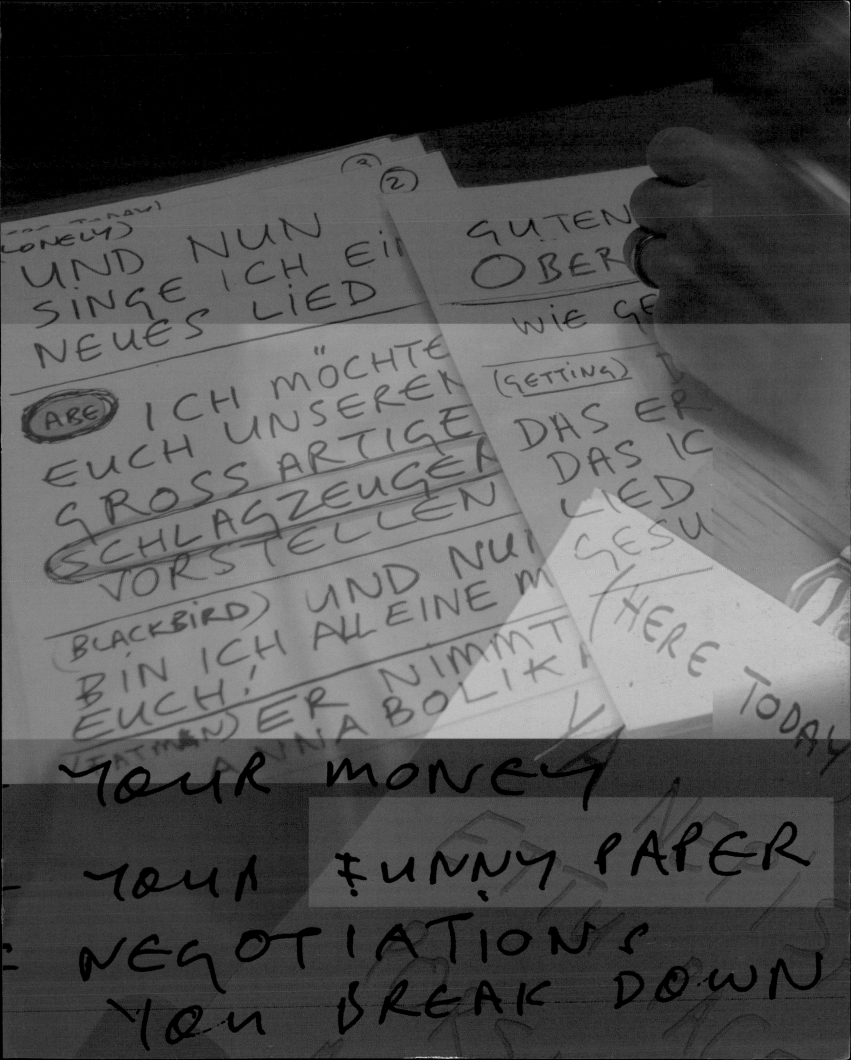

Remember Their Funny Faces

Gently and wonderfully trippy

CASTING THE PRE-SHOW, ITS DIRECTOR, JEFFREY HORNADAY, AND ASSOCIATE DIRECTOR, AMY TINKHAM, CHOSE PREDOMINANTLY YOUNG AMERICANS WITH NO EXPERIENCE OF ROCK-AND-ROLL TOURING. *The effect of the Pre-Show is gently and wonderfully trippy; late-goers to their seats find themselves confronting a grand dame Marie Antoinette, her hairstack and voluminous gown illuminated with flashing Christmas-tree lights, or a haughty flamenco dancer tossing her dress thigh-high as she struts through the gape-mouthed throng. A Mandarin man looms unsmiling at your shoulder, followed next by a harlequin and a Georgian English gent. Next comes the sudden appearance of a trio of seemingly startled Grecian statues, each body-painted in gold, and, behind them, a young bewildered ballerina in full tutu, appearing to have lost her way in surroundings she does not recognize. The experience is enhanced by the sight of Kathakali dancers waddling onto the stage accompanied by a Venetian masked man on stilts, who twirls around him a jeweled-tunic contortionist whom he's plucked from a small Perspex box.*

For the 17 mysterious minutes of the Pre-Show,
it can seem as if time itself is in suspension.
Behind the impeccably serene façade, however,
backstage preparations are reaching fever pitch.

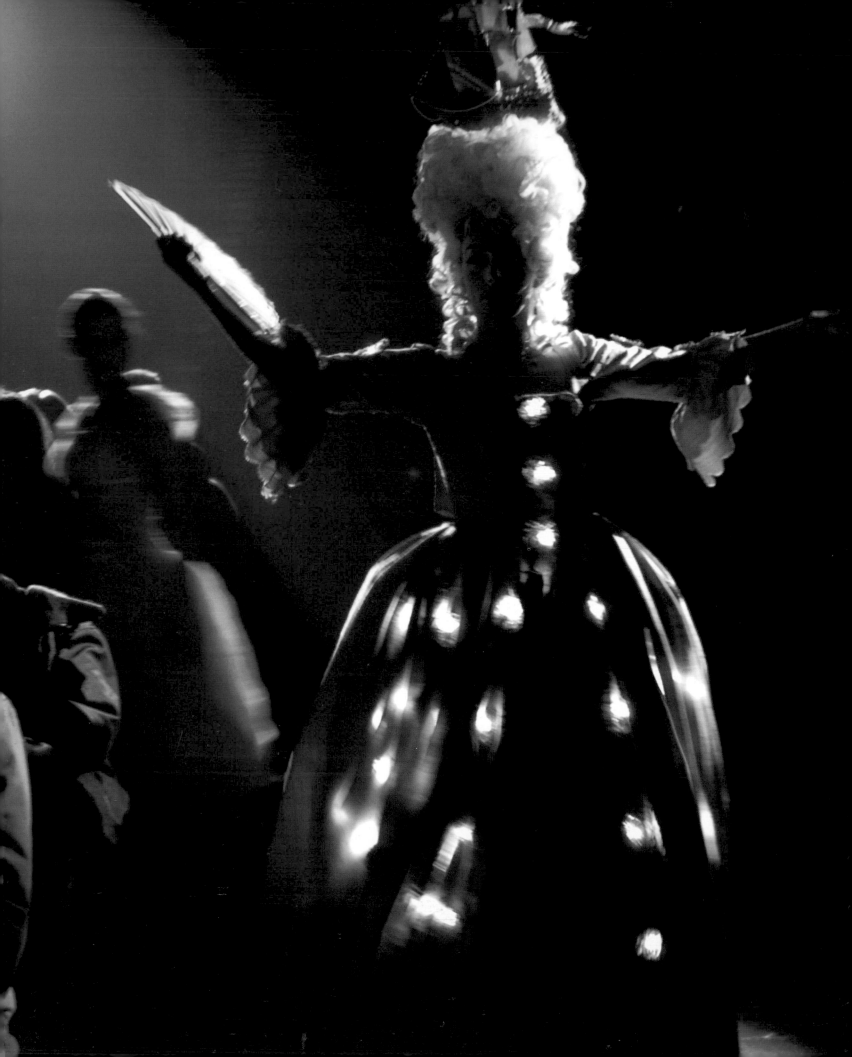

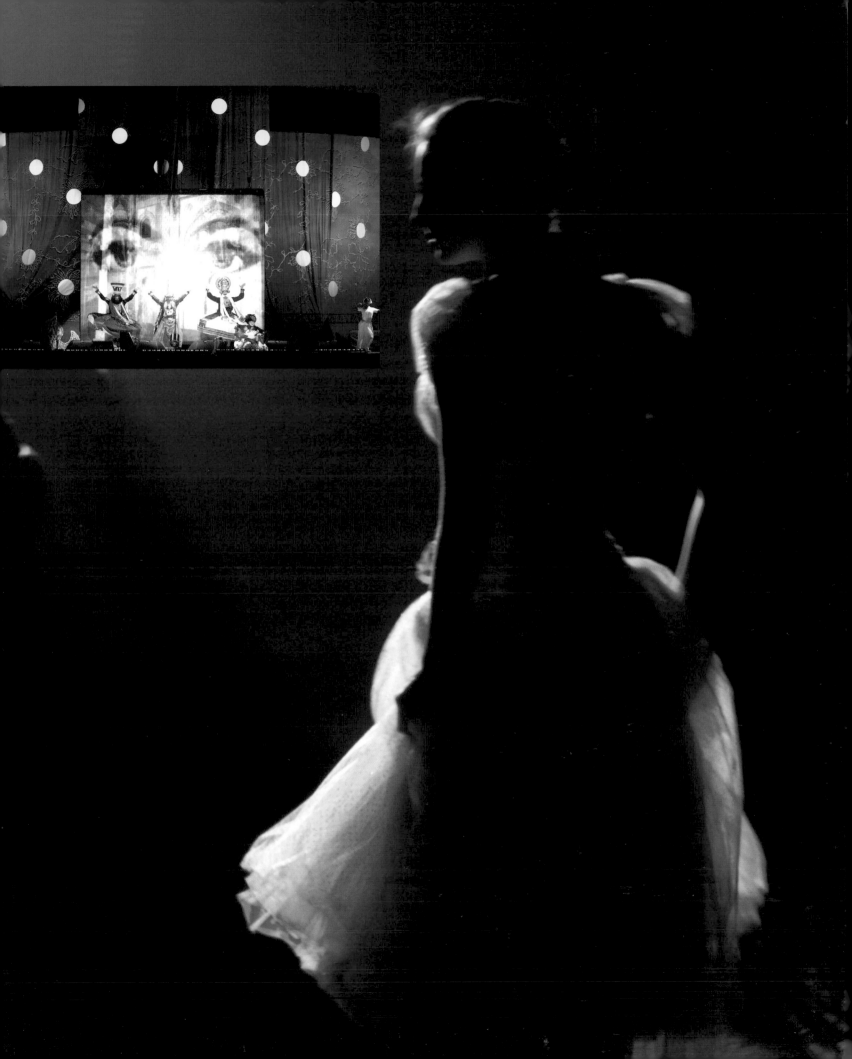

Middle of Something

The huddle, the Strepsil, the ritual

THE SCRUPULOUS DEVOTION TO CERTAIN ROUTINES CAN VERGE UPON THE MYSTIC. *Whether it's the sight of a band in prayer before they walk on stage, or the precise method by which a throat-soothing sweet is passed to Paul by his assistant John Hammel, a pattern takes shape and is observed with religious precision.*

Reporter, London: There are a lot of rituals on tour, aren't there?
John Hammel, Personal Assistant to Paul McCartney: Yeah, even with the way we set our stuff up; we use the same lead, the same tuner. It's ritualistic, and you don't want to change it because it might go wrong.
Keith Smith, Backline Crew Chief: The great thing about the way we do it, how any professional crew do it, is when a band walks on stage, whether it be in Iowa or Oslo, it's exactly the same. Walking on is just like walking into your front living room. It looks the same, everything's in the same place, and it sounds the same. They've got enough to worry about, being in front of 15–18,000 people, and it's a different city and you've just flown in. We make it very ritualistic—even Paul's set list goes in exactly the same spot every night, because he's so used to looking down at that spot.

Reporter: What is happening behind the stage curtain as the show is about to begin?
Bill Bernstein, Tour Photographer: As the tour photographer I am the proverbial "fly on the wall." Or, as Paul once called me after I tripped with my camera, a "bull on the wall." Some of the more interesting moments come just before the show. Paul follows an exact series of tasks before every performance. Getting ready, he pours himself a cup of tea, has a few sips, then goes into the bathroom and washes up. Sometimes he snorts a little warm water through his nose. I believe he learned this in India as a way to clear out his nasal passages. Then he goes through his wardrobe, picking out what to wear. He meticulously folds and hangs up his street clothes. Dressing in front of the mirror, he then combs his hair with his hand.

After Paul has had a last-minute wash and selected his costume, the band gather together to get their musical juices flowing. They may sing Hey Jude—*but then again, it might be* Hey, Hey, We're the Monkees.

There is a beautiful moment of calm right before the storm. (Right) Tour Manager Phil Kazamias checks his watch.

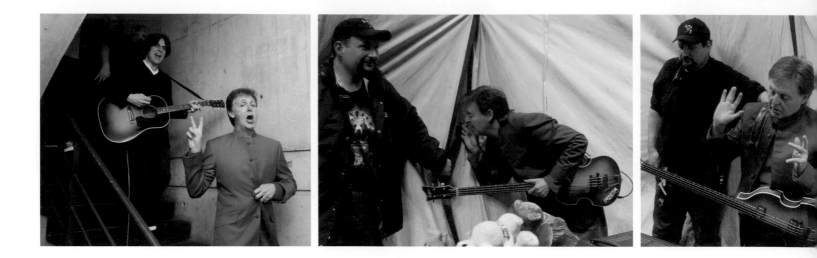

Next, he walks to the Band's dressing room where they are warming up. Rusty plays guitar, the rest of the band circles around Paul. They go through any number of songs: *Let It Be*, *Hey Jude*. The Tour Manager, Phil Kazamias, knocks on the door. The band leaves the room and walks down the hallway singing. Often the song they choose is *Hey, Hey, We're the Monkees* in four-part harmony. Behind the stage his assistant John Hammel gives Paul his guitar. John gives him a red cough drop. Paul puts it in his mouth. John and Paul "slap each other five."

John: That's right. As Paul comes to the stage, me and Sid [Pryce] will be behind the curtain with the guitars, and Keith will be over by the amps. Then I'll give Paul the Strepsil.

Reporter: The what?

John: The Strepsil. It's a sweet. I give him the Strepsil. Then we'll give each other five—"Have a good one." That's another ritual that we do every night. It's just before the "huddle," when the band all put their heads together. But this is me and Paul's thing: the Strepsil and then every night, "Give me five, man."

Bill: When Paul and the band approach the stage, the curtain is still closed. Paul walks to the center of the stage and pretends to peek out at the crowd. He turns back toward the band with a look of mock terror. He bites his nails and seems shocked.

Suddenly he looks up at the sky like he's receiving a message, or holds a pretend phone to his ear, getting word that "It is going to be OK." His entire expression changes. He is calm and relaxed—often putting his hands in the Buddha position. He walks back to the band. They circle around him, chat, and then get into a huddle where private words are spoken. They come out of the huddle.

Paul places his red cough drop on a speaker, the same spot every night. The entire Band gets into position. The curtain goes up. *Hello Goodbye*.

Abe: We warm up before we walk to the stage and do these vocal exercises that are very funny. It kind of breaks down the walls—breaks down the invincibility of what we do. We are back there going *(makes sounds)* to warm up and to get ready to do our jobs. We definitely get very goofy on our way to the stage; we get excited. And then we have a beautiful moment of calm before the storm, in which we huddle around and he leads us in a little prayer. The five of us are in a round of prayer, thanking God for being able to do this every day, you know, just to allow it to happen. It's a great grounding moment, just bringing you down to earth from this intense high, knowing what you are about to do. But still keeping your feet firmly on the ground and realizing the music we make is not our own. As my father has always told me, "music visits us." It's not ours to try and capture; it just kind of floats over us every once in a while. So it's great to remember that and just let it happen. *Let it be …*

Bill: One night I was photographing Paul in his dressing room, which happened to be a team locker room. He stopped to take a pee at the urinal. I put my camera down and asked if he wanted me to leave. He said no, and to keep photographing. "Now I can prove that even Paul McCartney goes to the bathroom," I said, snapping a picture. "That's funny," Paul replied. "When I was in Wings, the guys in the support band used to drink a lot. I didn't. They were always running off to the bathroom. I wasn't. So a rumor started that Paul McCartney never goes to the bathroom."

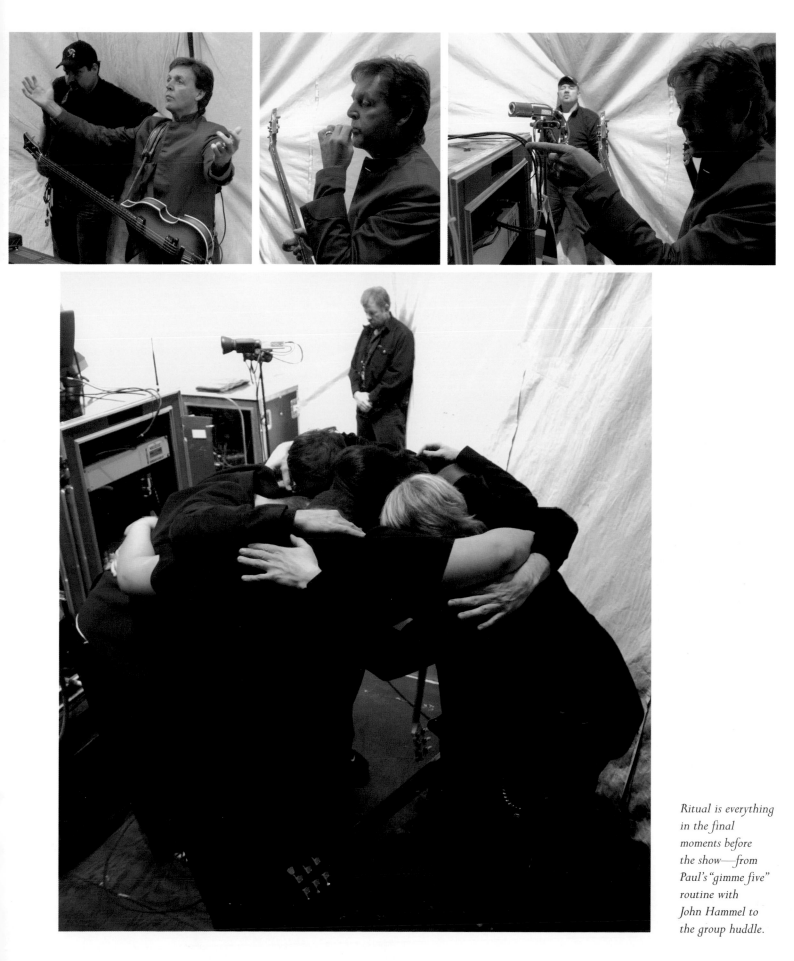

Ritual is everything in the final moments before the show—from Paul's "gimme five" routine with John Hammel to the group huddle.

My Dreams Tonight

Sheer emotion, memories, sensory overload ...

EVERY SO OFTEN THE MUSIC CAN OVERWHELM PAUL McCARTNEY, TOO. *Emotional surrender is the role of an audience; performers need to keep control. But as Paul admits, these songs release feelings from which he cannot always keep his distance.*

DJ, Chicago: We all have our memories of these songs and you certainly have yours. It must be kind of amazing to be up there for more than a couple of hours and maybe certain nights it hits you more than others. Is it almost like looking back at a family album?

Paul: When you've been around for a while, all your songs remind you of certain things. I like it, you know, I really like it. I think when I was about 18 I probably would have got embarrassed at the sheer sort of emotion of things like that. I think when you're an 18-year-old guy it's, you know, *"Awww, leave it out, don't talk about that; I don't wanna talk about that ..."* You don't want to go there. But now, it's not like that for me. I enjoy the emotion, I enjoy the kind of release of it, rather than bottling it up.

"FOR ME NOW, IT'S ... *YEAH, C'MON ...* LET'S GO THERE."

DJ: It's therapeutic for all of us.

Paul: We do it with the audience. But I don't always notice what everyone in the audience is doing. I'm maybe sort of trying to concentrate on the song. But I know last night the guys were saying *"Whoooaa"*; some of the people were weeping away. Just occasionally it gets me; I'm trying to not have it get me. I'm trying to just have a sort of light emotional response—because otherwise I'd be just kind of blubbering. You wouldn't get an awful good concert ... you'd get the crying show, *booo hoooo*.

Back to "bass-ics." Familiar icons appear on screen to herald the start of the show.

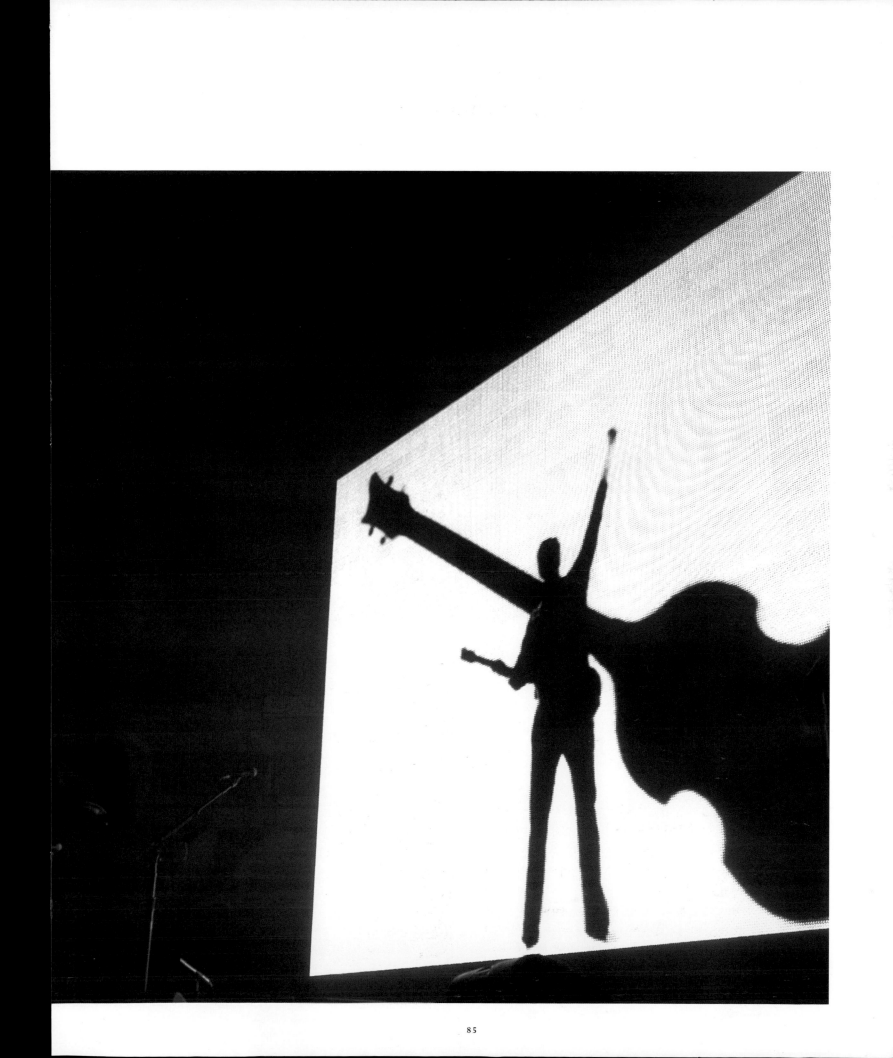

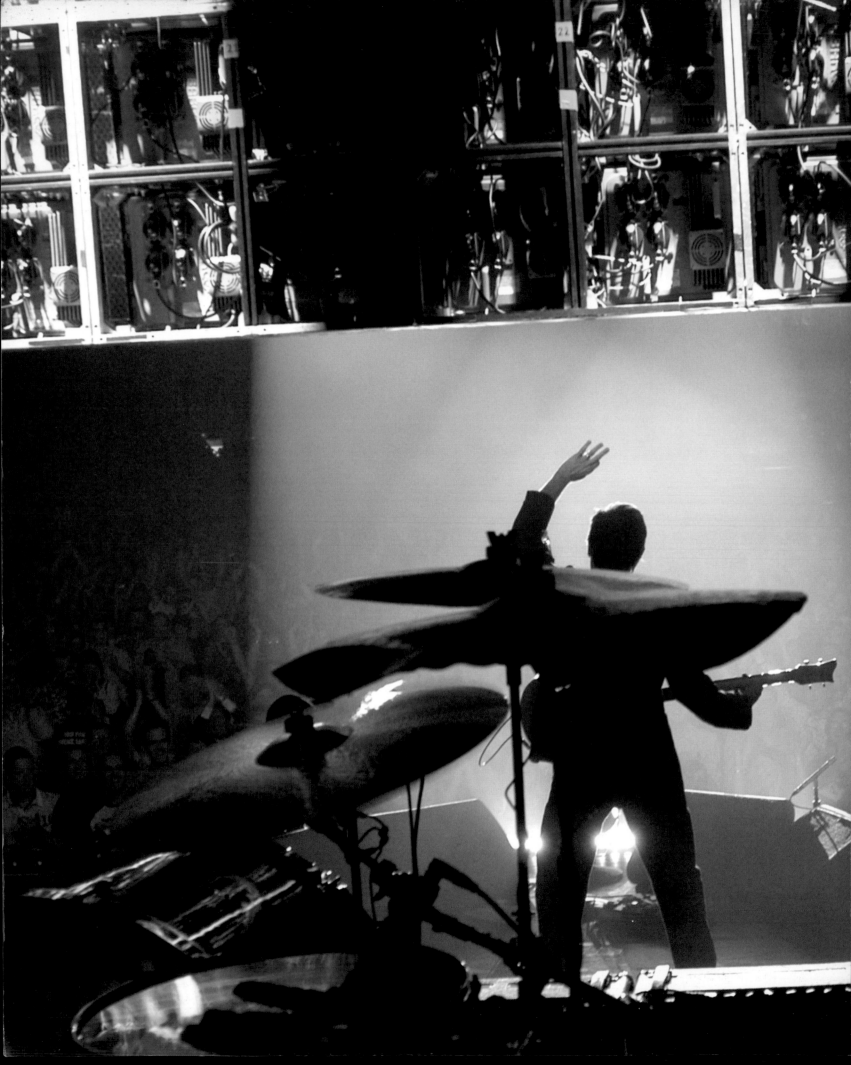

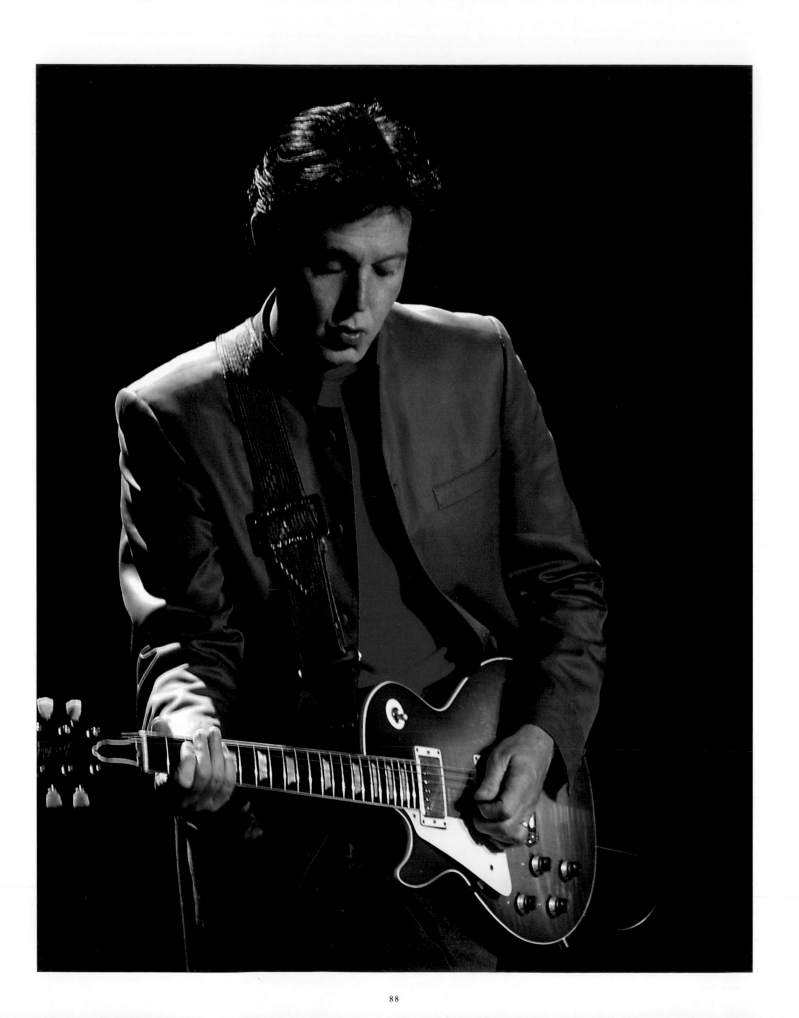

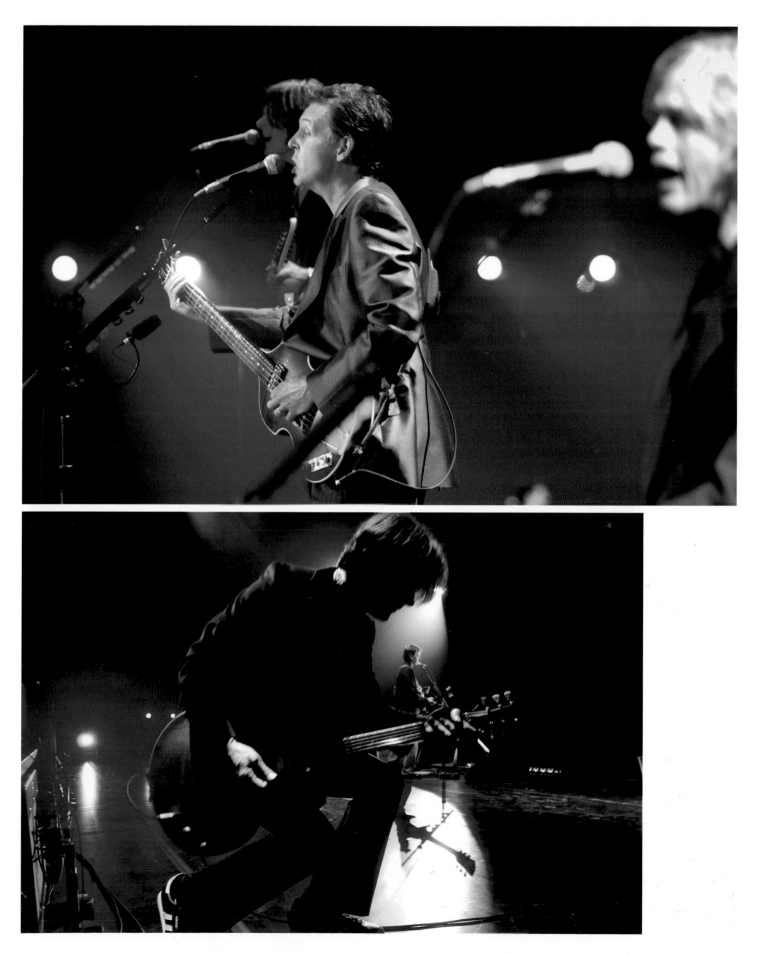

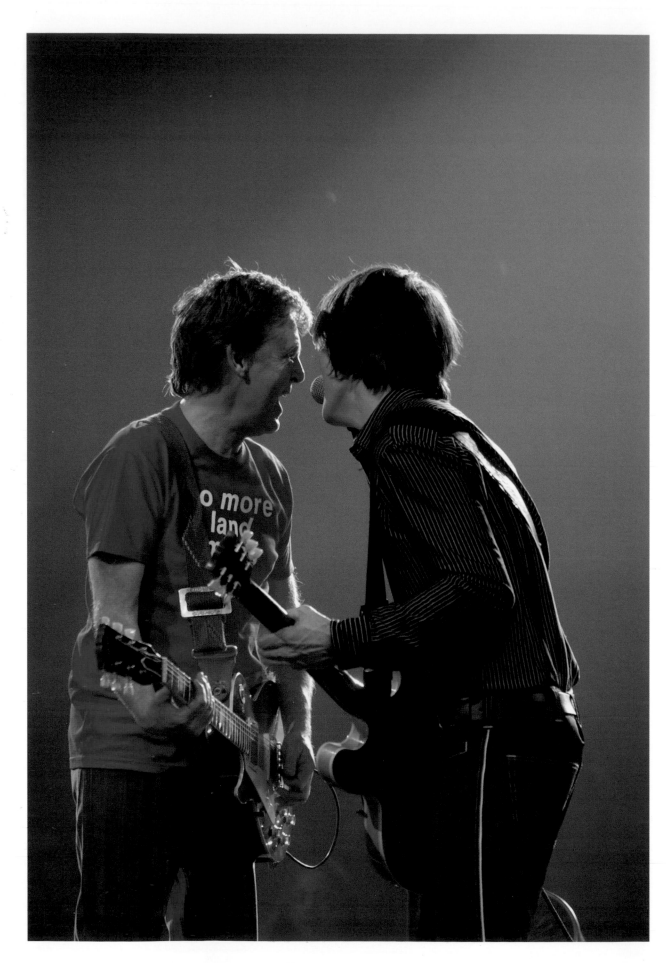

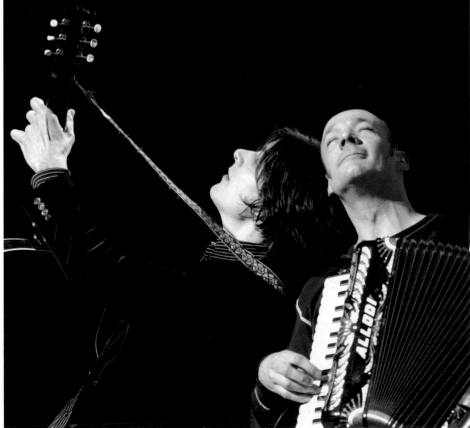

Paul: You can understand when people say, "Wait a minute, you should be fed up with this by now." I should, like, have had enough. But, you know, I haven't. I love playing music, and with this band it's easy, they make it really easy. For instance, if I say we're gonna do *Michelle,* the old Beatles song, if I say that, then when we get to rehearsal they all know their parts. I haven't got to "OK … *(hums* Michelle*)."* They just go … *"Bang!"* They're in there with this little blanket of harmonies, and that gives me energy. I should be jaded, I should be blasé about the success I've had and how long I've been doing it. But I love it: the band, the audiences, and the whole vibe at the moment just makes me love it.

IT'S IMPORTANT TO PAUL THAT HIS SONGS SOUND AS FRESH TO HIM AS THEY DO TO US. *Over the years, he has cultivated a way of putting his own material out of mind until the time arrives for him to perform it again.*

DJ, Las Vegas: You have three dozen songs in the set, only five of them from the new album. So there's a lot of songs going back a number of years. Do you remember all the words?

Paul: I remember most of it, especially when you've got a few gigs in. But I need to rehearse them and I need to relearn them. I don't just carry them in my head all the time—there's too many. I've written something like 300 songs on my own and with John and other people, and that's a lot to carry in your head. You know, you wouldn't be able to ever have a conversation with someone—you'd be saying, *"If there's anything that you want … she loves you …"* You wouldn't be able to say anything else; your mind would just be packed out with your own lyrics. So I have to relearn them when I come to do them. But that's kind of fun. I, like, wipe the records from my head when I'm on holiday or not doing anything.

"BUT WHEN I COME TO REHEARSALS, I RELEARN AND AM ENTERTAINED BY MY OWN LYRICS AGAIN. THEY SEEM FRESH TO ME BECAUSE I DON'T REALLY KNOW THEM."

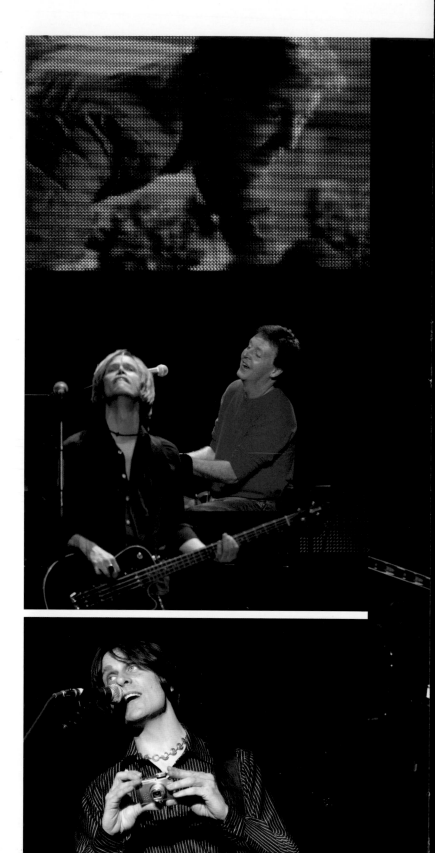

(Bottom left) "If you could all just squeeze in together?" Rusty covers while Paul is moving to his piano by getting the crowd to pose for a snapshot. Works like a charm.

Paul: That's one of the nice things about doing the show, you know. I get to see these lines again that I've written in the past, and I get to think, "Oh, I'm glad I wrote that … *Let it be, there will be an answer* … that's good, that's positive." You know, "*Take a sad song, make it better*" … that's good. I'm proud of it, actually, because there is a lot of that in my stuff. And in music I've always loved that, when I've heard, like, a really cool statement in a song and it's made me choke and think, "Thank God for that song." So I love to be part of that, I'm proud of it.

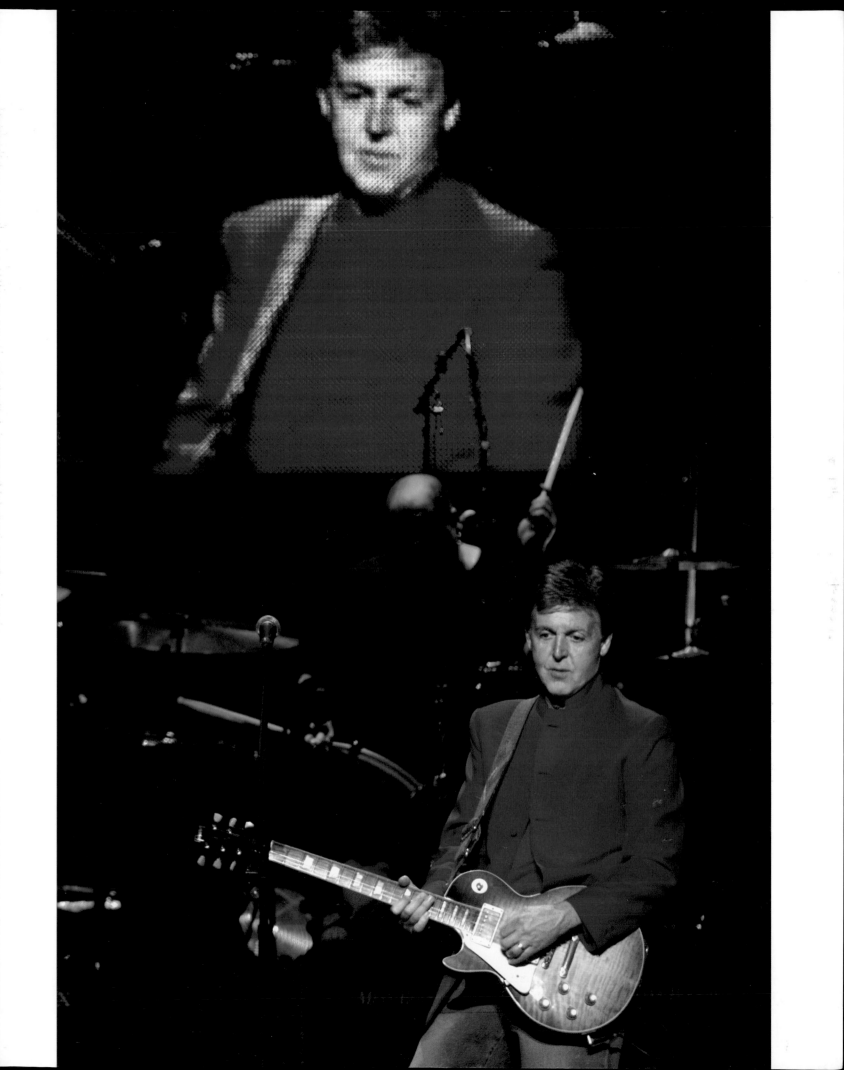

DJ, Washington, DC: What goes through your mind when you're on stage, performing?

Paul: Oooffff … impossible to say. It's … That would be a great movie. I mean … *everything* is the only answer to that, really. It's astounding, the abilities of the human animal, when you think about it. Me, for instance, I've got to be making my throat make these notes, that's like one thing I've got to do. And they've all got to be the right note, not flat or sharp. So that's one thing I've gotta do. Then I've got to be thinking of the words that go with these throat noises, and I've got to sort of perform them like I mean it. Then I've got to, then, forget all of that; I've got to play a bass line, which is completely different. OK, I've been doing it so long that it's like second nature. Then I've got to look at all these people looking at me—I don't even get to be in a little closet and try and remember all this stuff. I've then gotta look at all these people … and they're holding up signs! Distracting me!

And I'm reading these bloody signs and singing this, and making these noises … It's, ah, I don't believe it, it's uncanny. Sometimes it's a bit scary. I go, "My God, you know, this is like sensory overload." And then you're seeing some people and, oh, they're *kissing.* "Ohmigod, what is going on?" So you're getting, like, this movie you're watching, and all these signs— these subtitles—it's like a foreign movie … *"Paul! The first time I made love to my husband was during* Hey Jude!*" "What??!!* Don't say that, I'm trying to think!" You get all this stuff, and then you've gotta think what you're gonna say to them, because they react. So it's massive sensory overload … And you've got lights on you and an explosion during *Live and Let Die* … It blows up and you've all this dust to deal with!

"IT'S TERRIFYING! BUT I ENJOY IT. WE'RE HAVING SO MUCH FUN."

Brian: That opening night, it was one of those nights when the show just sort of seemed to carry itself. It was almost like we were being lifted through it in a funny way. It was like a dream; it just kinda happened, there wasn't a lot of effort. It was just like we were all transported to that first night. It felt like, "God, isn't it supposed to be tougher than this? Is this really effortless?" Yeah, it was magic.

Rusty: It just feels so natural to play those songs that it's hard to really head trip on it. You just … I don't know. Life—things happen and you go with it, you know. It's certainly a mind-blower. It's amazing. When it just actually happens, you're like *"Yeah!"* It just feels good, you know. It just feels good.

Abe: I think a tour like this is very rare. The joy that is definitely around everybody. I think it's a trickle-down theory; it's coming from the boss.

Wix: I have seen some great things. I have seen families and friends altogether in a lump, and they are giving high fives when their favorite song comes on. And they kind of get more and more excited, and then toward the end of the show you get up and do something that just takes the older ones back to where they were. And they lose it, that's it. They are all holding hands and they are crying, and it's taken them right out of themselves, but then back to where they were at that time in their life. Where that music was meaning something to them then, and it means something to them now. And you are up on stage thinking, "I know how you feel."

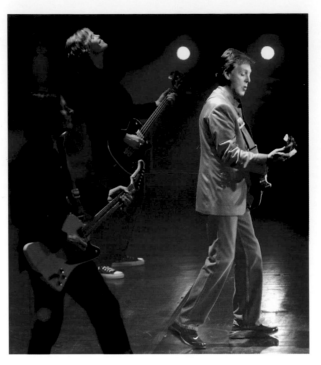

THE BAND ON SHARING A STAGE. *What do Brian, Abe, Wix, and Rusty think of Brian, Abe, Wix, and Rusty?*

Brian: Rusty's an amazing player. The first time I saw him was at a club in LA, playing a green Ibanez guitar with green Astro-turf speaker cabinets and hair down to there. I was impressed and thought he was cool, so I introduced myself and we became good friends. I love him like a brother.

Abe: Rusty? He's such a sweetheart and a very genuine person. He's an amazing guitar player, a lot of fire, a lot of passion. But

also he has that maturity to know when to pour it on and when to let the song speak for itself.

Wix: Rusty's great. He's got the most enormous hands that I have ever seen. Big long arms and big hands, and a very dry sense of humor, which I get off on.

Rusty: Abe just pours out all this, like jolliness, you know. And I think that really translates in his drumming and his whole personality. He puts out lots of energy as a drummer as well as a guy just hanging out every night.

Brian: Abe and I go back six years now. One time we were in Lyons and we went to a vintage guitar shop and I saw this 1955 Les Paul Junior. For some reason my card wouldn't work, so Abe whipped out his card and threw it down and I walked out of the store with that Les Paul; that's the kind of big bro he is.

Wix: Abe's a big player, a big guy, a big-hearted guy. And it is great for me because I am sitting up there next to this huge wall of energy that kind of floats over my way.

Rusty: Wix, what a great guy. He's got like about 90 pedals that he somehow operates while playing the keys upstairs. It's sort of like he's operating five sewing machines at once.

Brian: Wix is another talent. I call him "Legs Akimbo": there's songs we do where he's got all four limbs going at once.

Abe: Wix has incredible precision. He really is the glue that keeps this whole thing together. I attribute it to him that we were able to go out on tour after only ten days of rehearsal.

Rusty: Brian's very social and ends up knowing everybody fairly quickly. I call him "Nurse Brian" because he's always got a little potion of this or knows a cure for that. And it always works, because Brian says so.

Abe: Brian really knows how to play a song and he has the maturity to sit back and just let the music happen and know that he has a part within that.

Wix: Brian is a trip. Paul doesn't do auditions as such; Brian got recommended. Abe knew him of old and knew he could do the gig. So he is in and he is great. He is very amiable and comfortable to be around. You need to have friendly people if you are going to travel and spend a lot of time with them.

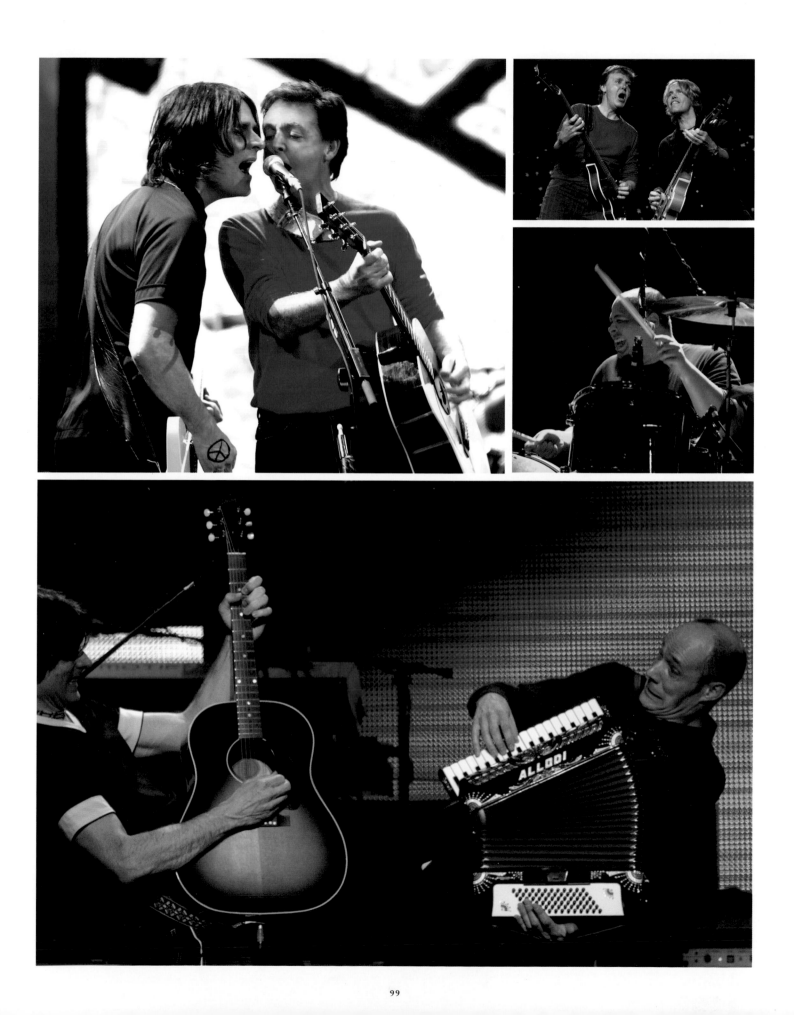

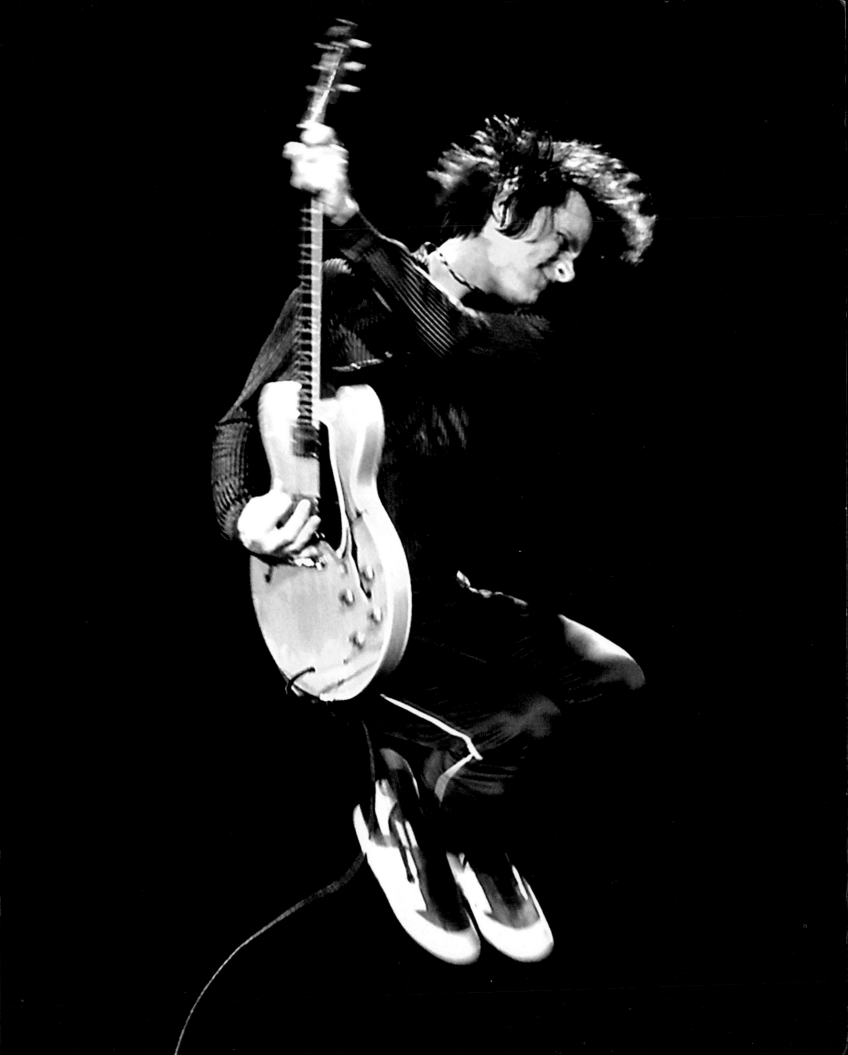

THE SHOW EMPLOYS 21st CENTURY TECHNOLOGY TO REJUVENATE SOME VENERABLE ELEMENTS. *Paul explains to a TV reporter in Philadelphia how certain visual effects go way back to the sixties.*

Paul: In the sixties there used to be a lot of light shows, and we wanted to recreate it for this tour. So we had a guy phone up some of the old hippies who remembered how to do that, because now it's all electronically generated ... and it turns out that what the guys used to do is have a little bowl with colored inks in there, and then another bowl underneath and you sort of squash these colored inks, and then you project a light through it, and you get this huge sort of psychedelic lighting thing. So we did that and we filmed it. We were gonna use it on a *Sgt. Pepper* project but we never got around to it, so we used it for the tour. Looks great.

The stuff that we used on *Fool on the Hill* is from *Magical Mystery Tour*. I'm always in favor of the simplest way to do a thing. So I said, "Let's just take one camera down to the south of France." And me and my roadie and the cameraman just went down there. We got up really early in the morning. We went up in the hills, and I said, "Let's just wait 'til the sun comes up, get the camera set up, and I'll just goof around and I'll just sing it." And I actually sang it into a little cassette recorder, so it wasn't lip-synched. It gave the editors murder later, of course. But that's what I did and that's the footage we use in the show.

THE SHOW IS SO RICH, VISUALLY, THAT YOU COULD WATCH IT 50 TIMES AND STILL CATCH SOMETHING NEW. *The video images that accompany each number look as joyous as the music sounds, but their giddy, kaleidoscopic progress is a nightly miracle of planning.*

Paul Becher, Video Director: I'm responsible for all the images that you see on the video screens during the live performance of the show. It's pretty hectic; we've got a lot of playbacks going on. We've got eight channels of playback, which go on six

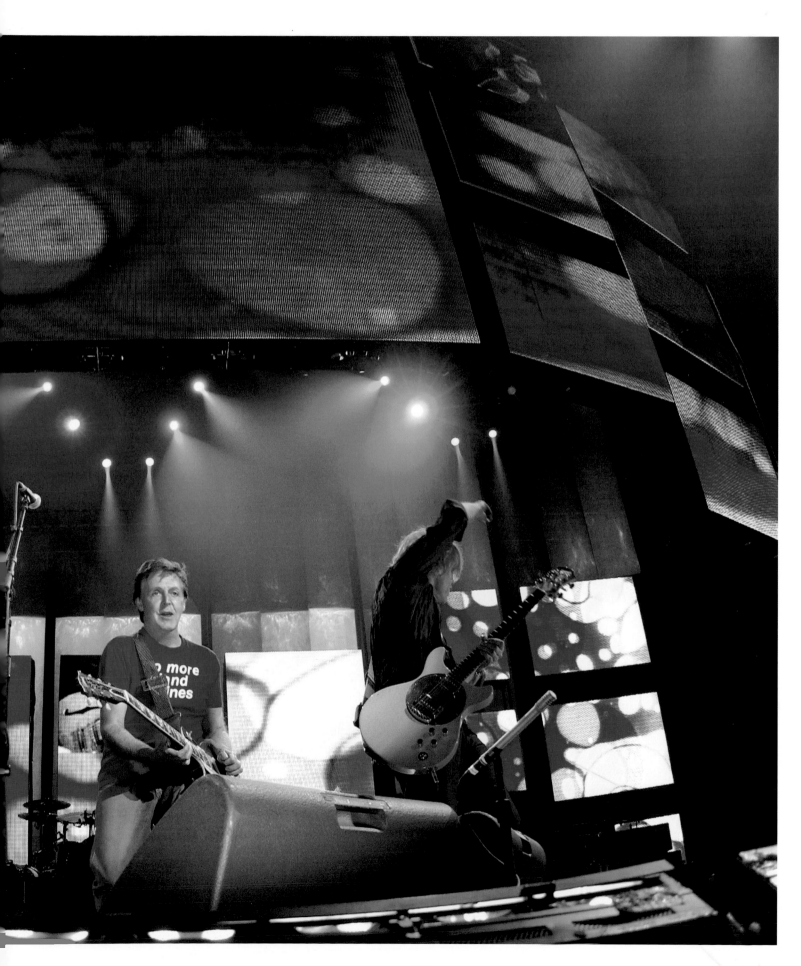

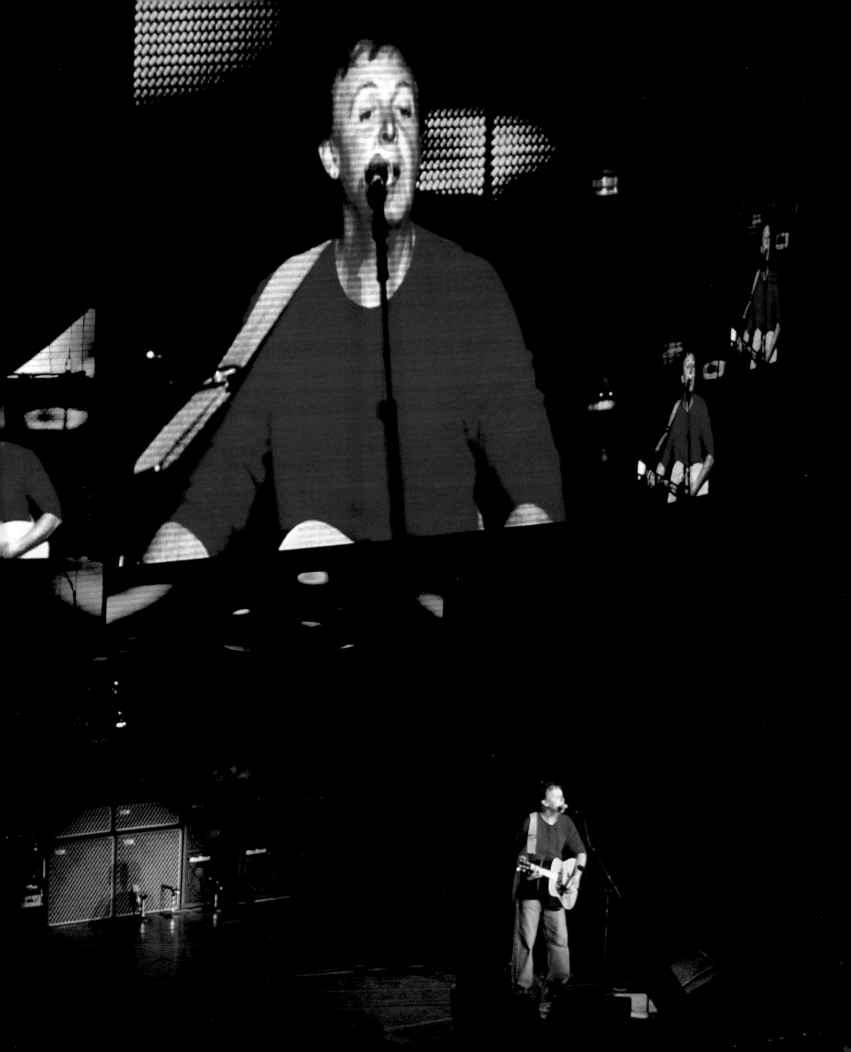

different screens. There's also shots of the audience involved and a lot of fly-on-the-wall video switching. We put everything on hard drive these days because access is instantaneous and we need that in this show, because it goes from one song right into another. We do limited effects. We've got nine DVDs built into the switcher, and we basically use that in the preproduction of the show when we are laying all the footage into the hard drives. The greatest challenge is getting everything together on time. There is a lot of video equipment on this tour—two truckloads' worth—and we set up the day of the show. It has come close a couple of times. On one occasion we had to hold the doors, but that whole day started slow. We've got to wait for a lot of other departments to be finished before we can actually get started, so with the day starting slow, the whole thing just kind of dominoed. It wasn't too long, it was about 15 minutes, but we got everything up and everything worked great. Besides myself, I've got a crew of ten—divided between LED techs and camera operators, an engineer, and an assistant director. They're just super. I love them, I couldn't do it without them. It's a pretty big staff, but it's a big show. Paul's such a charmer and we're playing to 15,000-, 20,000-seat arenas, and the people sitting all the way back can't get to see his facial expressions. So the images that I try to put on the screen are to make it much more personal for the people who are not sitting in the front row, to kind of give them a chance to feel that he's talking to them.

Live and Let Die is a kind of frantic number. It's got everything going on, from pyro to fast cutting, and every facet of what I do is in that song, from the playback, to the cutting, to screens mixing, to the pyro. That encapsulates the whole show, for me anyway. It's a fun song to do.

For the most part, life on the road is hard. We're thrown into a situation where we're with each other constantly, you know, almost 24 hours a day. For the most part we do all get along. We've been doing this for years and we know each other really well. It's more of a family and, you know, families don't always get along, but at the end of the day we're close.

I've been doing this for over 20 years, being on the road, and that's all my family knew. When they were younger I tried to get off the road, and I managed to for about the last year and a half, but then this thing started up and Gerry Stickells [Production Director] and Barrie Marshall [Tour Director] asked me to come back out on this, and you know, how do you say no to going out with a Beatle? And it's just been great.

Well, everybody knows the Beatles have been such an important part of the music scene, especially when I was

growing up. I think everybody's been touched one way or another. I've had relationships with people, and you can equate that to a Beatles song, to one song in particular. When that song comes on the radio, you think about the girlfriend you had when you were 16 years old. And it was more of an innocent time, and I think people now are looking for that, which explains part of the popularity of this tour. Things are in such turmoil now in the world that you hear these songs and it just brings you back to a more innocent time.

The screen show becomes a gig of its own with images from eclectic sources and inspirations complementing the action on stage: sixties footage of Paul scampering on a mountain on Fool on the Hill, *famously faced women of note for* Lady Madonna, *archive Beatles footage during* All My Loving, *a movie reel of Wings for* Band on the Run, *Parisian nightlife throughout* Michelle, *James Bond motifs during* Live and Let Die *(complete with pyrotechnic mortars), the famous bass being bashed to bits by leggy LA models in* Lonely Road, *and black-and-white stills shot by Michael McCartney throughout Paul's tribute to George Harrison,* Something. *The two-hours-plus of kinetic art will see the show close with an ironic film of the sun rising.*

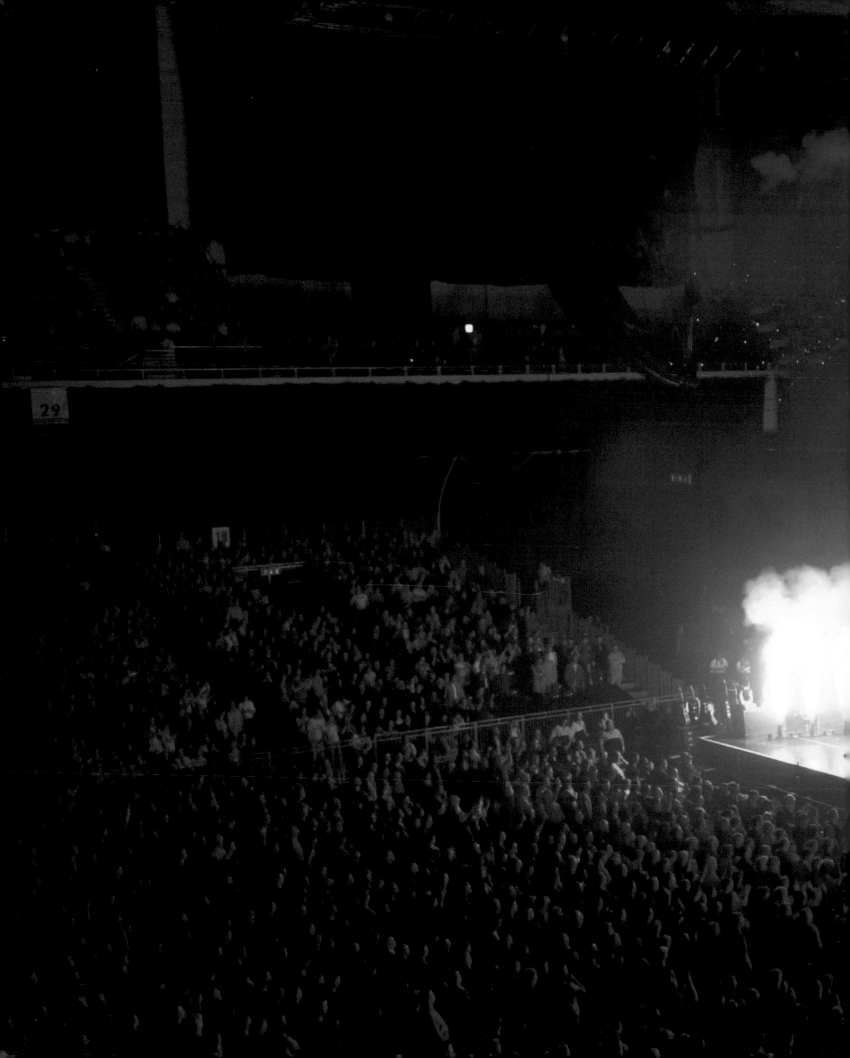

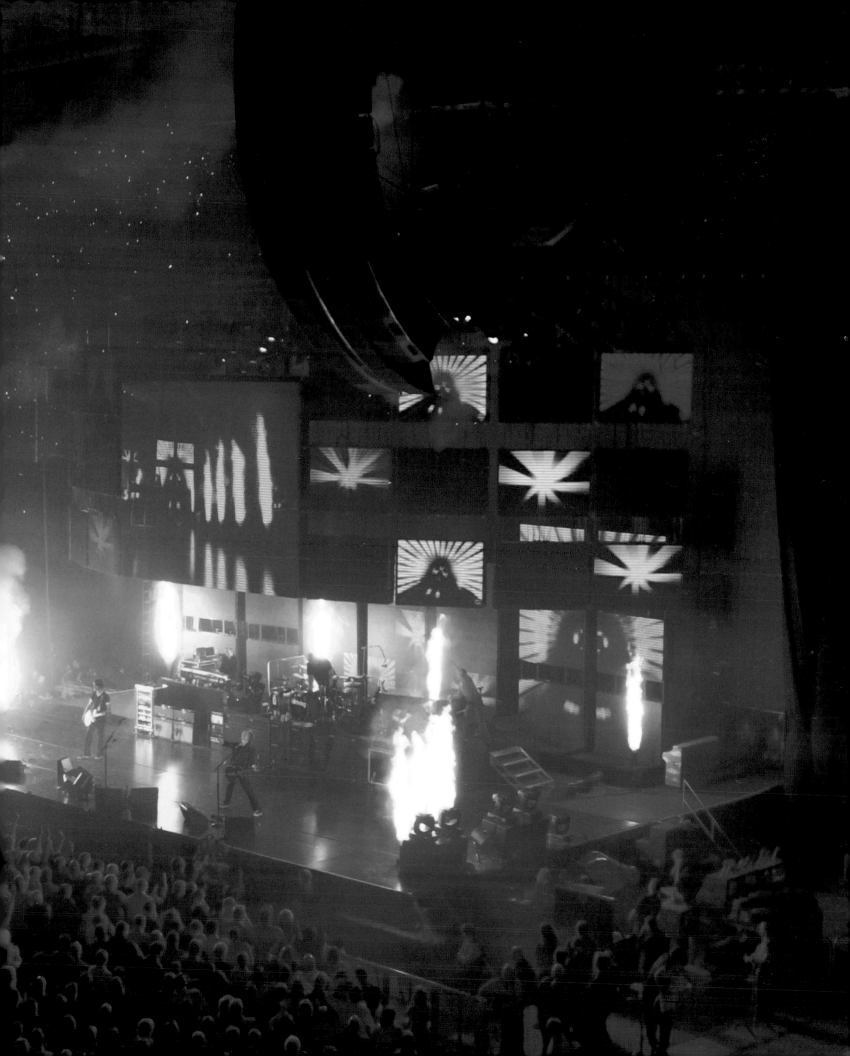

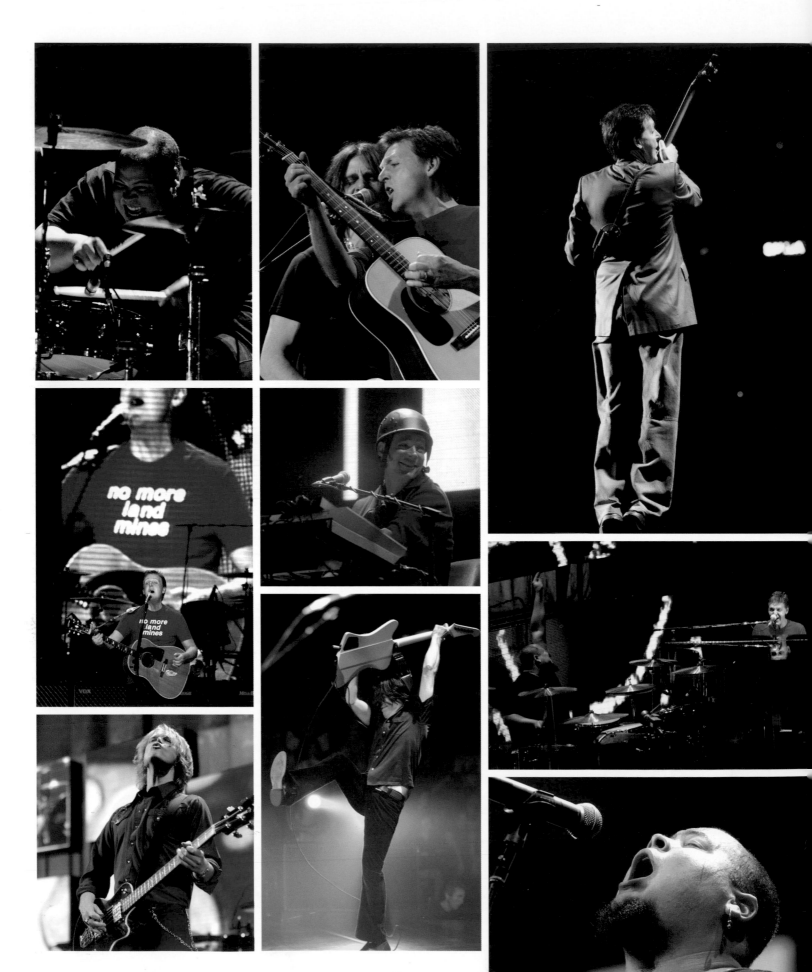

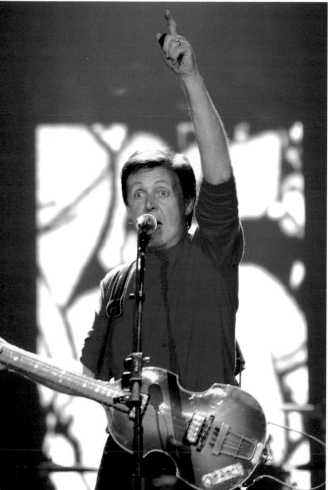
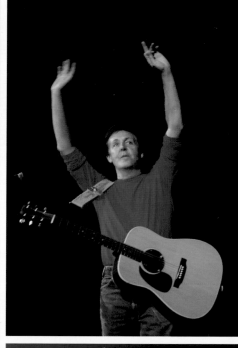
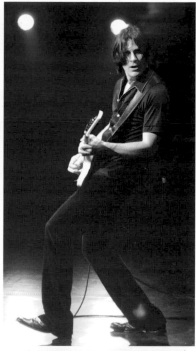

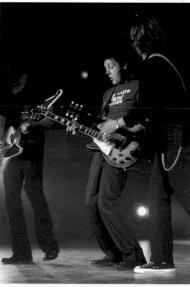

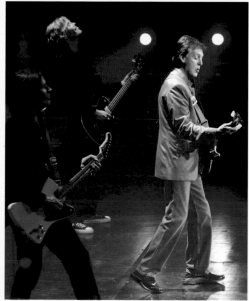
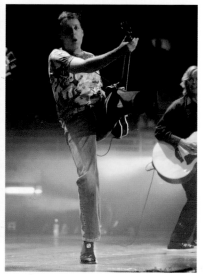

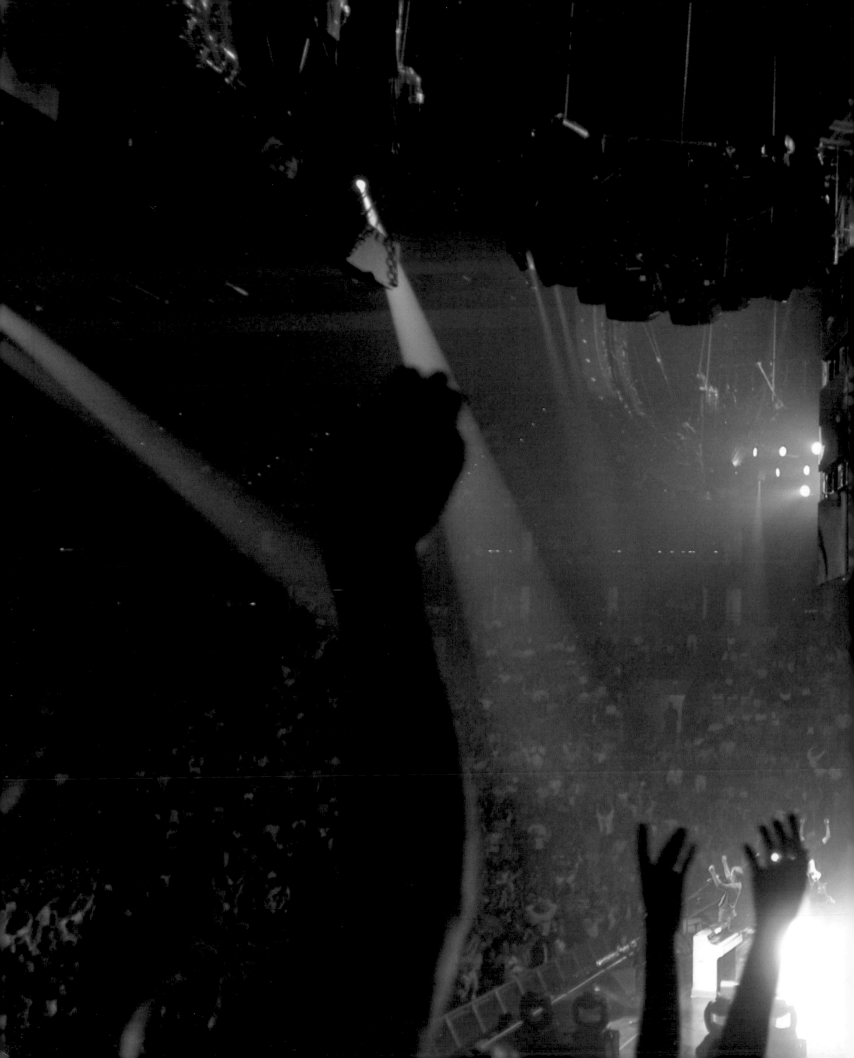

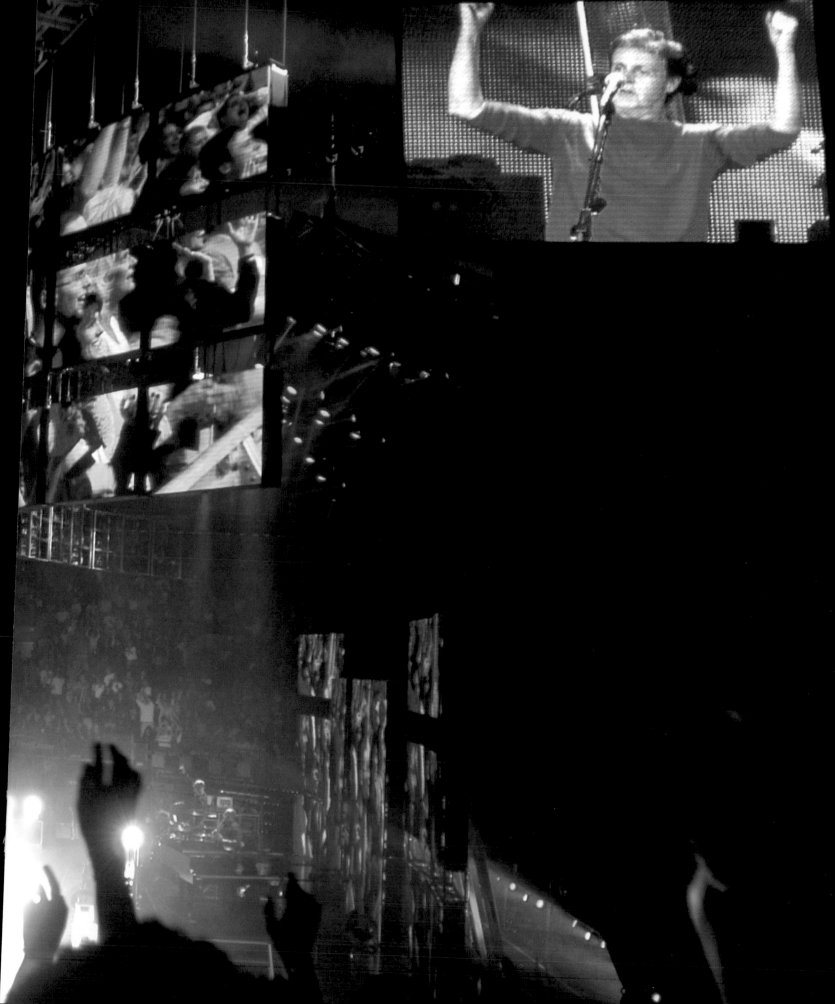

Paul: What's different about this from a lot of tours is that we're live; if we make a mistake, you'll see it.

"I'M FROM A TIME WHEN YOU JUST PLAY LIVE AND NOT PLAYING LIVE WAS NEVER EVEN CONSIDERED."

I know a lot of these bands use tapes when they perform these days, but what do I care if Britney works like that or if Madonna works like that? It's not something that I'm into. I know people say that they do all this dancing during their act, and they need to use tapes because they're dancing and you can't sing and dance at the same time. But I say, "Well, Fred Astaire could." But I think people like it that I'm doing it live. In fact, I'm taking it all a bit further because in a part of the show it's just me and a guitar and no band—that's probably scarier and more nerve-wracking. But I'm like that. I don't like to play safe.

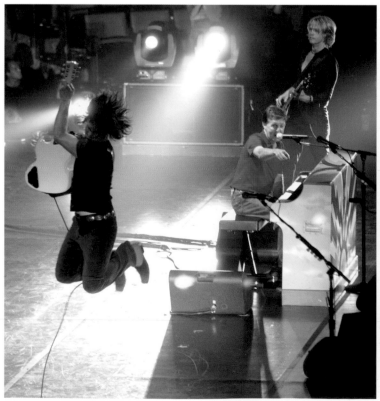

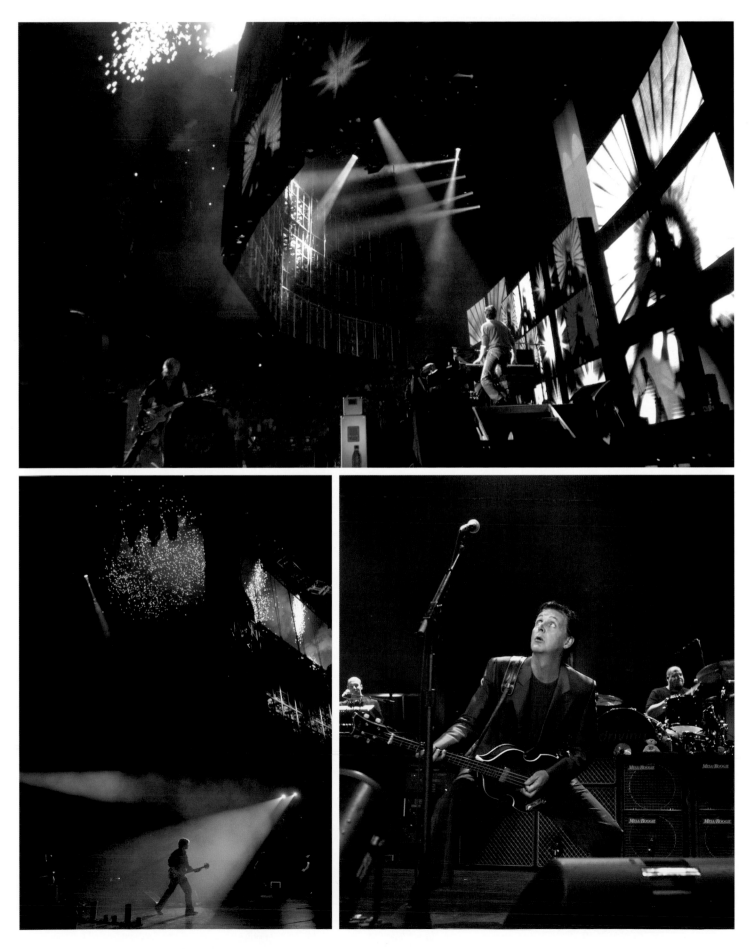

GOD GAVE NAMES TO ALL THE ANIMALS. *But does that apply to Big Knobby Bear as well? Just what is it with Paul McCartney and super furry animals?*

Keith Smith, Backline Crew Chief: The furry animals on top of Paul's amp started off in America. Giant, the merchandisers, had made a Freedom bear. [Tour Director] Barrie Marshall gave one to Paul to approve it for sale. Barrie gave him it as he walked into the building, then Paul walked on stage for sound check and popped it on his amp. He left it there for the gig. At the end of the gig, I cleared up as usual and just chucked it in one of Paul's drawers. At the next sound check, he said, "Where's the bear?" I pulled it out and put it back on his amp. And that was the beginning of the groove—they mated. When we got to New Orleans, one of [Film Director] Mark Haefeli's guys bought Knobby Bear. Did you see Big Knobby Bear? He's very similar to the Freedom Bear, but he had this big dick with a little blue bow around it. Someone left him next to Freedom Bear. Paul loved it! So then there were two of them and it just grew. Every time anyone saw a little teddy bear, any excuse, they just got more and more. I've ended up putting all his gear away at the end of the gig together with 15 teddy bears.

As fans notice the growing family of toy bears on top of Paul's amplifier, many start bombarding the stage with other fluffy bear toys at the end of the shows. Bears become the new Jelly Babies—reprising the Beatles experience with the Bassett's sweets that Paul remembers from the sixties.

"Anything that was cute caught on. We did like Jelly Babies. I think what happened was one of the newspapers said, "What's your favorite sweet?" in one

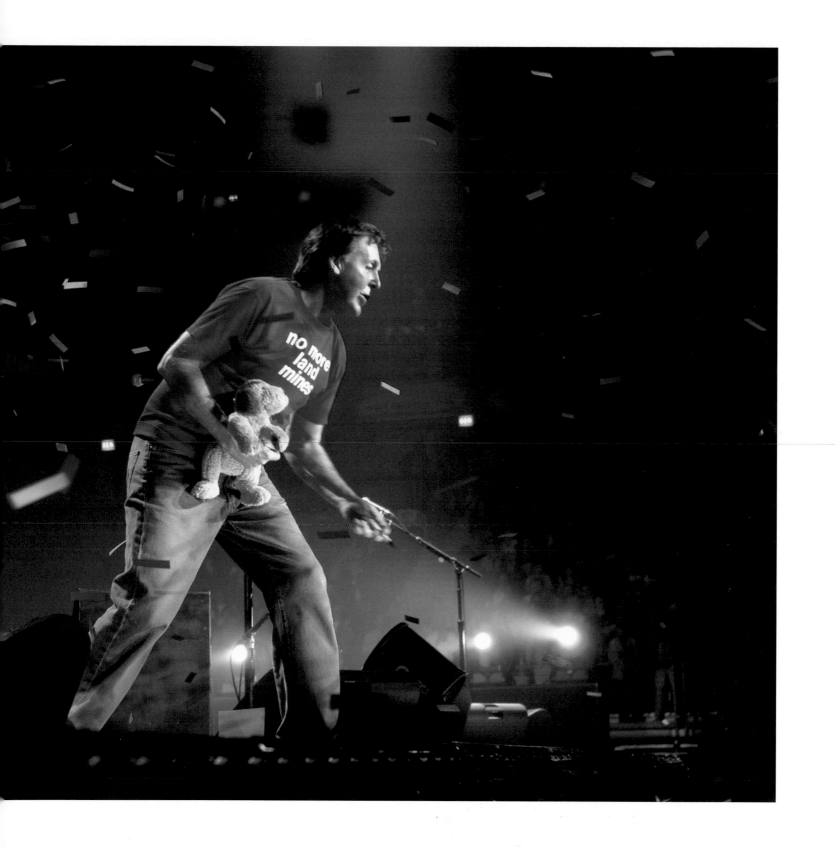

of those lifelines you used to have to fill in. Pet hate, pet love, favorite food, favorite sweet, favorite girls, hairstyle. It was always long, blonde hair. And Jelly Babies—I think we all probably put it in, Jelly Babies. So they started arriving with every letter. "Dear Paul, great, gosh, fab, gear, groove . . . here I enclose some Jelly Babies." But then, what happened was they started throwing them loose onto the stage, and they're very sticky, those Jelly Babies. And the worst was the

Washington concert where it was really bad news. The stage was, literally, you couldn't move. You stuck like superglue to the floor. We started to tell them, "Look, we don't like them anymore. Could you please tell all your readers we now hate Jelly Babies." Mind you, Bassett's shares went up. They did, literally. It was such a craze that one year we got letters from Bassett's. I think kids thought it was cute. Maybe it appealed to girls' maternal instincts."

Paul: I quite like to get in touch with my emotions now that I'm not 18. When I was 18, I'd hide from that, hide my emotions because blokes didn't show them. I'm no longer embarrassed about them now. But I'm not looking to be gloomy; I look for the good in the gloom. It's a strong theme in my life, that.

"NOBODY'S GOT THAT LONG HERE, YOU KNOW; THIS IS THE MAIN EVENT."

So the way I look at it is to try to enjoy my day and then enjoy another day, and if you add up enough enjoyable days together, then that's a life, and if you're lucky, it's been enjoyable. I don't have any deeper philosophy than that.

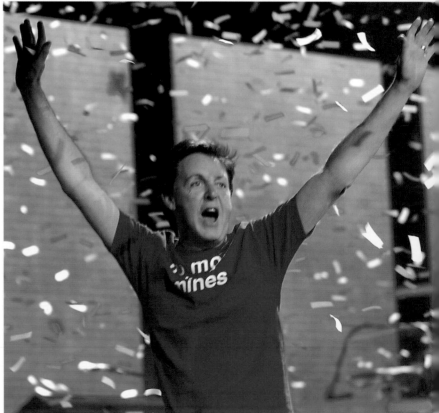

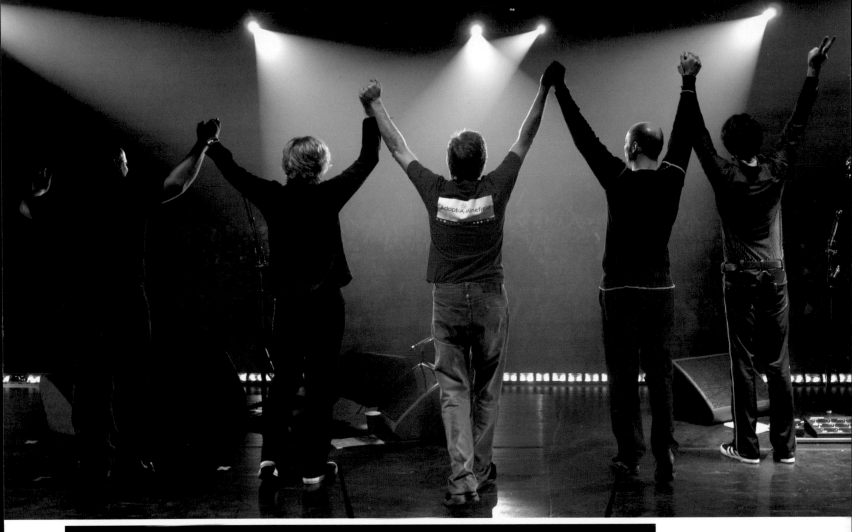

Emotions have been wrung, hearts have been uplifted, bedtime beckons for little furry bears. Another show is over.

DOWNSTAIRS TO
CLUTCHING HER
QUIETLY TURNING
STEPPING OUTSIDE

Clutching Her Handkerchief

Sheer energy, a different noise, not "our farewell tour"

THE SUCCESS OF A TOUR CANNOT BE JUDGED BY NUMBERS ALONE. *At almost every show, the crowd's reaction is loud and frenzied … Girls are screaming at Paul just as they did in the sixties. Those passing out with emotion are tugged by security from the baying bedlam. Ballads and memories move both men and women to unashamed weeping while the rock songs turn arenas into halls of heaving, hollering ecstasy. In Japan fans bring towels to the shows because handkerchiefs are insufficient to mop their tears. In Mexico parents bring babies as if to be blessed. In Moscow Paul's mere presence creates unprecedented fervor. Night after night, flowers, furry toy animals, and underwear are hurled at the stage as the scene gets back to Beatle-fan behavior.*

DJ, Sacramento, California: I saw the show in Vegas, and I spoke to someone who saw you in Oklahoma, and it's almost like seeing a Beatles show because you can hear the crowd over the PA system almost; there's this high din noise like it was when you were a kid. What's going on, Paul?

Paul: We came to just do a tour, just thinking that's good because we like playing together. But when we got that audience reaction it was like, *"Whooa! Wait a minute … this is going to be different!"*

And it is electrifying. It's like a warm blanket, a big wave of heat coming over you, and you just get this intensity, and you see these faces and you think, *"Wow! They've come to party."* It reflects on us and we respond to it, and it makes us give more and just try to live up to some of their expectations. I don't know what's going on. There is this kind of high intensity in the crowd, this really good feeling. We feel it; it's like a warm wave coming over us as it hits the stage. And it's there 'til the minute we leave the stage. It's fantastic for us. But it is like a Beatles crowd in the energy, the sheer energy. It just doesn't sound the same because it's not now just 16-year-old girls. It's a different noise, but it's as intense. We love it.

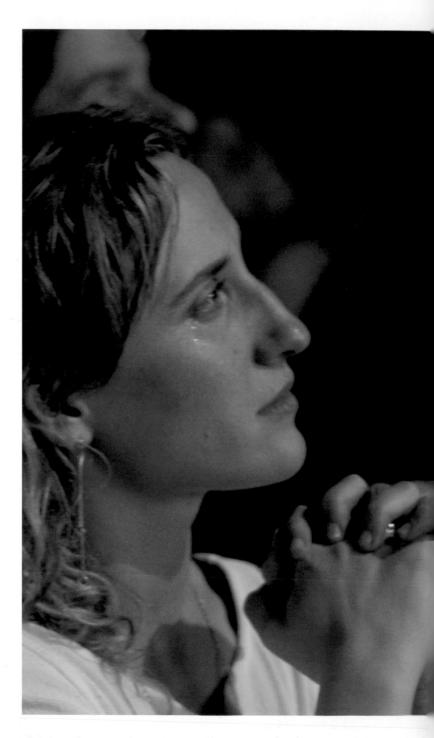

An audience of more than two million people see the Paul McCartney World Tour. *The one-millionth concert-goer catches the show in Osaka—and is personally presented with the keys to a new Colt car by Paul to mark the occasion. In Liverpool, 19-year-old Laura Andrew from the Wirral "wins" a VW Beetle convertible from Paul when she becomes the two-millionth face in the crowd. Laura breaks down in tears at the surprise.*

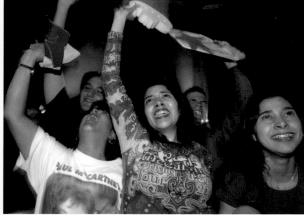

DJ: So with that energy you are feeling up on stage, does this mean that you're going to continue to do this touring?

Paul: I never think that it isn't going to continue. I suppose what happens is that you reach the sort of venerable age of like 60 and people go, *"Whoa, he's gotta retire any minute."* But I've never thought like that. Some people look at 30 and go, *"Whoa, that's old"*——and if you're 17, it is. It's all relative.

Now I look at people like B.B. King, Ray Charles, and think, "They sound good to me, those guys." I kind of fancy going on like them. But obviously there has been this sort of question on the tour, this "Is this your last tour?" I've seen it in reviews: *"This could possibly be his last tour."* It doesn't really do us any harm because it means people come even more sort of rabidly, because it might be our last thing. But I'm not one of those guys who plays that trick, *"Oh, it's our farewell tour . . ."* and then like next year they go, *"You know what? It wasn't——this one is."* So I never think in those terms. I just presume that I'm going to enjoy it forever, and as long as I enjoy it, I'll keep doing it. But I'll tell you what, this tour could have been 30 years ago for the level of enjoyment we've all got off it, the energy we feel in the band, and the reaction of the audience. And I think it's simply ageist to suggest otherwise.

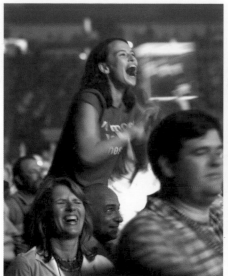

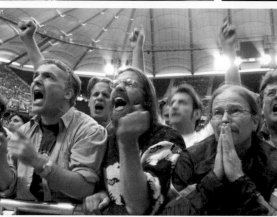

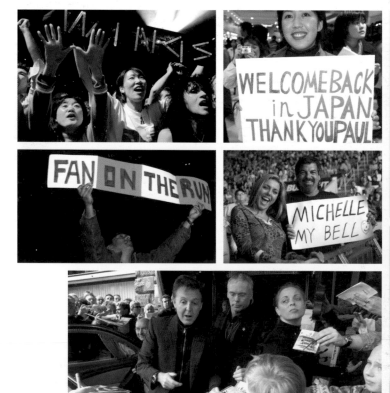

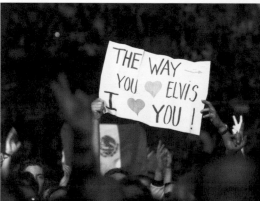

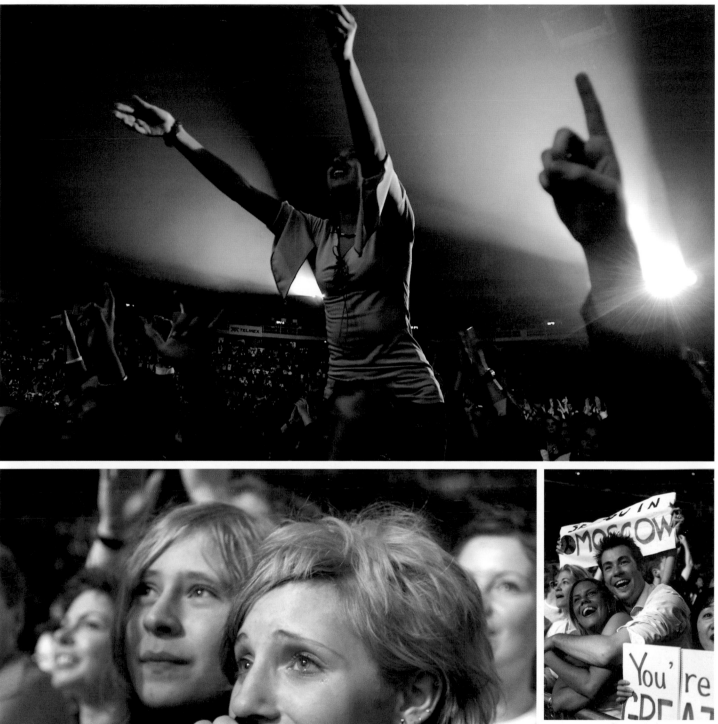

(Above, left, and previous two pages) Fans all over the world declare their dedication — whether in words, gestures or pure expressions of emotion.

The events at Palacio de los Deportes on the night of Saturday, November 2, 2002, stun not only the residents of Mexico City but the entire crew. The Beatles never played Mexico, and Paul has only performed there once before—just two gigs ten years ago. But despite the frenzied expectation, nobody anticipates how berserk the 17,511 crowd will become in their collective mania and tears of joy. The crew's astonishment at the scenes is heightened by watching young parents in the crowd holding babies—not toddlers, babies—above their heads to share the experience. When Paul, solo on stage, sings Every Night, most of the crowd take out cigarette lighters to flick the flames on and off in beat to the song. Paul is so amazed that mid-song he stops singing and, with just the snap of forefinger and thumb, conducts this Light Orchestra through the middle eight in perfect rhythm. The veteran of all and anything rock-and-roll, Production Director Gerry Stickells weeps "because it reminded me so much of the old days." After the close of the show, Tour Director Barrie Marshall says, "This is the happiest I will ever get in my life." Jenny Marshall adds, "When you get a night like this, the whole of your life makes sense." Creative Consultant Robby Montgomery believes "just to be here is all that will matter," and Paul's assistant John Hammel remarks, "It was like a Beatles audience; you can't beat that."

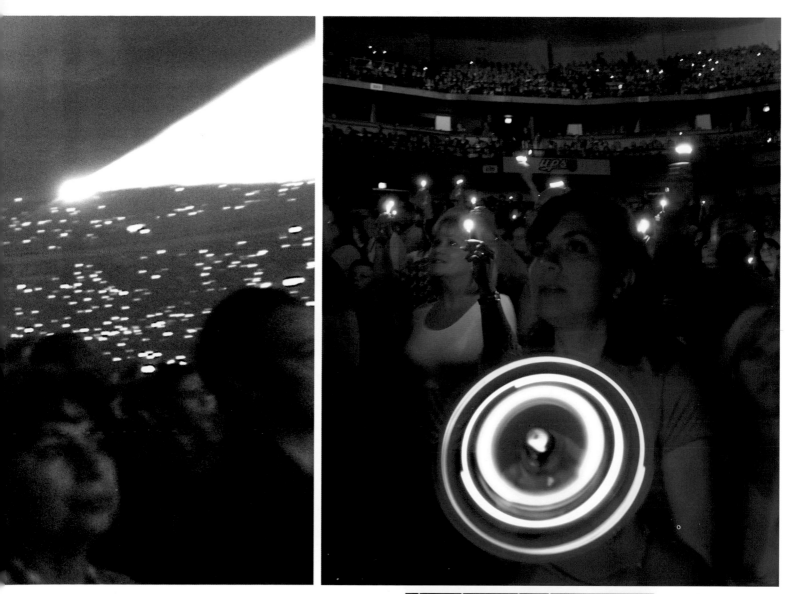

"PAUL McCARTNEY'S CONCERT WILL BE THE MOST LEGENDARY IN HISTORY FOREVER."

The Excelsior *newspaper, Mexico City*

"There is still a light that shines on me": The fans respond to Paul and his band in a universal language (from top left to bottom) at shows in Detroit, Mexico City, Anaheim, and Cleveland.

КОМСОМОЛЬСКАЯ ПРАВДА

26 м

27 миллионов экземпляров в месяц в России и СНГ

самый большой тираж

ОСНОВАНА В МАЕ 1925 г.

№ 92-п (23037-п)

московский еженедельный выпуск

Рекомендуемая цена в Москве - 5 рублей

прог

AY
IF I AM RIGHT

YOUR WAY
T WE MAY FALL AP
NG

See It Your Way

Roman ghosts, good soups, the Russian president with half a dozen KGB men

ROME WASN'T BUILT IN A DAY. BUT McCARTNEY CAPTURES IT IN A NIGHT. *A gig at the ancient Colosseum was always going to be a tall order, even for the awesome organizational machine of this tour. It's a challenge to play a site so charged with history and symbolism. But later the triumph of Rome is perhaps exceeded by the most ambitious gig of all—Red Square in Moscow.*

Paul: This is very special. I've been there as a tourist, when I was in Rome. You know, you go to see the Colosseum. There's a huge sense of history and wonder. And to come now and add another element to it, which is me and the band playing … it'll be very special. We're really looking forward to it. We're doing the two shows: the one inside and the one outside. I'm looking forward to both of them, but the one outside will be nice because it's free for people, so we could have all the Italian people out there. It's great to combine the two, the history and the music. It'll be the first time we've played in there, the first time anyone's played in there. Really cool.

We're doing an acoustic kind of set. It's a little bit quieter really, so we don't knock the Colosseum down. It would be a pity, after all these years. No, we're just doing a special set. A little bit more intimate, one or two surprises that we don't normally do just to make it a little bit different from the usual show. We haven't got the big screens, which we'll have outside, so we're just gonna make it a bit more simple.

Brian: In my whole life I could never imagine being here playing at the Colosseum. First pop show in 2,000 years. *(Laughs.)* Amazing. And then on top of that to be able to play here with Paul McCartney, you know, it's like more than a dream come true.

The day after the first concert at the Colosseum.

Reporter, Rome: Can you tell us what was the feeling yesterday, inside?

Brian: It was, I know this word gets used a lot, but it was *magic.* When you enter across the floor, when you look down at the catacombs inside the Colosseum, and you're walking along and you imagine so many years ago what was going on in there. And you look at ruins around you and the way that the lights were coming up, it was just, oh my heart was very full, you know. It's just *Wow!*

Reporter: You know that centuries ago inside there was a very dramatic show, because of the suffering of Christian people. Maybe the music can transform history in a new vibration.

Brian: That's a wonderful thing to say, and it's funny you should say that, because as we were driving to the venue with Paul, he said, "Yeah, a lot of Christians died here." He says, "Maybe we have a chance to come here and exorcise the ghosts of many people who suffered, and some animals too. And maybe change the energy a little bit for the better." I remembered during the show watching some birds flying by at night. Usually you don't see birds flying at night, and I thought to myself that this was just an example, maybe, of exorcising ghosts.

Reporter: Would you consider this concert one of the high points of your brilliant tour?

Brian: There is no doubt about it, you know. You'll stand up there and play the most amazing songs maybe in our history, with the most important writer of our time, and in this venue. You're up there, and you've got many things going on. You've got your job, you're singing and you wanna be in pitch, and you wanna play the right notes, and the lights are coming and you can't see the neck, but you have to get above all of that and just look around you, and say, "Oh, my God, it's come to this. I'm playing with Paul McCartney in the Colosseum and look at this beautiful night and these beautiful people, and it's incredible." Yes, you have to take a second to get above the mechanics and see the experience, you have to remind yourself to do that, because it is magic.

TV Reporter, Rome: What do you love about Italy?

Paul: Pasta. Food. Italian cooking. Very good. If you're vegetarian, Italian cooking is great because there are so many beautiful vegetable dishes. So many good soups. Super.

(Below) An
altogether
magnificent
monument.
The Colosseum is
looking good, too.

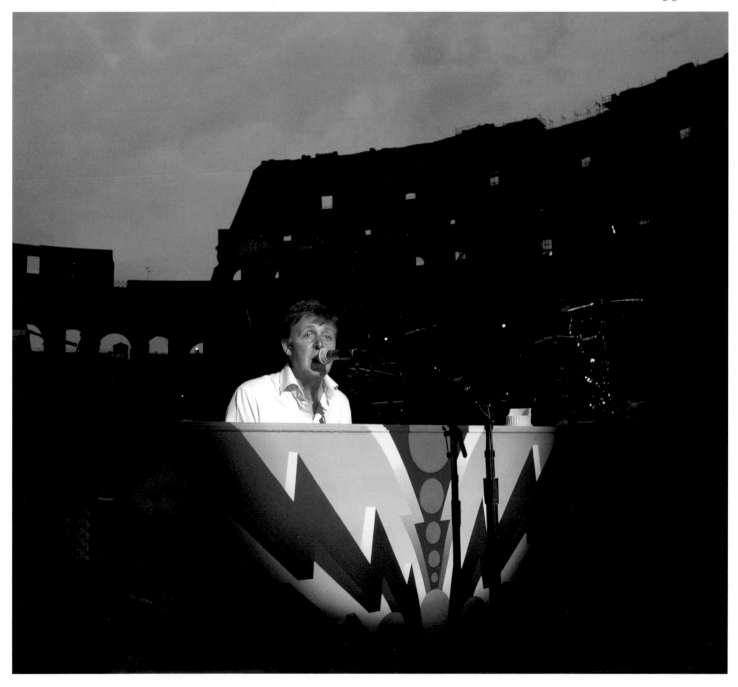

Paul's concert inside the Colosseum on May 10, 2003, marks the first time that rock songs have been performed inside the ancient monument, which was built in AD 75. However, the set has to be performed acoustically because the authorities fear that the million-watt McCartney show could bring what remains of the old walls tumbling down (not for fear that it would keep the Pope awake, as mischievously rumored by the tour press office). Built over three years by 40,000 slaves, the Colosseum is accustomed to loud crowds. In its heyday as the venue for the earliest arena shows, crowds of 50,000 were entertained here.

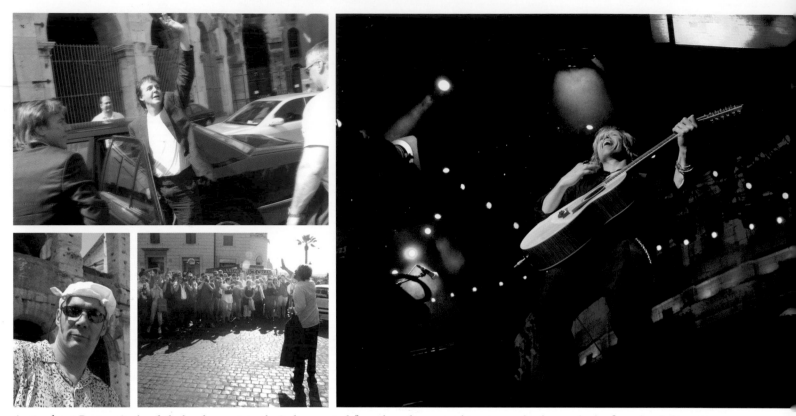

Arrivederci Roma. *Paul and the band sweep into the Italian capital for a show that proves historic even by the standards of an already historic tour.*

Italians are great cooks, as you know. I love the music. I love the people. I think they're very passionate. And I like the fact that there's a strong love for family, a strong human bond. If you ever talk about a good mother, a good family, you talk about an Italian family, or maybe a Jewish family. But, you know, Italians are known for being good, strong, passionate people who love each other. Well, I'm sure they all don't love each other. But you know what I mean.

TV Reporter: What Italian music do you love?

Paul: Some of the great operas or just some of the great tunes. Just some of the old classics. When you think of a tenor … *(Sings.)* You think of him singing in Italian. So that kind of thing is beautiful. A lot of beautiful old melodies. We used to see a lot of Italian bands when we were working in Hamburg. In all the clubs there'd always be Italian bands, and they would always be a little bit smarter than us. They had suits on and we had jackets. They always had good microphones with echo on. They were good bands. I used to like Marino Marini when he was a hit in England, and I used to do one of his songs.

TV Reporter: What is, for you today, a song?

Paul: A song is a special combination of a few elements. For me, I like it to have a beautiful melody, because even if you're not singing the words, there still stands a song. I like it to have some good words if it's a song, you know, to be sung rather than just played. I think it's a combination: a beautiful melody, interesting, beautiful words, maybe a good title helps. And something that just means something and makes you feel something special.

TV Reporter: Is it possible for you to say to the Italian people, *Via specto a Coliseo*— "I expect you at the Colosseum"?

Paul: Via specto.

TV Reporter: Via specto a Coliseo.

Paul: Via specto a Coliseo. Pronto.

TV Reporter: You are a gladiator.

Paul: I am now. I'm Christian. That's a start.

TV Reporter: It's possible for you to make a "Ciao" to a young boy, he loves you. He …

Paul: What's his name?

TV Reporter: His name is Simon.

Paul: Simon.

TV Reporter: Ciao, Simon.

Paul: Hey, Ciao, Simon. Va bene. Grazi. Finito.

TV Reporter: Thank you, Paul.

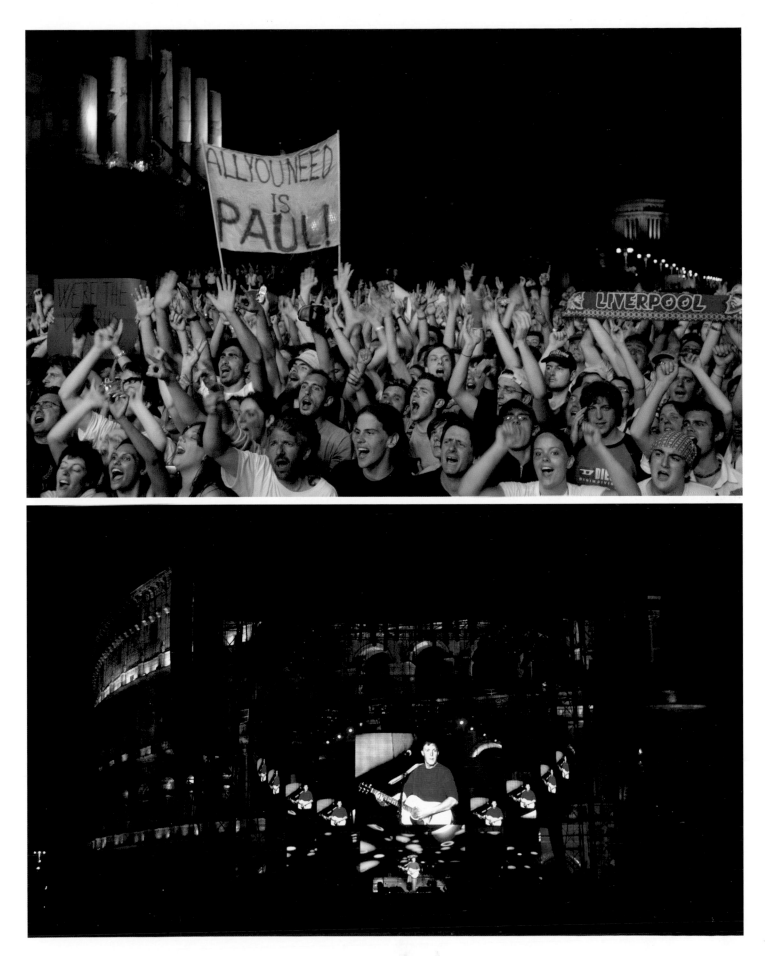

Paul's concert at the Colosseum in Rome on Sunday, May 11, is his second at the ancient arena. The night before, he played for an audience of just 300 people. "McCartney Makes Magic at the Colosseum," reads the front page of La Repubblica. Paul's concert outside the Colosseum walls has been in the planning for two years. At the outset, Tour Director Barrie Marshall was told that the Sunday night show could attract up to 300,000 people. This would be a career-best for Paul McCartney, who had played to 56,000 at Shea Stadium in 1965 with the Beatles, to 67,000 at the Seattle Kingdome in 1976 with Wings, and to 184,000 at Rio's Maracana Stadium in 1990 during his solo period.

However, crew enthusiasm for potentially setting a record at the Colosseum show is dampened just days before when the Italian promoter tells the McCartney

press office that it would be rash to expect a crowd of more than 100,000. The promoter's pessimism is unfounded. By the time Paul and the band take the stage, more than a mile of people stand before them, and the mayor of Rome officially announces that the crowd exceeds 500,000. When most of them hold cigarette lighters aloft in tribute during Let It Be, the sight is one of great wonder. As Paul describes it—"street lighting." The headlines the next morning carry the flame: "Half a Million Encore Paul—A Better Concert You'll Never See," La Stampa; "The Concert of the Year—McCartney in Street of Glory," Il Tempo; "Paul Enchants a Sea of Fans in Night of Magic at the Fori," Il Messaggero; "Huge Crowd Invades the Fori for the Event of the Year," Corriere Della Sera.

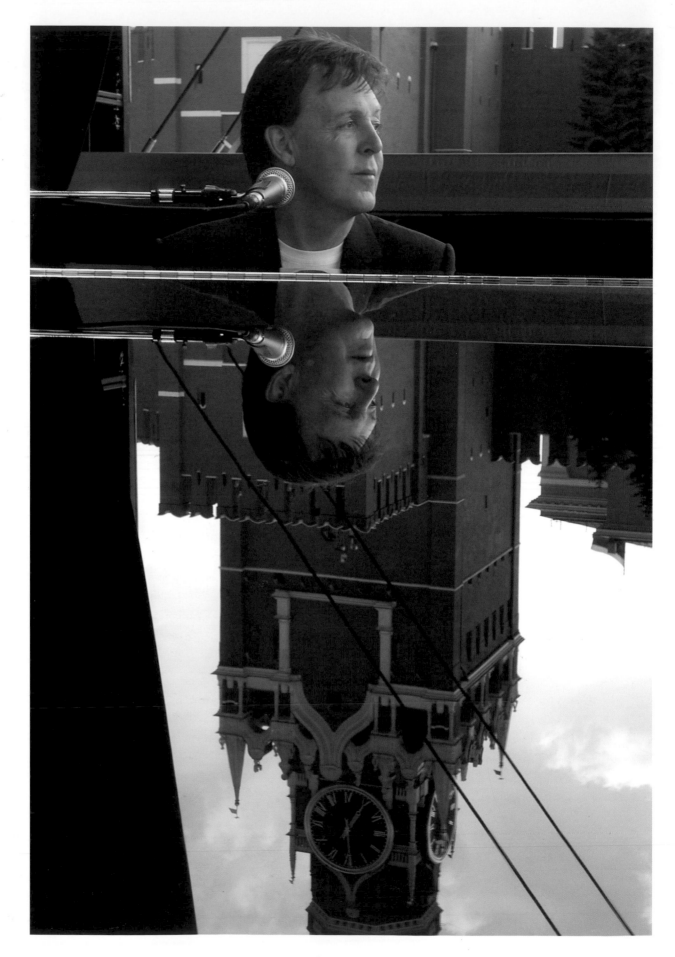

"BEATLEMANIA HAS FINALLY MADE IT TO MOSCOW …"

COME AND KEEP YOUR COMRADE WARM. *The Beatles have passed into history. But so has the USSR. Finally, Paul McCartney gets to perform in the land where his records were once condemned as agents of subversion, and his Moscow concert becomes a media event of global proportions. In the words of just one broadcaster:*

Newcaster, Chicago: He's been singing about it for more than 30 years, and tonight, for the first time, Sir Paul McCartney brought the Beatles music to the former USSR. McCartney took his world tour to Moscow's Red Square tonight, something he's wanted to do since the eighties, but authorities refused him until now. In the words of Russia's president, Vladimir Putin, "Back then Beatles music was seen as alien propaganda." Well, tonight the president joined the sell-out crowd as a fan … Now Paul McCartney really is back in the USSR.

(Opposite) Sound check in Red Square: The gig represents a milestone, not only in the tour, but also in McCartney's career.

Paul: I'm excited to be in Russia because of its great history. We get to play in Red Square—that's been a sort of dream for a long time, you know. I think there was some talk, I'm not sure when, maybe 20 years ago, that we could play in Red Square, but it fell through. So it is something we've been thinking about and we've been imagining …

When I was growing up in England, we would always look at Russia and wonder how the people were, and we never knew what they were like because there was a kind of media blackout. But then when we were in the Beatles we started to hear that many people in Russia were Beatles fans, so that was very exciting for us. When the Iron Curtain came down, it was very exciting to think you could go to Russia. Somebody told me that there was a rumor that we just came to an airport and did a show, but it's not true. This is the first time I've come to Russia.

We had a record made by Melodia, which was called *CHOBA B CCCP,* so it was *Back in the U.S.S.R.,* and that was a record of rock-and-roll songs. The people in America were a bit annoyed because they couldn't buy it in America. It became an import because they had to import it from

Russia. I thought that was a funny idea, you know, it's a switch, because normally the Russians have to import from the Americans. It was right at the beginning of glasnost, and I think a lot of people over here were excited that Russia was sort of changing its lifestyle. And we just thought it was good that it was getting free, it was exciting, so I thought to mark the event it would be a cool thing to do. To just release a record only in Russia. I thought it was just an exciting idea at the time. And it turned exciting because it's a collector's item. It's a sort of special album in their collection.

I had been asked to do a master class in St. Petersburg, to give something back to the Russians, before I went and did the big show. And that appealed to me, that idea. I had been asked to do that a couple of years before … So I went to St. Petersburg to the Glinka School and heard young gentlemen playing music. They all impressed me. One particularly was a guy playing classical guitar. He played a really lovely piece, very nice, without the music. It was pretty impressive, lovely tone, and it sounded great. And afterwards I said, "Who wrote that?" And he said, "I did." And I said, "OK." That was good.

Going to the conservatory of St. Petersburg was really amazing for me, for one main reason. I was actually going to now walk the steps in this day and age that Tchaikovsky walked then … It's really exciting to be in the same school that such great people as Tchaikovsky came to. It's fantastic for me. And it was such a huge honor; they gave me an honorary doctorate. You know, I mean, *Wow!*

We got a private viewing by the director of the Hermitage. He showed us through the whole place and gave us a little private history as we went. It gave me a good perspective on a section of Russian history. St. Petersburg was such a beautiful city. Little things like that made the whole journey very special.

Actually the original reason that I had gone to St. Petersburg was to help with this effort, the Menshikov, and to help orphaned and underprivileged kids. That was why I really wanted to go there: to help set up this new charity for them. To see them, knowing that they're orphaned kids … honestly, you look at each member of the choir and you know there's a story there, there's a big story. And suddenly there they are, they're singing my songs, and it's very emotional. I just got the feeling that these kids were there, giving it their best. That somehow music and this whole thing was going to maybe, hopefully, give them a better life, give them something to look forward to, something to aim

In and around
Red Square, there is
a sense of cultures
clashing and yet, in
the last analysis,
becoming united as
never before.

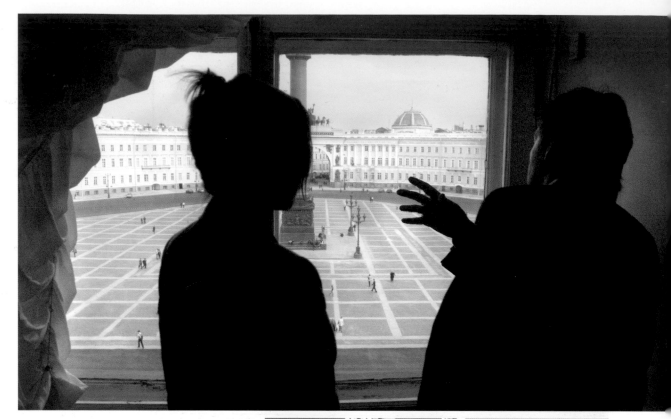

at. I turned quickly to Heather and she was welling up. What really got me was looking at them all and thinking, "They're in their Sunday best. This is it, this is their best outfit they've got on".

We had this visit with Mr. Putin, you know, which was great. It was a real honor going into the Kremlin. It was kind of slightly strange being met by a general. It was very Russian. Then walking through these miles of corridors … but then eventually sitting down and having a little chat with him, which was really nice. You got to realize, deep down he's an ordinary guy like we all are, you know, but he's an important man.

Paul: When you were growing up, did you listen to the Beatles?
President Putin: Yes, it was extremely popular. It was like a gulp of freedom. Your music was like an open window to the world.
Paul: It was banned by the authorities, yeah? I understand.
President Putin: It was considered at this time a propaganda of some alien ideology.
Paul: Maybe you know that Heather and I campaign against land mines. Do you know this?

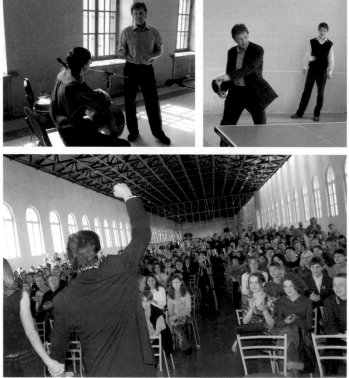

Before rocking the Kremlin in Moscow, Paul takes in the imperial splendors of St. Petersburg (top) and then visits the city's Glinka School for musically talented orphans. Keeping a promise made years before, Paul gives a personal master class to the children (not omitting a refresher course in table tennis).

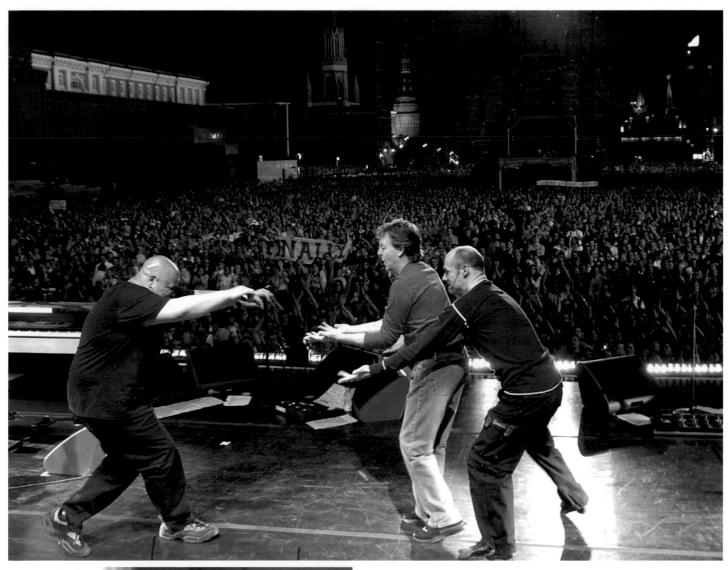

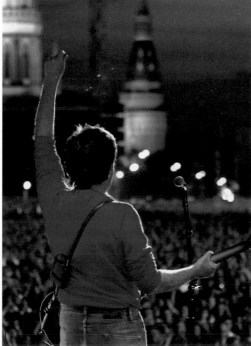

"IT WAS LIKE A GULP OF FREEDOM. YOUR MUSIC WAS LIKE AN OPEN WINDOW TO THE WORLD."

President Putin tells Paul McCartney
what it was like growing up with the Beatles music.

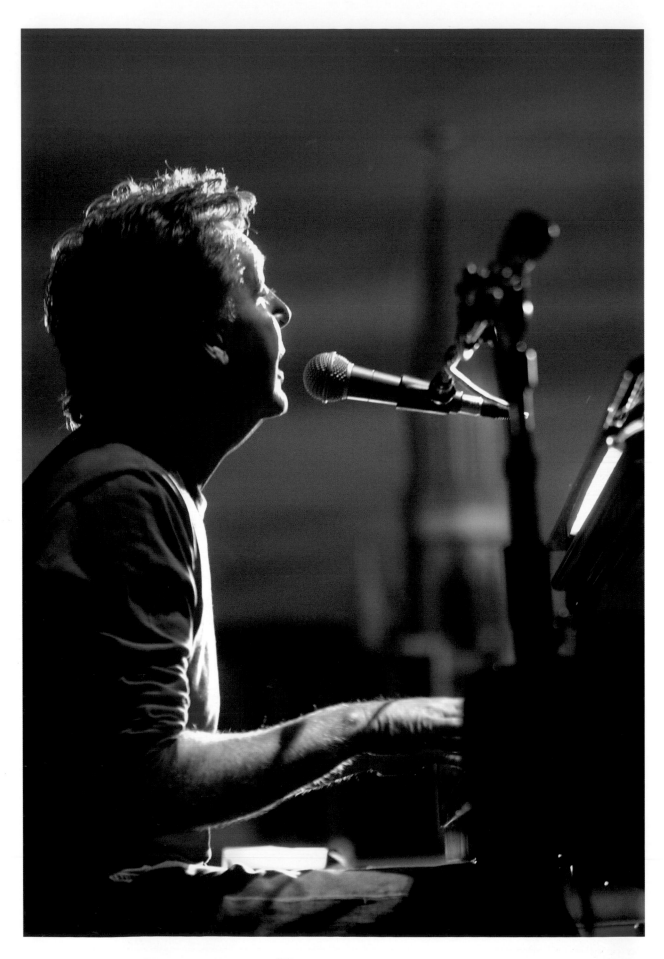

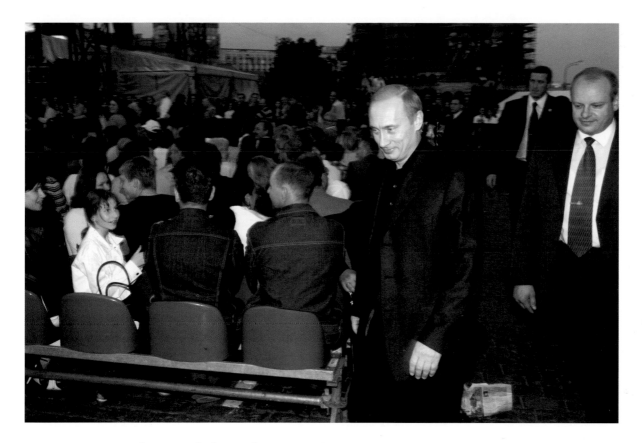

President Putin: Yes, I know. And I know that your wife is very actively involved in that.

Heather: Do you think one day Russia will be able to join the ban treaty or do you find it too restrictive?

President Putin: I think that anything which is aimed at saving peoples' lives deserves our utmost attention and support.

Paul: He showed us around other bits of the Kremlin. He told us some of the history of the czars being crowned there. I asked about Rasputin, and the lady said, "Oh, I suppose he must have been around here, because he used to hang with the royals."

Nice guy. Seemed very genuine, like most of the Russians that we've met. Said he's from a working-class family. He's got those values. No wonder the people like him … I asked him if he was coming to the concert because I thought there was half a chance that he might be. But he said, "I don't think I'm going to be able to make it." So I played him *Let It Be*. I thought, "Well, I'll give you a little private concert," you know. He was very nice, just sort of sat. And I thought, "Well, that's that. He's not coming. It doesn't matter; we're still going to do the concert."

So then we played Red Square. After so many years of looking at an audience, if someone starts to leave or somebody starts to move, or a little group of people start to do something, I notice it. And suddenly I saw a rustling in the crowd, saw a lot of people turn around. And I said, "What's that?" I could see a little phalanx of men walking in ahead of someone. So I thought, "That's got to be him." And the crowd started to applaud, so I thought, "He's a popular president; it's got to be President Putin. He's arrived." And all at the same time, I'm still singing, remembering my chords, remembering my words, and trying to keep it all together. And you know my mind is boggled, going, "Wait a minute, the Russian president just walked in with half a dozen KGB men."

For me it was just fabulous, just seeing people all stretching back there. The square was filled with people. And then me singing *Back in the U.S.S.R.,* and the place just went electric. Just like somebody put an electric current through it. And then, of course, you know suddenly I start doing the lines about Ukraine girls and Moscow girls. And I think, "Of course it's going to go down well here."

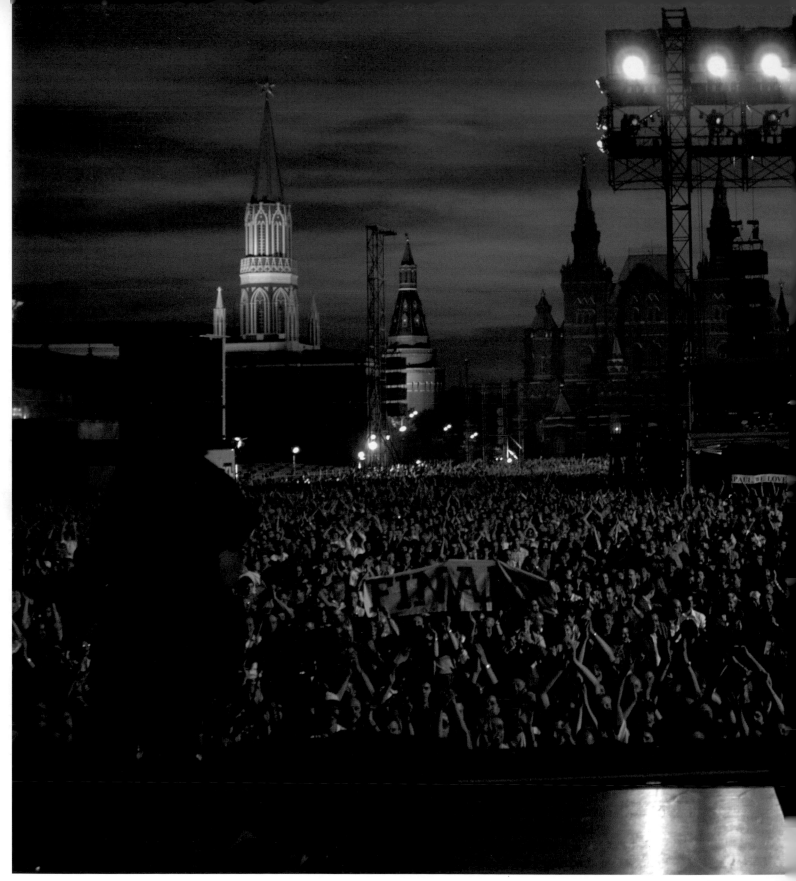

May 24, Moscow, and symbols of two contradictory beliefs stand side by side in Red Square: the Kremlin and Paul's stage. The historic event draws media from all over the globe. Correspondents fly in from the USA, Japan, the UK, and across Europe for the event: there are 45 television crews, 60 photographers, and 388 reporters. Tickets to see Paul have been set by the authorities to range from $30 to $300. Such is the lure of the night that tens of thousands have spent the equivalent of almost an average week's wages ($35) to see the show, some telling the milling TV crews on camera that they have traveled 550 miles to be there.

For weeks previous, Tour Director Barrie Marshall has argued with the Russian promoters that the 35,000 set capacity will be insufficient. His point is proved on the night when the crowd swells to 95,000, filling Red Square. Among them are President Putin (for whom Paul will reprise Back in the U.S.S.R. at the end of the show, after noticing that the president missed it the first time due to his late arrival) and former President Mikhail Gorbachev. Wary of a Chechen outrage, Spetznaz special forces mingle with the crowd and snipers are positioned on the roof of the Kremlin. Although leftist and nationalist

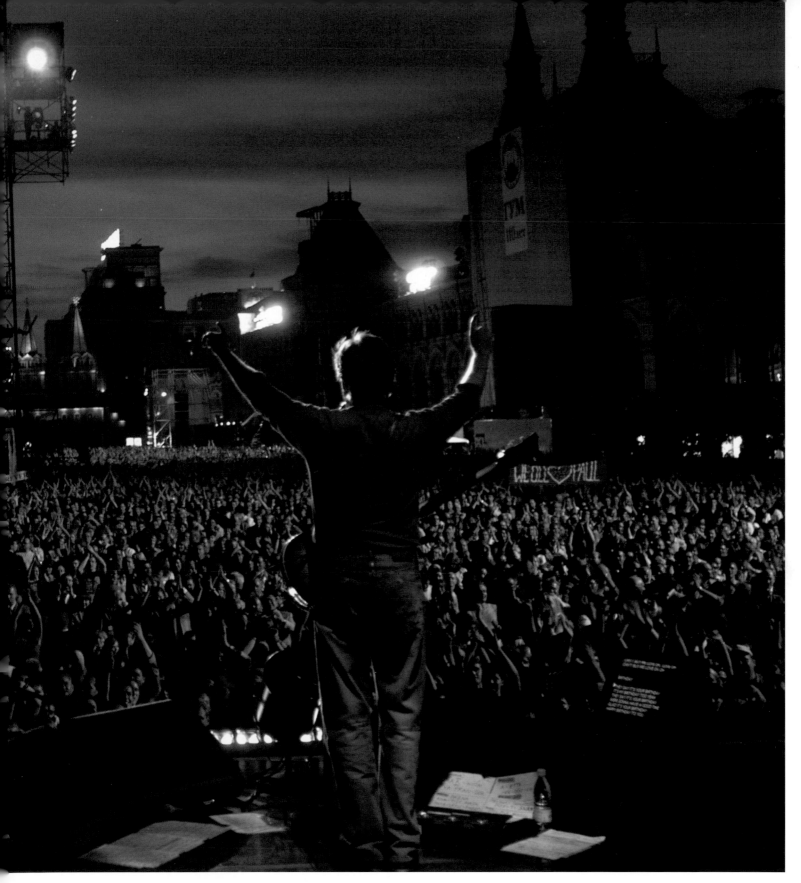

deputies in the Russian parliament have previously opposed the concert—on the grounds that it will be an affront to the memory of Lenin, whose tomb stands just yards from the stage—as the Russian media will later note, a night of national joy is landmarked.

"The only person in Red Square who wasn't moved was Lenin," says the MK News; "All they need is love and Paul—we have seen McCartney and now we can die," claims Izvestia; "McCartney brings Beatlemania to Red Square 40 years after the rest of the world," reports the Russian Newspaper; and Komsomolskaya Pravda states, "McCartney storms the Kremlin. He is the victor."

See How They Run

Bathrobes, mayors, and the power of this tour

NOTHING BEATS THE ELATION OF ANOTHER SUCCESSFUL SHOW. *At the end of each night, the champagne is already chilling as the last chords die away, in readiness for Paul and the band to board the bus and make their getaway.*

Brian: We come off the stage and we are put into a bathrobe, each of us into a bathrobe, and we walk straight onto a bus, and we'll drive with Paul and Heather and some of the security team and go to an airport or to a hotel. Paul will usually take a private flight and we'll continue on, but on that ride for those 20 minutes or so between the gig and the airport, there's a lot of laughs, and a lot of congratulations, and a lot of Dom Perignon. It's just a good time. Everyone's really up for this. We might go over something that was funny in the crowd: a certain sign that was in the audience, or what someone was wearing in the front row. It's just a gig and we're all talking about the gig. We've all got our own stories about what happened on our side of the stage. It's just fun, you know, it's just fun.

"Dublin is bubb'lin," Paul tells the 40,000 crowd at RDS Stadium during his first concert there since the Beatles. As Band Party Bus 1 leaves the gig (below), the local Evening Herald newspaper prepares to print a review that will close with the words "one fan was only slightly exaggerating last night when he said the show was akin to hearing the Bible read out by Jesus Christ."

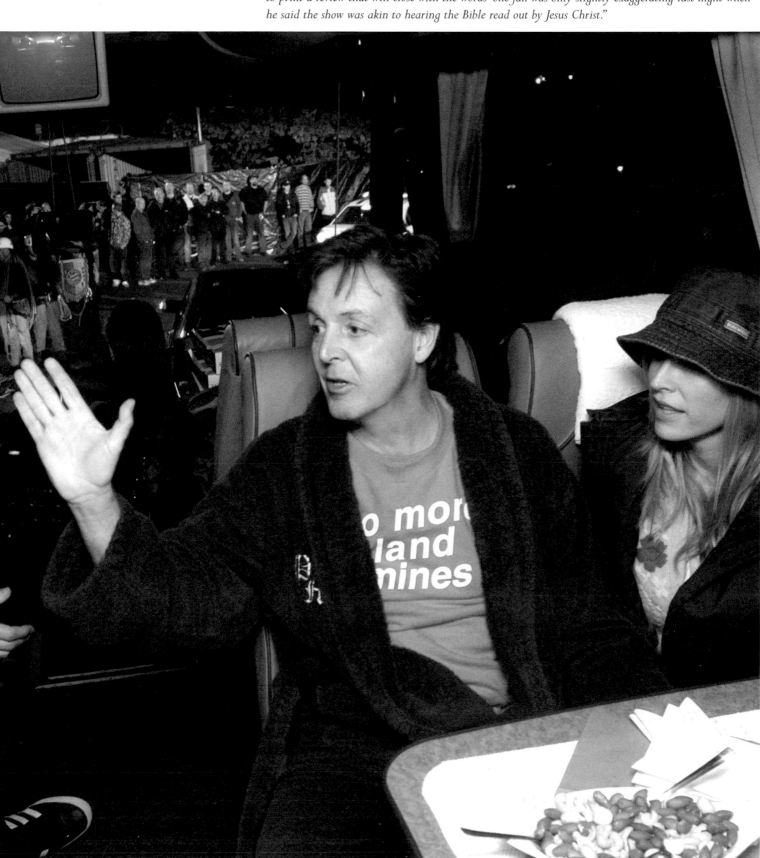

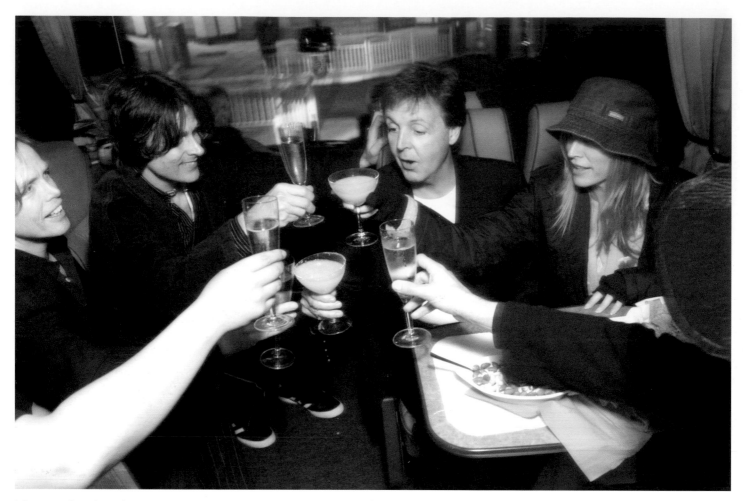

The scene aboard Band Party Bus 1. Champagne, bathrobes, and the slap of palm against palm are each intrinsic to "the Runner"— the safe removal of Paul and his party from the venue to their destination for the night.

ANAHEIM, CALIFORNIA: PAUL AND HEATHER AND THE BAND RELAX EN ROUTE TO THE HOTEL ON TOUR PARTY BUS 1. *Following in convoy on Band Party Bus 2, the backroom boys are far too hyper to calm down.*

Robby Montgomery, Creative Consultant: Too early for me to have caffeine, I won't get stressed enough if I have it now. Need to wait a couple of hours. I tend to find that a double espresso just before bed usually does the trick …

Bill Bernstein, Tour Photographer: Why'd ya do that?

Robby: Do what?

Bill: Drink coffee when you're going to bed? Doesn't that make it kinda hard to sleep?

Robby: Yup. That's the point, Bill. I don't like to be calm. Calm is crap. Stress is good; helps me concentrate. If I get the correct amount of sleep, I get calm and then I can't think. Trouble is that this fucking tour is going so fucking well that it's getting

kinda hard to stay stressed. I'm thinking of buying new shoes one size too small …

Paul Freundlich, Tour Publicist: Hey Rob …

Robby: What?

Paul F.: Hate to ruin your night with more good news, but did you see this? Early word on the *LA Times* review …

Mark Haefeli, Film Director/Producer: That Hilburn's?

Bill: Hilburn? Bob Hilburn? Isn't he meant to be like some real hard critic or something? Like you read him and then you phone the Samaritans?

Paul F.: Yeah, he's hard—he's got a fucking hard-on over this gig. Get this: "To get the most accurate sense of a concert's worth, it's normally wise to discount about 25 percent of a fan's enthusiastic report in the days after the show. They are, after all, fans. However, no matter how much coworkers rave over the water cooler today about Paul McCartney's concert Saturday at Staples Center, you should *add* 25 percent"!!

Catching a broadcast of Access Hollywood, *taped a week earlier, on Band Party Bus 2.*

(*General raucous shouting and gimme-five slapping ensues.*)

Paul F.: Hey Geoff—what'd ya think about this thing in Atlanta with the mayor?

Geoff Baker, Press Officer: The Paul McCartney Day thing?

Paul F.: Yeah. Think we should do it?

Mark: What's Paul McCartney Day?

Geoff: The mayor wants to make it Paul McCartney Day on the day of the first gig, 'cos like it's a big deal that we're going there.

Robby: Every day is Paul McCartney Day …

Paul F.: Think we should do it?

Geoff: Yeah, it's cool. What's he want, meet-and-greet and a quick photo?

Paul F.: When shall we do it?

Geoff: I guess as usual, after Paul's changed, before he goes to the stage. But we'll have to be quick. Phil [Kazamias, Tour Manager] has been leaning on me a bit about all the meet-and-greets. They're eating into the time he's got before the gig, making it all too rushed, apparently.

Bill: You do cut it close.

Geoff: I know, but what can you do? All these people want to see him. You hear about the flag? Paul wants us to get everyone on the crew to sign that American flag that he waves every night. Like a memento for him. We've all gotta sign it.

Bill: Is that allowed?

Geoff: Is what allowed?

Bill: Like signing the Stars and Stripes? Are you allowed to do that? Isn't that like some big irreverence?

Paul F.: That's setting light to it; you can't set it on fire.

Geoff: Listen man, the way America's getting into this gig, he could fucking set fire to Atlanta if he felt like it, like in *Gone with the Wind.*

Mark: Gone with the Wings …

Geoff: I tell you, man, it's the power of this tour.

Keeping Perfectly Still

A riot, constantly surrounded, mobbed …

EVERYWHERE IS DIFFERENT. *Life inside the bubble of a tour can become an insular experience. But such is the stir that Paul McCartney creates, that each stop of this tour has exceptional moments and specific security requirements.*

Mark Hamilton, Security Director: This is my third world tour with Paul McCartney, so I had a number of previous experiences to compare it to, but there is a special feeling about each show that you can detect from everyone in every country. In the USA it was the genuinely enthusiastic way fans and security staff reacted and responded.

The amazing transformation in the Japanese, who became much less physically and verbally restrained without losing their capacity to be polite, was clearly demonstrated by the way they reacted to our arrival (a riot), our stay (constantly surrounded and/or chased), and our departure (mobbed up to the departure gate). The magnitude of the Rome concert was

Me and my shadows. Paul poses with his security A Team— Charles Bayford, Mark Hamilton, Missy O'Linn, and Brian Riddle.

"THERE ARE OVER 500,000 PEOPLE IN THE STREET … EVERYONE IS HAVING THE TIME OF THEIR LIFE IN SAFETY. IT CAN'T GET ANY BETTER THAN THIS."

Mark Hamilton, Security Director

up there with Paul's 1990 Maracana Stadium concert in Rio for sheer scale and energy. My experience has taught me to make sure that there was a way of closing the main street where the audience would stand facing the stage and Colosseum. Everyone thought this was unnecessary, as the street would easily hold 300,000 people. On the night, the promoter asked if everything was OK. I pointed along the street and calmly replied, "There are over 500,000 people in the street and beyond, the street is closed as I requested, everyone is having the time of their life in safety. It can't get any better than this."

Security for the concert in Red Square took on special significance for many reasons, and wherever we went the crowd reacted with an intense fervor. My observations during the reconnaissance visits were that once they all got over the shock of seeing Paul actually in Russia, everyone involved would rise to the occasion. The fans, the scores of soldiers manning crowd barriers, local security staff, President Putin's own security team, all got involved enthusiastically to make this a concert to remember for all of Russia.

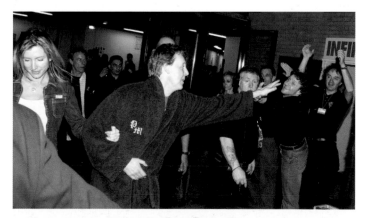

(Left) Top security in Tokyo. Nobody—but nobody—is getting close to the crew's egg and chips. Meanwhile, Paul proceeds in his customary bubble of attention: in Sheffield (top) and in Paris (bottom).

Ride in the Sky

On wild times, cufflinks, and lessons

IN THE TRAVEL DEPARTMENT, EVERY DETAIL MATTERS.
*Organizing the travel schedule for this band of gypsies and their
130-odd entourage is a logistic migraine for Travel Director Mike
Walley and Travel Co-ordinator Michele Lawley. Not only do the
entire band and crew parties have to be in exactly the right town
at exactly the right time by various transports of buses, vans, trucks,
limos, town cars, scheduled aircraft, and chartered jets, but once
they have got to wherever they are meant to be, they must then be
accommodated. While some of the crew sleep in their bus bunks on
occasional overnight journeys, during the course of the tour the Travel
Company book the entourage into hotel rooms for about 20,900
nights in total, at an approximate cost of more than $4 million.
Besides booking hotels, Mike and Michele must also ensure that each
establishment can accommodate the tour's "special requests." Chefs
have to be fully trained in the rapid presentation of fine vegetarian
fare, and the hotel kitchens must be capable of preparing a choice of
main courses and desserts for up to 40 people, who will not be ready
to eat until midnight at the after-concert suppers Paul frequently
hosts. In addition, the Travel team must preview each room Paul and
Heather occupy—their suites have to be nonsmoking with windows
that open. On rare occasions when the windows are sealed, John
Hammel's ingenuity is called upon (John being adept at removing an
entire window frame using only a penknife). Potential crowd chaos
dictates that Paul cannot emerge through arrivals at a city's main
airport, so secret landings at private airfields in chartered jets have to
be smoothly arranged—along with the unusual request for a convoy
of vehicles to get authorization to meet the plane on the airfield
tarmac and for the frequent Customs waiver.*

*Traveling in style aboard a chartered airliner, converted for comfort
to boast sofas and recliner armchairs instead of the usual restrictive
rows of seats, Paul, Heather, the band, and Band Party A leave
Detroit en route for Paul McCartney's first concert in Los Angeles
since 1993. As all tickets for the Staples Center show—a hometown
gig for Abe, Rusty, and Brian—have sold out in 27 minutes, all
aboard are in high spirits. Buoyed also by his recent induction as an
official New York detective, awarded for his work for the Concert for
New York City, Paul roams the plane playfully busting miscreants
and, on discovering that the trays of inflight meals have been
accidentally left on the tarmac, administering retribution in
the form of the feigned thrashing of Mike Walley.*

Pilot: I've been a fan of him since '64.
Security: Have you really?
Pilot: Oh yeah. No turning back. We're going to drop off these
folks, then we will go back to Las Vegas …
Security: You missed a good show man, fantastic show.
Pilot: Spread the word that anyone who wants to come up if
they're not sleeping is more than welcome to …

Band: Happy Holidays.
Heather: Look at you. You've got a jolly face.
Paul: Wow, configuration.
Heather: Get on the couch. This is the quietest part of the ride.
Paul: The quietest, the coolest, the rockingest.
(Paul wanders around the plane and then returns.)
Heather: You missed all the jokes.
Band: You missed all the jokes.
Paul: I want them back.
Heather: This is the other side of him. It's not the public side.
Band: Having a wild time man! Yeah!
Paul: I love it. Alright!
Heather: That was it.
Band: Let's act real wild for the camera. Oh, camera. You got a
beautiful shirt on, beautiful cuffs, nice cufflinks, and a black
T-shirt over it. That's rock-and-roll. That's what it's all about.
Paul: You've always been known as a fashion plate. Well, John,
you are a bit of a fashion plate.
John Hammel: To "20" man.
*(They toast the 20th house record broken on the second leg of the
US tour.)*
Paul: Cheers, man. Wow. Great old tour. Great. Really great.
Loving it. Having a fabulous time.
Rusty (reacting to camera): I'm not at liberty to … hey … wait,

I'm building mystique. I'm the shy one. It's not going away!

Abe (reacting to camera): I'm very uncomfortable right now. It's like some alien eyes are looking at me. Don't know what to do with myself.

(Brian picks up his guitar.)

Heather: When did you start playing guitar, Brian?

Brian: When did I start playing guitar, are you serious? It was the Beatles, actually, that made me want to play guitar.

Heather: What's it like playing with one of them?

Brian: God, good question. Um, geez. It's exciting, what can I tell you? It's … incredible, it's amazing. It's a gift.

Heather: When did you start playing drums, Abe?

Abe: I got my first drum set when I was four. And there's, of course, pictures of me at 18 months with pots and pans and headphones on and wooden spoons. So yeah, I started playing officially I guess when I was four. Jamming with my dad. And listening to the *White Album*. Thank you, for that.

Paul (reacting to camera): I'm under contract, the exclusive's been given. I'm sorry. Turn the camera off, please. *(Paul goes into a rendition of* Tutti Frutti.*)* I never looked back. I ain't never looked back, no more. This is it baby, this is rock-and-roll. This is the only thing.

(Paul plays at being angry and "punishes" Mike Walley for the food mishap by pretending to administer a headmaster-style thrashing.)

Paul: The food was on the bus! There's no food for anyone. He's loving it, he's loving it! Unfortunately, he's loving it! *(Laughter.)*

This was supposed to be a punishment. He's loving it. *(Laughs.)* Oh my God. Who needs food at a time like this? We need more wine. This is the two-mile-high club. That was the bad news—there's no food on this flight. The food was left on the bus. Who needs food? That's what we do to these lads. If there's not enough food in here, that's what they get.

Rusty: Let this be a lesson to you.

Paul: Let this be a lesson to you, lad. You'll never eat again …

Across its three legs, the tour travels a total of 94,036 miles, driving to and from 91 shows through 60 cities in 26 states of the USA, plus Canada, Mexico, Japan, England, Ireland, France, Spain, Belgium, Holland, Germany, Denmark, Sweden, Italy, Austria, Hungary, and Russia.

IN ST. PETERSBURG, RUSSIA, DAYS AHEAD OF PAUL'S ARRIVAL, MIKE WALLEY NEGOTIATES TRAVEL ARRANGEMENTS WITH LOCAL ORGANIZERS.

Mike Walley, Travel Director: There's no private airfield we can use? When we arrive at the airport, can we arrange for special clearance at Customs and Immigration? And also, we'll need to get a police escort to bring us into town.

Russian hotel representative: Excuse me?

Russian promoter's representative: The security arrangements have been done already.

Mike: OK. Right. Fine. What about the cars?

Hotel rep: Yes. I'll show you the cars that we have parked now at the front of the main entrance. One thing … regarding his suite. The suite is occupied now. It's occupied until the 11th of May.

Mike: Can I just look at it? When the occupants are out? Can I see it if they're out?

Hotel rep: I'm so sorry, sir, but I cannot do that.

Mike: You can, actually.

Hotel rep: I can?

Mike: Well, nearly every other hotel in the world would just let me look in.

Hotel rep: But if someone is staying in the room …

Mike: Yes, I know, but if you could ask the people …

Hotel rep: I could ask my general manager regarding that.

Mike: Yeah, if I could just be let in the room for a minute. I would be escorted by someone. I know it's personal but it would be good.

Hotel rep: I will check.

Mike: That would be a good idea. I just want to see it. Also I want to see the floor plan, and the food and the cars …

Hotel rep: Would you like to see the other suites available, as an option?

Mike: No, I want to see the best presidential suite you have.

Hotel rep: But that is the one that is occupied by the King of Malaysia.

Mike: Yes, that's the one I want to see. I really want to see it.

Hotel rep: I understand … I understand that's why you're here … that is your mission.

Mike: Yes. The Imperial Suite. I want to see it. What about transportation? Do you have a stretch limo?

Hotel rep: Yes, we do. We have one stretch. We have a BMW limo. The hotel has the following cars: we have one stretch and we'll have three BMWs of the seven series.

Robby Montgomery, Creative Consultant: Is that the new seven series?

Hotel rep: Brand new.

Robby: New, right?

Hotel rep: It's about two months old. Then we have four Volkswagen cars. It's like Mom's car, you know? Like it's comfortable.

Mike: You're not saying it's like a Beetle?

Hotel rep: No, no, it looks like a minivan.

Mike: That's fine.

Hotel rep: Then we have a stretch Volvo, which is a little bit old-fashioned …

Mike: How little bit?

Hotel rep: It fits 12 passengers.

Robby: Yeah, right …

Mike: Well, we're going to have loads of luggage.

Hotel rep: I do not know how much luggage it can take.

Mike: You can get a baggage van, can't you? That's no problem?

Hotel rep: Actually we'll have a baggage van, which is good for the baggage but not for the passengers.

Mike: That's fine. Security … security will have their own vehicles, won't they?

Hotel rep: Yes.

Russian promoter's rep: I don't know if you want to check this but the cars often have the name of the hotel written on their side.

Mike: Good point. Do the cars have any advertising on their sides?

Hotel rep: A little writing.

Mike: How big?

Hotel rep: Well, it's on the front door … it's … I wouldn't say that it's big. It's like a logo, like a …

Mike: Does it come off, though? Does it peel off?

Hotel rep: I don't think so.

Mike: Is it on all the cars?

Hotel rep: Of course.

Mike: That's not a good idea.

Hotel rep: I know.

Mike: So we have to find cars from someone else. What's another company you would hire from?

Hotel rep: Err, well … there's another company that's a local company with local cars. But they are not like international cars. There are several companies which have very nice BMWs, very nice Volvos, some which are used during the official visits of presidents.

Mike: OK, but they can't have any logos on them. You'll have to

bring them in. I'm sure that your concierge can do that. And we'll get five regular cars.

Hotel rep: Five?

Mike: And [Film Director] Mark Haefeli might need a passenger van, for the cameras. Alright, let's go with two passenger vans. How many people have we got coming? I think we've got 14 coming ... Paul, Heather, band, Mark's team, Lady Martin. Let's go with one stretch, five cars, two passenger vans, and a luggage truck. When we land at the airport, will they come to the tarmac or will we have to go through Immigration?

Hotel rep: Paul will not have to go through. I do not know about the others.

Mike: The problem is that it's nice to stay as a unit, if we can all not go through together.

Hotel rep: OK, I will speak to them tomorrow.

Mike: And before we leave here we should try to get the airport to give us the immigration forms that they hand out on the airplanes, so if we can take a handful of those, we can fill them in ahead. Otherwise, when we land, we will have to do that. Now I would like to see the Imperial Suite.

Hotel rep: I would like to show you the suite for sure, but we have the King of Malaysia.

Mike: I have come all this way to see this and nobody bothered to tell me about the King of Malaysia.

Hotel rep: Because this is the second inspection. The first inspection was for security. Mr. Hamilton has already been shown the room, both rooms—125 and 123—that make the Imperial Suite. He was actually satisfied with the room.

Mike: Yeah, well, I have to see it. Just, aesthetically, I have to see it. I can take literally 30 seconds. I can go in, and you can walk in with me. I don't wish to offend anyone. I will be quick.

(They take the elevator to the Imperial Suite.)

Hotel rep: We will have to make like we are housekeeping.

Mike: Housekeeping! I'll get my brush out ...

(They knock at the door and open it.)

Hotel rep: Housekeeping! It's empty. The bathroom is over here.

Mike: It's great. Is this a double bed? OK ... the windows open, loos are clean, which is always good to know ... and we can get out. Great. Thank you very much. It was kind of you to do that.

Hotel rep: You're welcome.

Out of My Head

VIPS, VVIPs, and VVVIPs

EVEN THE WORLD'S MOST FAMOUS PEOPLE CAN BECOME A LITTLE STAR-STRUCK WHEN PAUL McCARTNEY IS IN TOWN. *Backstage in Los Angeles, celebrities wait in line for an opportunity to meet the man whose status as a legend outranks their own. No matter how important—or very, very, very important— they are.*

Michele Lawley, Travel Co-ordinator: Right now, let me talk and walk you through the hospitality … there's a room for special guests …

Robby Montgomery, Creative Consultant: Where's that? Where do guests go?

Michele: They're on another floor, three floors away, in fact.

Robby: So how do they get to meet Paul?

Michele: They don't. That's why they're special guests …

Paul Freundlich, Tour Publicist: Uh-huh. Makes about the usual degree of sense.

Michele: Listen! Guests are upstairs. Downstairs, in Paul's corridor, we've got a room for VIPs and another room for VVIPs.

Robby: What's a VVIP?

Michele: Somebody who's not a VIP.

Paul F.: How do they know if they're a VIP or a VVIP? And how do we know, for that matter?

Michele: They'll have passes.

Robby: What does a VVIP get?

Michele: VVIPs get to be in a room closer to Paul.

Robby: So the VVIPs—whoever they are—get to go in Paul's room?

Michele: No, they get to go into the VVIP room.

Paul F.: So who gets to go in Paul's room?

Michele: Nobody …

Paul F.: Should make for a fun-packed night.

Michele: That's because we're going to take Paul to them.

Geoff Baker, Press Officer: Where do we take him?

Michele: We'll all be monitoring the VIP and VVIP rooms for VIPs and VVIPs who he will want to meet.

Paul F.: Do they have passes for that as well? "Paul Wants Me" passes?

Michele (sufferingly): Now it may be that a VVIP goes into the VIP room by mistake, in which case they need to be escorted to the VVIP room. However, VIPs can't go into the VVIP room because they won't have the right pass.

Robby: The pass that none of us knows the look of …

Paul F.: What happens if a VVIP brings a friend who is only a VIP?

Michele: Use your judgment.

Robby: So explain again who gets to meet Paul?

Michele: That'll be the VVVIPs.

Geoff (taking notes): Sorry, how many Vs was that again?

Michele: VVVIPs are the VVIPs or the VIPs whom we take out of either the VVIP room or the VIP room and who are then escorted to Paul's lounge, where he'll come to meet them.

Robby: That's his dressing room, right?

Michele: No. His lounge. His lounge is next to his dressing room.

Paul F.: How do we know who to pick to go to his lounge?

Michele: You'll get the hang of it.

Robby: What constitutes a prospective VVVIP?

Michele: It's Hollywood, Robby; you'll recognize them.

Paul F.: So who's coming?

Michele: God knows; it's Hollywood—they all come at the last moment. The point is that we all split into teams, monitor the rooms for VVIPs or VIPs, and upgrade the right ones to VVVIPs.

Robby: Who's on the list?

Michele: Jack …

Robby: Who is Jack?

Michele: Nicholson; Paul will want to see him. Let's see … Eddie Murphy, Tom Cruise and Penelope Cruz …

Geoff (furiously taking notes): How do you spell that?

Michele: Spell what?

Geoff: That Penelope person, is she a Cruzz or a Crooze? They married?

Michele: Not yet. Let's see, who else? Sly Stallone, Kevin

Jack Nicholson: A VVVIP. May 4, 2003, Los Angeles.

Spacey, John Cusack, Nicholas Cage and Lisa Marie. Cameron Crowe and Nancy Wilson. Maybe Demi Moore. I think Brad said Cameron Diaz was coming.

Bill Porricelli, Promotion Co-ordinator: I'll escort her.

Paul F.: Yeah, right.

Michele: The thing we've all got to be careful about is not to make it obvious when you're escorting a VIP or a VVIP out to become a VVVIP. All the VIPs will want to be VVIPs anyway. The VVIPs shouldn't be put with the VIPs—unless a VIP and a VVIP are with Paul, in which case they are all considered to be VVVIPs.

Paul F.: How do you not make it obvious when asking a VVIP if he'd like to become an instant VVVIP? Do we smuggle them out under our coats?

Michele: Be discreet. Just don't shout, "Hey, you wanna meet Paul?" or they'll all rush at once.

Paul F.: Well, it all sounds very simple ...

Michele: It is. Just remember a VIP is not a VVIP unless the VIP is under escort, in which case the VIP becomes a VVVIP. But if a VIP who is upped to a VVVIP is then not with Paul, he's still not a VVIP. Anyway, the VIPs and VVIPs are arriving now, so let's go to work. Robby and Geoff, you do the VIPs. Paul and Bill, you come with me and do the VVIPs.

(Escort teams move off to monitor VIP and VVIP rooms. In the VVIP room sits Beach Boy Brian Wilson, among a heaving crowd of expectant faces.)

Bill: Hey Brian. You wanna come meet Paul?

When Michele Lawley is not rushing around organizing last-minute changes of flights, instructing hotel chefs in what constitutes vegetarian fare ("No, no fish, and no caviar either"), she and VIP Tickets Director Shelley Lazar deal with the frequently late requests from celebrities' agents and managers for tickets for their charges and access to the backstage sanctum. On a number of nights, the backstage area resembles the red carpet at the Oscars. Among the friends and famous who attend the shows are: Julian Lennon, George and Judy Martin, Tom Cruise, Penelope Cruz, John Cusack, Jack Nicholson, Cameron Crowe, Eddie Murphy, Brian Wilson, Pink, Sylvester Stallone, Michael Douglas, the Edge, Sting, the Prime Minister of Hungary, former President Gorbachev, Demi Moore, Bob Geldof, Howard Stern, James Taylor, mayors of almost everywhere, Ozzy and Sharon Osbourne, Emmylou Harris, Steve Buscemi, Judy Collins, Steve Tyler, President Clinton, and, often during the USA legs, ordinary American firefighters who'll politely wait with a backstage beer in order to say "thank you."

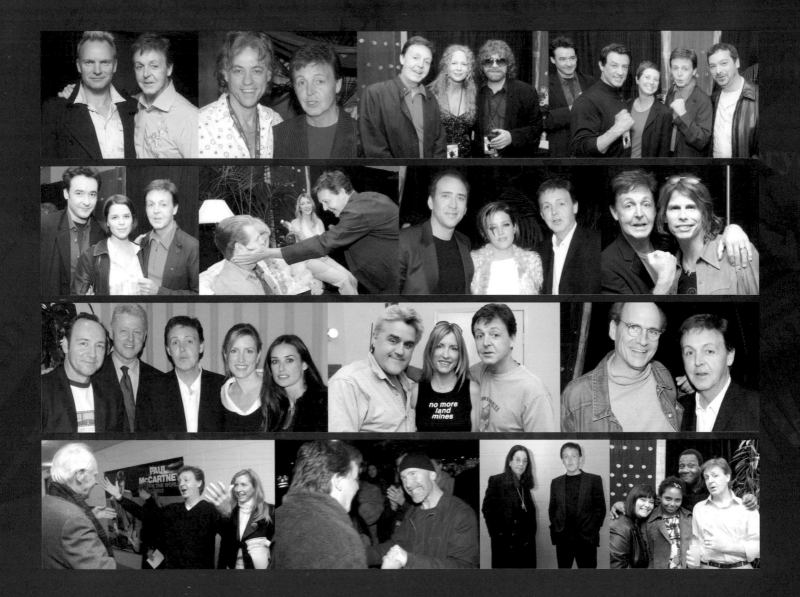

"I CAME IN A LIMO AND THEY SAID TO LEAVE BEFORE THE ENCORE TO AVOID THE CROWD. THEN I SAW THE SET LIST—*SGT. PEPPER* AT THE END! HEY, I'LL HITCH A RIDE HOME."

Steven Tyler, Aerosmith, Boston, MA

(Above) I know that face: friends and the famous pose for Bill Bernstein backstage. Well-wishers include Sting, Jeff Lynne, Sylvester Stallone, John Cusack, Brian Wilson, Nicolas Cage, Lisa Marie Presley, Steven Tyler, Kevin Spacey, Bill Clinton, Demi Moore, Jay Leno, James Taylor, Sir George Martin, U2's The Edge, Ozzy Osbourne, Dawn French and Lenny Henry. (Opposite) The mug shots taken for the Access All Areas laminates worn by some of those who helped the tour to roll.

I Can't Tell You

Party, party, party, and the police officer's thong

SUNDAY, MAY 4, 2003, STOCKHOLM: *Events take crew morale to a massive high; first news reaches the tour that all 30,000 tickets for Paul's homecoming show in Liverpool sold out in 48 minutes—inspiring the team to rename the city "Liverpaul." The euphoria is heightened by the crowd reaction at the Copenhagen show, where 46,000 Scandinavians (a house record) go so utterly berserk that, during* Yesterday, *Paul stops singing and lets the crowd sing the song for him. But the sparkle is lost at the first Stockholm show, due to the audience's nonreaction. The crowd is so restrained, polite, and essentially Swedish, that as Paul prepares to go back on stage for an encore, Stage Manager Scott Chase tells him, "Go knock 'em deader." Refusing to become downhearted by the conservative Swedes, Paul, the band, and the usual late-night suspects return to the hotel and party until almost 5:00 in the morning. A few hours later, as the team begins to prepare for the second Stockholm show, the* Tour Newsletter *(a day-to-day information sheet written and published by Geoff Baker, the press officer) puts the collective hangover into words.*

BACK IN THE WORLD The Newsletter (Stockholm Second Show)
WHY NOT TO PARTY WITH PARTY, PARTY, PARTY:

1. Because you oversleep.

2. Because then you panic.

3. Because then you start writing lists.

4. Which nobody except the emotionally suicidal understands.

5. All off the top of your head.

6. What head is that, then?

7. The one inside which that which remains of your brain is desperately searching for a scant memory of whether or not Paul said it'd be OK not to write a Newsletter this morning, under the circumstances.

8. The misery of realizing you do not have that in writing.

9. The total horror of realizing you cannot translate in a state where to walk to the door is tantamount to an arctic crossing.

10. The greater horror of telling flu-struck Paul Freundlich that you are too "ill" to work today.

10b. The shock of suddenly knowing that Johnny Walker, Chateau Effete, and Silver Haze are not a very good mix.

10c. The blisters on your feet from bopping with Dancing Queen [Tour Manager] Karen Gault—on a fucking table?

THINGS WE DO TODAY Besides calling in sick …

5:00 pm—Sound Check (not too loud, please)

6:00 pm—Doors Open

7:30 pm—Pre-Show

7:45 pm—The Show

After Sound Check, Paul:

1. Sleeps

2. Sues Karen Gault

3. TV Interview *(You're fucking joking—Ed.)* with Rai 1, Italian television; 10 mins or as long as you can stay not swaying.

4. Possible Phoner with WAZ newspaper, Germany. 10 mins

5. EMI Meet and Greet

TOUR OF TOURS IN PULITZER BID

First the album, then the movie, now the book (working title *Bible Two*) that will utterly celebrate and commemorate this past and glorious year of ours. The Press Officer and Robby have a bit of a hand in its making, and they have asked us to announce that if you want to be featured heavily in the book, they can be easily bribed by the provision of heavy sex or stimulants.

THE FOUR SEASONS HOTEL, BEVERLY HILLS.

Paul, the band, and chosen crew gather in a suite to toast the birthday of Missy O'Linn, Los Angeles attorney-at-law and Heather's personal security guard. The party, which is being filmed by Mark Haefeli for his tour movie, is interrupted by the arrival of the hotel security manager, accompanied by an LAPD officer. The policeman insists on detaining Press Officer Geoff Baker as substances believed to be drugs have been found in his room.

Security Manager: Please excuse this interruption; is there a Mr. Baker here?

Charles Bayford, Security: Who wants him?

Security Manager: I'm terribly sorry about this. Could we just have a private word with Mr. Baker?

Mark Hamilton, Security Director: Geoff! Over here for a minute, pal.

Geoff Baker, Press Officer: Can I help?

LAPD: Mr. Baker? I need you to come with me, sir.

Geoff: Why?

LAPD: I'd rather not discuss it here, sir.

Geoff: What's the problem?

LAPD: You need to come with me, sir, to discuss something that has been found in your room …

Mark Haefeli, Film Director / Producer: What's going on?

Geoff: No. No, this is like … Just … just hold on. We do not need this. Alright, we do not need this being filmed.

Mark: Why?

Geoff: What did you find in my room?

LAPD: I can't say right here.

Paul Freundlich, Tour Publicist: Missy! Missy! Can you have a talk with this guy? There's some legal thing going down with Geoff.

Missy: Oh great.

Geoff: I do not need this being filmed, alright? 'Cos … this is just …

Missy: What's going on?

LAPD: Hi. Sorry, we just have a bit of a problem.

Security Manager: We found some contraband in his room … I'm with hotel security.

Missy: I'm sincerely doubting you because you would have had to have a warrant. I'm not believing you.

LAPD: No, the maid found it right out in the open.

Missy: I'm not buying it—and don't start taking your clothes off …

LAPD: You're gonna have to sit right there …

(The "police officer" strips down to a thong, to the raucous encouragement of the room.)

Heather: Could you believe that? It was amazing.

Paul F.: I told the guy, I told him you're not gonna get like one or two lines out of her because she's gonna know you're fake. And he's like, "No, I'll get like one or two … " She noticed the badge was fake right away.

Mike Walley, Travel Director: Yeah, she's too smart.

Heather: But she believed at first that Geoff was under arrest.

Mike: Who wouldn't?

Paul F.: When she saw him walk in, I saw her eye …

Heather: She's so quick, isn't she? Tell me about it. She's unbelievable. When I'm walking down an aisle at a concert I can sort of walk and dip around people. But she literally gets them out of the way. I said, "Missy, it's OK. It's the last song, I can walk around them," but she's like, "Outta the way." It was funny because today I was quite fluey and cold and someone came to the dressing room and said, "Someone from IMF wants to meet you." They pronounced it incorrectly; they meant someone from IMG, my agents. So I said, "No, I'm not seeing anyone." The next thing I hear outside is this, "No! You can't come in here!" And it's like the heads of the organization, and they're saying, "But we're the heads of the … we're Heather's agents." And I hear, "I don't care. Heather's not well. You can't come in here, I'm sorry." Really. I was like, "Missy, it's alright, they can come in … " She's very protective.

Each One Believing

Warmer, wilder, special

THE LOVE YOU TAKE IS EQUAL TO THE LOVE YOU MAKE.
The infectious joy that radiates from the stage is strengthened by the camaraderie of the touring party itself.

Paul: A nice thing that's happening is the crew, the band, and all of us here have got a good camaraderie. It's been a very friendly tour. There is a sort of solidarity here. When you get on a good tour the feeling spreads … there's not one little department that remains bitchy. The Pre-Show performers help the volunteers who go on with the balloons. There's a team at work. The best thing for me is the music that we've been playing, the crowds that got warmer and wilder, and then the backstage camaraderie. People who visit us say, "I don't believe it, you know, there's such a good feeling around," and that will always be a special memory of this tour.

"NOTHING'S CHANGED; I STILL BELIEVE THAT LOVE IS ALL YOU NEED."

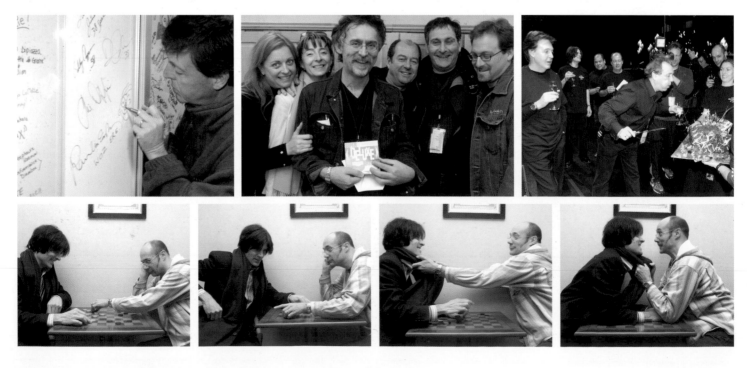

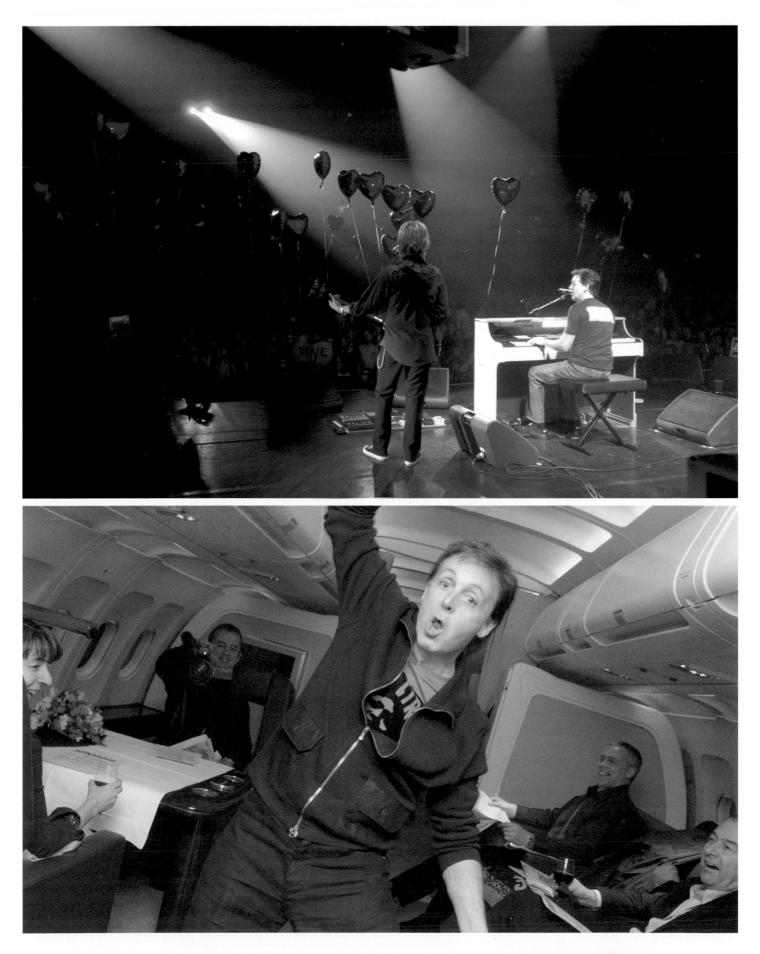

WHEN THE
NIGHT IS CLOUD
IS STILL
THERE IS STILL
THAT SHINES
SHINE
LEFT

Shine on 'Til Tomorrow

Bikes, guards, and temples

WHAT WE DID ON OUR HOLIDAYS. *The tour runs a total of 196 days on the road, and of these 54 are reputed to be days off. Although Paul and the band do not perform on those precious 54 days, for many among the crew time is spent either advancing to the next show or occupied planning and organizing gigs further in the schedule. When Creative Consultant Robby Montgomery and Press Officer Geoff Baker attempt to compile a list of days actually spent not working, they calculate six: Thursday, May 16, 2002 (Paul, the band, and some crew go swimming and play volleyball on the beach in Florida); Sunday, October 20, 2002 (a children's birthday party for Wix's daughter, Lily, and Michele Lawley's children, George and Jessie, is enjoyed at the pool of the Four Seasons Hotel, Beverly Hills); Monday, November 4, 2002 (either shopping or in bed with food poisoning in Mexico City); Friday, November 15, 2002 (sightseeing in Kyoto, Japan); Tuesday, April 15, 2003 (shopping in London); and Saturday, May 31, 2003 (inter-crew soccer tournament in Liverpool).*

Paul: Brian says he's been to Japan many times, but he's never seen Japan like we saw it. It was like real Japan, it was like local. So that was great for us. We usually only see the big cities and the gigs, but Heather and I got out. We nearly got arrested 'cos we sat on the wall of the palace. *(He mimics Japanese guards.)* The cameras saw us. "Paul arrested for sitting on temple wall."
Reporter, Osaka: NO!
Paul: Nearly, but it was OK. We didn't understand you weren't allowed to sit against the wall—did you know that?
Reporter: No.
Paul: Now you do! Don't lean on the wall. I'm warning you!
Reporter: Thank you. On this tour when you have some days off, what did you do?
Paul: We did all sorts of things. We went to swim in a hotel. We went to visit a temple outside Tokyo. We went for a bike ride, and when we got to Kyoto we went on the bullet train and then visited the Golden Pavilion, which is beautiful and very special.
Reporter: This is one of the best seasons to visit Kyoto, and wasn't the town crowded with tourists?
Paul: No, it was OK. We had bikes so we could always get away from everyone. We're very fast on our bikes. It was great, we didn't get bothered. Japanese people are polite; they don't bother you.

(Left) Time out in Kyoto and (opposite) precious off-duty moments, everywhere from Moscow and Osaka to Los Angeles, London, Munich, and Liverpool.

Midway through America Paul discovers that the action of plucking his guitar strings during Blackbird has bust a fingernail on his left hand. To fix it, he visits a manicurist to have a fake, acrylic nail attached to add power to his pluck. With soles sored by standing on their feet performing for almost three hours a night, the band accompany him.

My Heart Can Stay

Very quiet, bad feeling, sorry

AMID THE ARMY OF TECHNICIANS AND THE AWESOME ARRAY OF EQUIPMENT, WE MUST REMEMBER THAT THE CORE COMPONENT IS A HUMAN BEING. AND HUMAN BEINGS CAN MALFUNCTION … *Sunday, April 6, 2003, the Hallam Arena, Sheffield, England. Tension is in the camp as, at a late-hours party following the first Sheffield gig the night before, it is noticed that Paul's voice has become hoarse. He is suffering from a bad cold. Backstage in the press office, concerned crew begin to pose the possibility that he may be unable to perform—a fear that provokes tour veterans to scoff, citing that on this and two previous world tours Paul has never been too ill to play.*

Michele Lawley, Travel Co-ordinator: Apparently his voice was barely there this morning. It's getting worse.

Geoff Baker, Press Officer: He'll be fine.

Michele: Mike [Walley, Travel Director] is not so sure. You could hear it last night; he was very croaky after the gig.

Mark Haefeli, Film Director/Producer: What's the matter? Paul losing his voice?

Geoff: No. He'll be fine.

Robby Montgomery, Creative Consultant: I wouldn't be too sure about that.

Geoff: He's never canceled a show on any of the world tours.

Paul Freundlich, Tour Publicist: Apparently Barrie [Marshall, Tour Director] wants to know how many interviews we've got for him tonight. Can we cut them back?

Geoff: He's got Independent Radio News and another radio with the BBC.

Paul F.: Do you wanna can them?

Geoff: No. Let's go on as usual.

Mark: Why not can them?

Paul F.: We don't want to draw attention to a possible situation which may not happen. Where's the IRN guy coming from? Do you think we can at least switch him to another night?

Geoff: He's come up from London; all the way up the fucking motorway. Anyway, they're in watching sound check …

Michele: What are you going to do?

Geoff: Let him do sound check, and if he's a bit dodgy, then we'll cancel the interviews afterwards.

Mark: They'll be pissed. All the way from London … *Jeez.*

Michele: Has sound check stopped?

Robby: What?

Michele: It's very quiet.

Geoff: Fuck! Paul, c'mon. Let's get the journos out of there. Tell them we're getting them set up for their chats.

Paul F.: I'm getting a bad feeling about this.

(Enter Barrie Marshall.)

Barrie: May I have a word with you gentlemen?

Geoff: Problem?

Barrie: I'm pulling the gig.

Michele: It's off?

Robby: Oh shit!

Paul F.: Fuck!

Barrie: I'm pulling the gig. My decision. His voice isn't there; it's getting worse. He's tried doing *Coming Up* and it's not there. Can't risk the rest of the tour. So I'm pulling tonight. We need to get out a statement. I need you to write a statement.

Geoff: Sure. Saying what?

Barrie: I've got a doctor on the way. Let him see him first, and then we need to get a press release out fast to the radio stations.

(Enter Charles Bayford, Security.)

Charles: Mr. Baker, the boss wants to see you.

(Baker leaves the room and returns minutes later to type rapidly on his laptop. His colleagues crowd round.)

Robby: What'd he say?

Michele: What are you gonna say?

Geoff: I'm trying to write it.

Barrie: How long will you be?

Geoff: I'm fucking … sorry, Barrie. I've just gotta write this …

Paul F.: You've put two *l*s in "release."

Robby: Give him a cigarette.

Geoff: Can't read my writing. "I'm sorry to all … "

Barrie: Sorry, old chap, we really need to get this out.

Geoff: Barrie, I'm trying … Paul, you want your mobile

What's up, Doc? Backstage at Sheffield, Paul receives the bad news about his throat.

number on this as well?

Michele: How is he?

Geoff: He's talking in a whisper.

Robby: Yeah, he's like whispering, man. Can barely hear him.

Barrie: Sorry, guys. Is it ready?

Geoff: Paul's gotta see it.

Robby: Paul said he wants to see it first. Before it goes out.

(Baker exits to Paul's dressing room and within moments returns.)

Geoff: Fuck it! *Fuck!*

Paul F.: What's the problem?

Geoff: Gotta retype it. I typed some shit wrong.

Robby: It's only a few words.

Geoff: Still gotta do it. "I apologize to … " Why's it doing that? Fucking machine! "We'll be back to do the show … " He's talking in notes.

Michele: Notes?

Geoff: He's lost his voice so he's writing notes now.

Barrie: Sorry. Is it ready?

Geoff: He's communicating by notes. Yeah, almost finished.

Mark: What's going on?

Paul F.: Paul's communicating in writing.

Mark: I know. I've been filming him, man.

Barrie: Can I have that now? Sorry to rush you.

Geoff: Sure … I'll print you up anoth … Oh, you complete fucking, bastard machine … Fucking print! OK, it's coming now.

Barrie: I'll make copies.

Geoff: Let's just fax this out: PA, AP, Reuters. Barrie's doing the radio stations. Where's that guy from IRN? Get a copy to him. We need to get this out everywhere.

(Paul Freundlich exits with the press release.)

Michele: What do you think will happen?

Robby: It's a virus; he'll get through it. He won't want to be doing this, you know. This is really going to piss him off, losing a show like this.

Geoff: We're saying we're rescheduling.

Robby: Rescheduling when? When exactly is there time to reschedule in this hectic schedule?

Geoff: Fuck knows. Ask Barrie.

Robby: Yeah, he'll work it out. So much for "It'll be fine," eh?

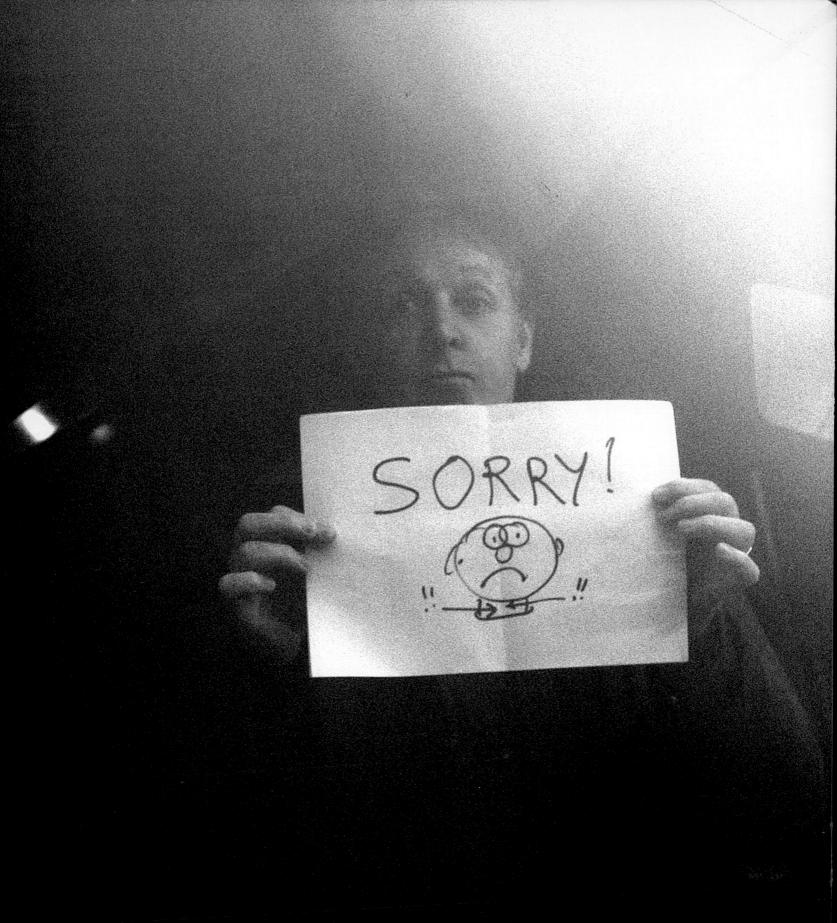

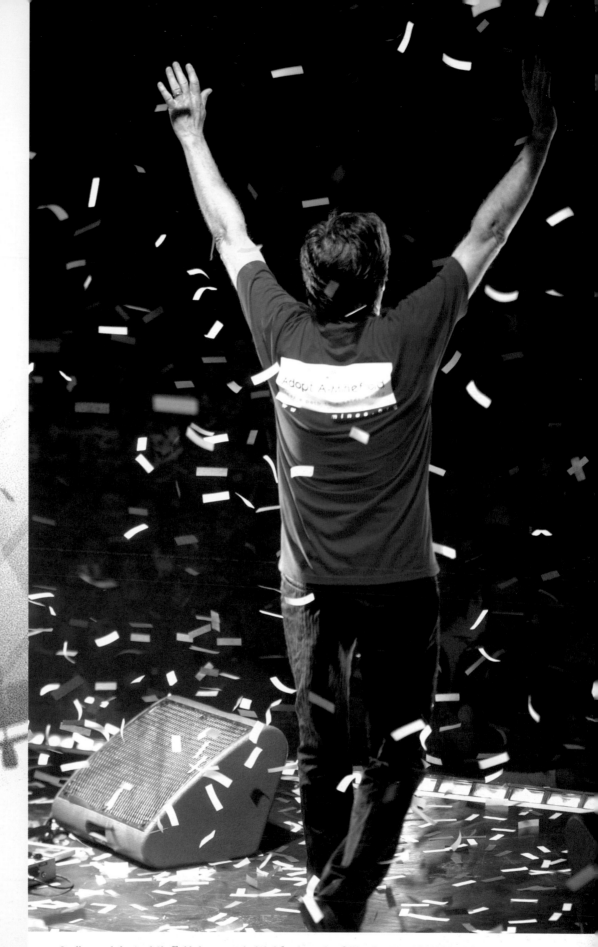

Paul's canceled second Sheffield show is rescheduled for the night of Thursday, May 29, 2003. Although ticket-holders for the original concert are offered their money back, less than 40 of the 12,000 crowd take up the offer. The rest prefer to retain their tickets for the rescheduled show. The audience for this becomes the loudest, most fevered indoor crowd of all the English gigs.

In Times of Trouble

The rallying cry, a sort of healing thing

IT'S ONLY ROCK-AND-ROLL, AS ANOTHER SONG GOES, BUT NEVER UNDERESTIMATE THE POWER OF SONG.
Just as in February 1964 when the Beatles first visit gave America reason to smile again after the months of mourning that followed the assassination of John F. Kennedy, so this tour finds it unwittingly and unintentionally has a function—as Paul puts it, "Our role now is to try to raise spirits." Paul figures that if the dreadful events of September 11 prevent America from enjoying itself again, then the terrorists have won, but by retaining the lifestyle so evidently under attack, America can make them lose. Although bludgeoned, America is finding the spirit to put on its dancing shoes. The point is reflected in the reviews of the opening night of the tour. The San Francisco Examiner *writes, "For many in the audience the experience was nothing short of a metaphor for rebirth, for a renaissance following September 11." But it is a British newspaper,* The Sun, *that first spells out what America is feeling in the excerpt that follows.*

HOW PAUL McCARTNEY IS HEALING AMERICA
(Just Like the Beatles Did Back in 1964)
In 1964 the Beatles helped America recover from the shock of President John F. Kennedy's assassination. Nearly 40 years later, former Mop Top Paul McCartney is back in the US—this time helping to heal the nation in the wake of September 11. McCartney, 59, is getting rave reviews on his *Driving USA* tour—his first in nearly ten years. It includes 28 gigs in 19 cities from San Francisco to New York. Maccamania is gripping the US just as Beatlemania did when it soothed the hurt after the horror of JFK's shooting in Dallas, Texas, in November 1963. The Beatles made their US debut in February 1964, sparking fevered screaming among teenagers and an outpouring of adoration from a nation grateful for the chance to embrace an exciting new era. That tidal wave is repeating itself 38 years on with a new generation—and Macca's song *Freedom* is in tune with the feelings of America today.

Pat O'Brien, Access Hollywood: After the assassination of John Kennedy in the sixties, the Beatles came over and you guys were really a therapy for us here. Now, after 9/11, your music has again become like group therapy for this nation.
Paul: I'm very proud if that is the case. With the Beatles we didn't come over feeling that we wanted to heal America; it was just the right time and America wanted to party again. This time around that feeling is more so, there is a sort of healing thing going on again, and I'm proud to be a part of that. Again, we didn't set out to do that with this tour, but we're here at the right time, and I'm proud and lucky to be able to help. There is a lot of emotion in this show, and at this time it seems that people want to be both emotional and also to party; they want to let it out.

I'm a great believer in fate, and it was fate that put me in New York on September 11. And now, if I'm able to help Americans with this show, then that's something I'm really glad of. I believe that things happen for a reason—here we are, a band of two Brits and three Americans touring around at this time and being able to give something back, hopefully helping people to have fun. We're also making a big emotional connection with the audience. They are doing something for us, responding, and we're able to give them something back. It feels great and it's my pleasure.

"The truth is," writes the *Baltimore Sun,* "Paul McCartney's been making people happy for nearly 40 years in a way and to a degree that few other human beings can match. Few have embraced the role of cultural statesman so warmly and so responsibly. After September 11, such constancy and grace seems even more reassuring. With the anthem-like *Freedom,* a song McCartney wrote as a rallying cry after the attacks, he's even taken on the role of cheerleader … When he sings *Getting Better,* it's nice to hark back to a day when that seemed true and to hear those words from a guy able to make us believe that it still is."

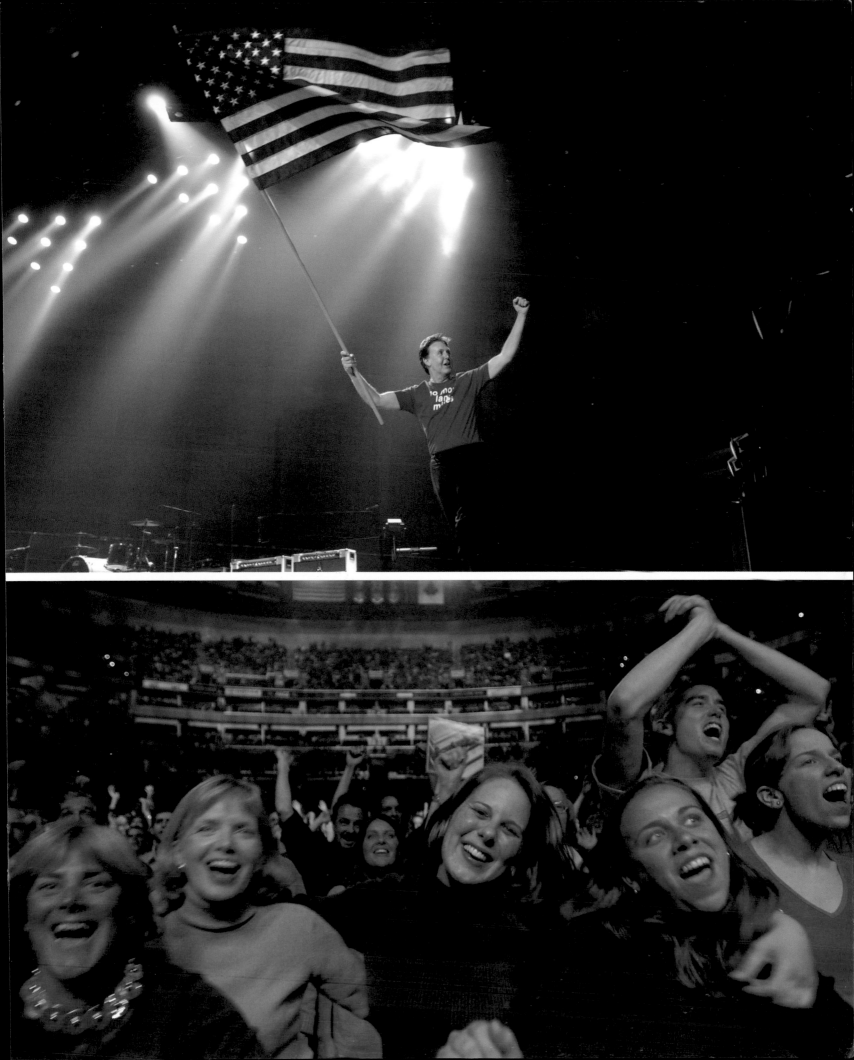

Thoughts of You

Plucking up the courage, one-to-one, look away quick

FOR MANY, THE HIGHLIGHTS OF THE SHOW ARE PAUL'S SIMPLE TRIBUTES TO A FEW OF THE KEY PEOPLE IN HIS LIFE. *The set incorporates a song for George Harrison and one in memory of John Lennon. And certain Wings numbers—notably My Love—form Paul's tribute to Linda.*

DJ, Boston: You do a song in the show for your old buddy John Lennon, *Here Today.* That seems to be quite an emotional moment. How did that come about?

Paul: I had a poetry book out called *Blackbird Singing* and off the back of that I'd been asked to do some poetry readings. So that is a kind of challenge, you know. How do you do a poetry reading? So I talked to a couple of mates of mine who'd done this sort of thing. And they said, "Why don't you just read your stuff, and just do a little talking in between the poems?" So I thought, "Oh, OK." So I did, I did a few readings. I did one at the Y in New York, and I did a couple in England—one in Liverpool and another at a poetry festival. And I found it quite nice, actually … something I had never done, just standing up and talking to an audience of people. I'd always had a guitar before, always got some form of, you know, prop, something to lean on. So I quite enjoyed it.

And when we were doing this stuff for *Blackbird Singing,* doing this kind of promotion for the publishers, we went to Bush House, to the BBC in London, to do a radio interview for National Public Radio in New York. I read some of my poems, and then the woman interviewing me said, "Would you read *Here Today?*" I'd never read it aloud before, but I thought, "OK." So I read it, and I tell you, it was getting to me, like I could feel myself almost going to choke reading this. It was very emotional for me. But I got through it, and thinking about it afterwards I thought maybe I'd try to do that at these poetry readings we had planned, just recite *Here Today* as a lyric without the music. And that went down quite well, just as the words. So when I was putting the set together for this tour, I thought that is kind of interesting, maybe I should just look at the idea of putting the original guitar part back and sing it— and then just do it for John. Because it's a song I wrote for John, about John, when I was in a sort of retrospective mood after he had passed away. And I was thinking about the way you are in life, and when you're guys you goof around a lot, but you don't actually sit down and say, "John, let me just tell you: I think you're a terrific person, I think you're a marvelous musician and I really love you." You don't ever do that; what guys do that? Well, we didn't anyway … And so after he passed away I just had those kind of feelings and I just thought it'd be nice to try and condense some of that stuff into a song.

I got a little bit scared about doing it as rehearsals came close. I didn't know if I'd be able to handle it on the night, because this is, like, emotion in public time. I'm plucking up the courage to do these songs one-to-one in the way that I wrote them, me and a guitar and alone—without the security blanket of a band. Like I'm up there on stage naked … Then I thought, "This is OK," and now I really like doing it. I have never sung *Here Today* on tour before. So it's fresh for me, even though it's not a new song. It's fresh for me to perform it. And it's interesting in the show because a lot of people don't know the song; it's not like a famous song of mine. It is nice for that. I think some people think I wrote it last week or something. But I think it's nice that a lot of the audience don't know it; it works as a song because it's kind of very straightforward and very from the shoulder. So, it says what it has to say. It's not a big

Prior to Paul's 2002–03 World Tour, the greatest hits album, The Beatles 1, *set a new world record for becoming No.1 in an unprecedented 34 countries and selling more than 25 million albums. Soon after the album's launch, the 20th anniversary of the death of John was marked on Friday, December 8, 2000. In response to many inquiries, Paul released the following words on the eve of the anniversary: "It is shocking to think that John was killed 20 years ago. If he was alive, I'd be chuffed to let him know that his album has gone to No.1 in 28 countries; I know he'd be tickled by that. On Friday I'll be doing what we always enjoyed best together—making music. What else would you want to do? I'll be thinking of all the great times that we had together and I'll be remembering him with all the love in my heart."*

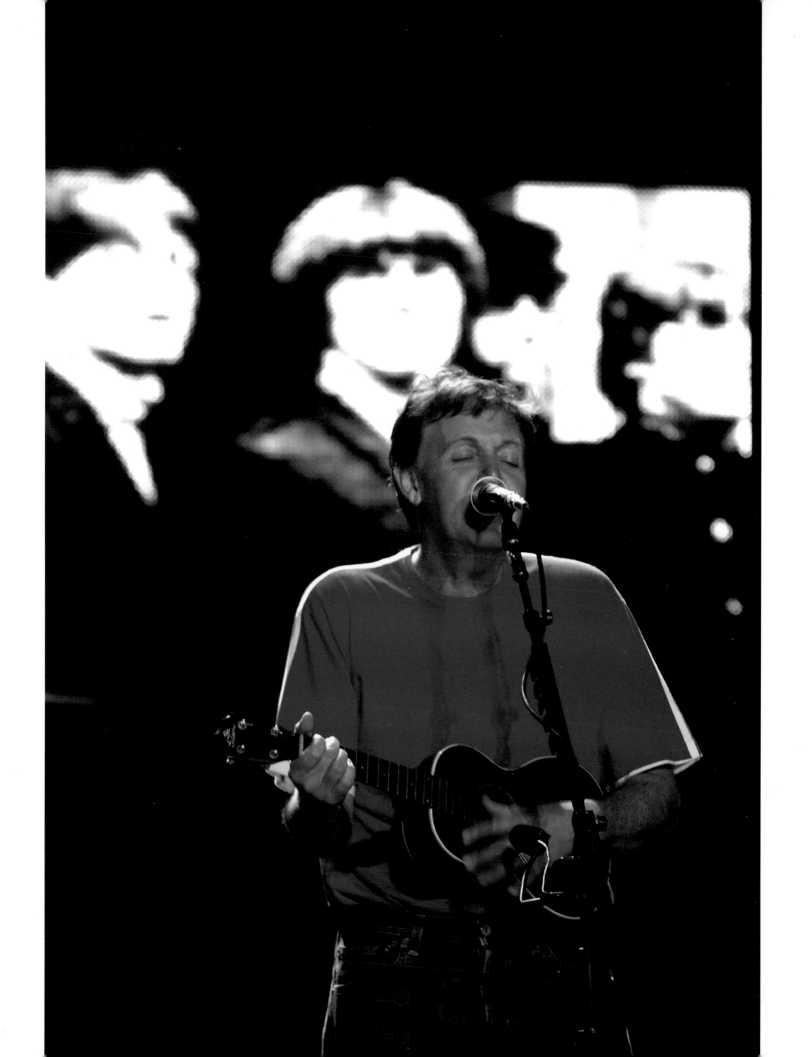

kind of crazy hit, but the feeling and the emotion gets over the fact that it's new to most people's ears. So, I think that's quite a good thing about the tour; there's some little surprises in it that take the edge off it just being a sort of sing-along-with-the-hits tour.

DJ: A lot has been written lately about the tribute that you're doing for George Harrison, your version of *Something*. Why did you decide to include that?

Paul: In thinking of the tour, I wanted to do some kind of thing for George. As I tell the story in the show, you know, George was great on the ukulele. He could really play it well, and he loved this star in Britain called George Formby, who played a lot of ukulele. And I like George Formby stuff; he's a real old British institution, a comedian. In wartime all our parents used to know this guy. George became a big fan of his and therefore learned all of his stuff on ukulele. I've had a ukulele quite a long time, since the early days of recording in New York in the early seventies. I used to have it for going in the back of a taxi. You know, sometimes you might be working on something, and you could sit in the back with a ukulele, just working on it—instead of taking a big guitar with you. And nobody can take an amp, in the back of a cab. A ukulele is really portable.

When I thought about what to do for George I was immediately reminded of the second-to-last time I saw him. We had dinner and we played ukuleles together. It was his thing, he really loved the ukulele. And at that point I made a little joke and sort of said, "I'll do this number, you know," and I played a little bit of *Something*. He quite liked it, and he made a joke back and said, "No, no, it goes like this." He thought it should be done faster; he wanted me to do it George Formby-style. We talked about it, it was a laugh, it was like … one of our last moments, I suppose. But it was such a lovely memory, a really lovely memory of George. And so after he passed away, thinking of this tour, I thought it would be really nice to do *Something* for George, and the idea occurred to me—"I wonder if I could do it like that in front of 15,000 people," and if I could, whether they would like me to share it? I thought, "Wow, dare I actually just stand up there in front of 15,000 people with a ukulele and sing *Something*?" Then I thought, "Yeah, go ahead, try it." So I plucked up the courage and I do it. And it has gone down very well. It's emotional, but I think a lot of the audience likes emotion. I mean, you go to a movie and it's good to get emotional. I don't see why concerts are any different. And I'm at a time in my life where that's important to me as well, you know; I'm sort of getting into a bit of emotion. I think it's a great thing.

DJ: What goes through your mind when you do the Wings songs without Linda?

Paul: That's sad and that's difficult … It's as sad as it is doing Beatles songs without John, and now without George. It's always sad to lose someone you love, you know. It is sad, but I think one of the things that alleviates it a little bit is that this is basically a new band. Except for Wixy, who was in the old band with Linda, and he has his lava lamp in memory of Linda, so that's a little poignant thing that he does. I think it is helpful that it's sort of new people. I think if I had exactly the same band, and I was in exactly the same position on stage, and I looked over and it was like … Linda wasn't there and a new keyboardist was there … I think that would probably be impossible. In actual fact, I cited that as the reason why we didn't reform Wings. Someone wanted us to reform Wings during the whole Wingspan thing. But it is difficult … it is difficult. But you know, life goes on. It's five years since she passed away and time's a healer. It's difficult … I just … I just remember the good stuff. It's the same with John; some nights it's almost impossible to get through the song I wrote for him, and some nights it's just lovely and emotional. It's life at my age. There's been one or two nights when I've had to … you know, sort of catch my breath up there when I'm doing these songs. You know, once or twice I've been … like close to just losing it. But I said to all the guys, "Look, if I lose it, the audience is just going to have to come along with me." Sometimes it's like the look on people's faces that gets me; if they've lost it, I know I will lose it. So I look away quick.

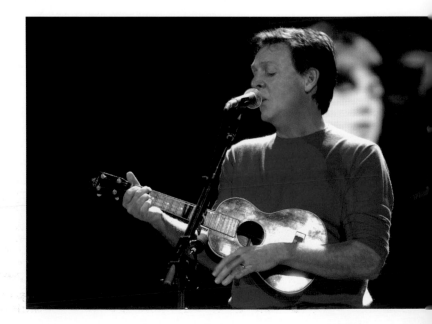

*(Below)
Paul's ukulele
solo on George
Harrison's*
Something
*becomes one of
the tour's most
treasured memories.
(Right) Meanwhile,
Wix supplies some
sweet accordion
backing to some
numbers, including*
Here There and
Everywhere
and Michelle.

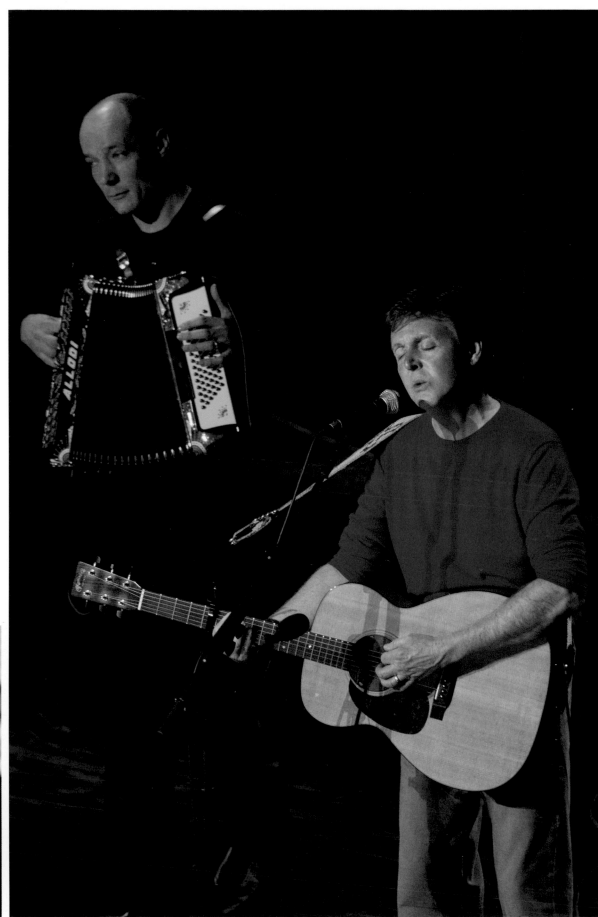

As We Fell into the Sun

The unthinkable ... actually happened ...

WHILE THE WEST REMEMBERS THE BEATLES AS A MUSICAL PHENOMENON AND A CULTURAL FORCE, THEIR LEGACY ELSEWHERE MAY BE EVEN DEEPER.
In the lands behind the former Iron Curtain, the liberating power of the Beatles' music stood for much more than the way you wore your hair. In Moscow, meeting political leaders past and present, Paul begins to learn the true scale of that influence.

Paul: I'm very proud to have been in the Beatles. Without knowing it, we made a lot of changes. I mean, we were just guys trying to make music and make a living, and just enjoy ourselves. But something came through of the freedom that we started to represent. And we were very honest. So when we were asked about things like the Vietnam War or stuff like that, we spoke honestly. When we were asked about the planet and the environment, and peace, and things like that, we spoke honestly. And I think that people around the world who are now grown-ups, who were kids then, saw all of this stuff, and I think it helped to make a lot of changes. We didn't set out to make changes, but fortunately we did. We were kind of part of a group that wanted changes. We were just in the right place at the right time. So I'm very proud to have been part of that.

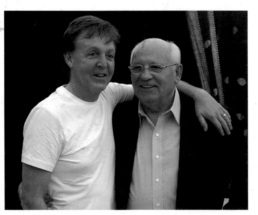

Sergei Volynets, writer: Every party we had, birthday party or just a party, was always with the Beatles. We danced to the Beatles. I kissed a girl for the first time to a song of the Beatles.

Paul: Just when Mikhail Gorbachev had instigated the program of perestroika a lot of us were very excited that this was going to happen—that there was going to be freedom in Russia.

Mikhail Gorbachev, former Soviet President (through a translator): To Paul McCartney. The best musician and a fantastic person. With sympathy, from Mikhail.

Paul: That's beautiful. Thank you very much. Spaziba.

Sergei Ivanov, Defense Minister: Back in the middle sixties, late sixties, there was no talk even about perestroika, it was unthinkable.

Andrei Makarevich, musician: I knew that the Soviet power would fall, but I thought that it would take 50, 60 years more. It happened much earlier. And I think that rock-and-roll and the Beatles did a lot for it.

Gorbachev: I do agree that the Beatles' music has taught the young people of the Soviet Union that there is another life. That there is freedom elsewhere, and of course this feeling has pushed them toward perestroika, toward the dialogue with the outside world. I congratulate you on something that should have happened a long time ago. But it's better late than never.

Paul: It's good. This is my first time in Russia. And it's beautiful.

Gorbachev: Of course young people are crazy about you. But adults and serious musicians also value your music very highly. I don't think this is just pop music. This is something much greater.

Paul: When you're a kid, your idea of the Russian defense minister would be a very strict, cold kind of person. Actually meeting him and finding that he's a fan ... and he bought *Love Me Do*, and he openly admits it ...

Sergei Ivanov: I was born in 1953. I'm 50, but I still remember one autumn day in 1963 when I was ten. When for the first time in my life I heard a Beatles song called *Love Me Do*, from their first album. And in fact the Beatles songs motivated me greatly to study English.

Paul: It's a great satisfaction, people learning English through our songs. It's something we never imagined. Yeah, it's beautiful, it's great. It is amazing, and you know, in the sixties we did realize that one day our generation was going to be in power. But now it's actually happened.

(Above) Meeting Mikhail Gorbachev in Moscow.

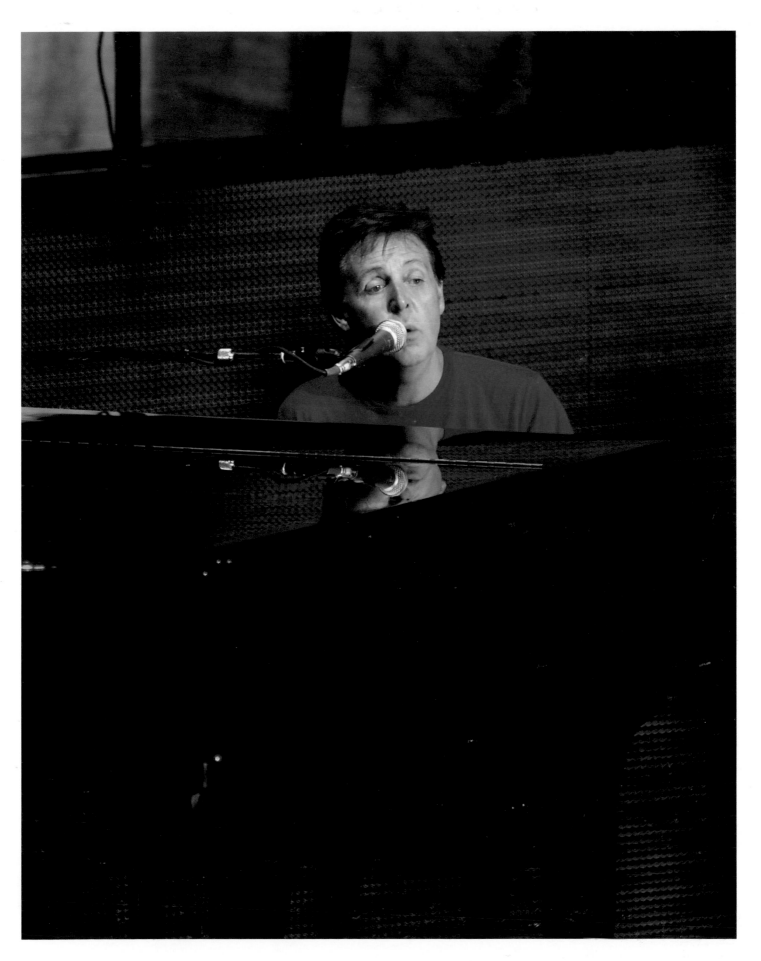

You Can Be the One

Works like a slave, a really hot dancer, amazing

BACKSTAGE IN BARCELONA, HAVING PERFORMED HIS FIRST SHOW AS A NEWLY MARRIED MAN IN PARIS, PAUL CHATS WITH FELLOW LIVERPUDLIAN AND JOURNALIST BRIAN READE ABOUT LOVING AGAIN. *Paul and Heather first met at a* Daily Mirror Pride of Britain *awards ceremony two years before, which Paul attended to present an award inaugurated in Linda's name.*

Paul: I'm really lucky. It's not every man meets up with a good woman during their life. I know how lucky I was to find Linda. And it's the same with Heather, you know. It's strange, too. We met at the *Pride of Britain* awards, and I nearly said, "Look, I can't go. It's nice of them to do the Linda McCartney Award, but I can't go." But I just thought, "You know what, let's go." And Heather was a little bit the same. And we ended up there. And we didn't talk. I just saw her and thought, "She looks great."

Brian: I saw her that day, and I thought the same thing, but you copped off with her. I thought, "He's got the balls."

Paul: Well. You didn't ring 'er. I rang 'er. I got her number!

Brian: What does Heather bring to your life?

Paul: She's a great woman. She's very strong, she's very caring. And, that combination is very attractive to me. A friend of mine said after he met her—I actually wrote it down, it was so cool—he said something like, "She's got a great sense of purpose in life, she's got a great sense of humor … and she's not hard to look at." That's paraphrasing it. But it's sort of like that, you know. We do the land mine thing together, and she works like a slave. I just heard her the other day with a young girl. She says, "What do you wanna do? What's the main thing you wanna do?," you know, once you've had your amputation. And this young girl—and this is what they nearly always say—says, "Dance." And she says, "Well, don't you worry; you'll be dancing better than all of them." 'Cos Heather's like a really hot dancer. We enjoy dancing. So that's it. The bottom line is that she's amazing … and she's not hard to look at!

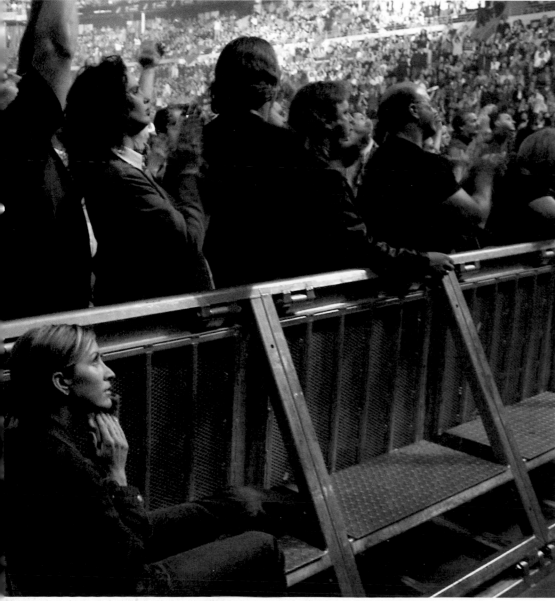

"SO THAT'S IT.
THE BOTTOM
LINE IS
THAT SHE'S
AMAZING …
AND SHE'S
NOT HARD TO
LOOK AT!"

The Movement You Need

Mines, the media, and Brian

THE CAMPAIGN AGAINST LAND MINES RECEIVES A MIGHTY BOOST THROUGH A COLLABORATION BETWEEN TWO OF THE GREATEST COMPOSERS OF OUR TIME. *September 17, 2002, Sony Studios, Culver City, Los Angeles. Rehearsals for the second leg of the tour are now nearing completion in the giant Studio 15. After driving himself to the studio in his little black Corvette, Paul leads the Band through a real-time*

run-through of the show. But real-time is interrupted by the arrival of a tall denim-clad figure hesitantly walking to watch at the side of the stage. Brian Wilson (left) is here with friends for his rehearsal with Paul of their duets for tomorrow night's Adopt-A-Minefield benefit at the Century Plaza Hotel. The entire crew down their tools and wander out to watch the historic moment when the Beatle and the Beach Boy first sing together.

Paul: OK. So Brian's going to take the first verse … I'll do the second verse or we both take the second verse. We'll see what happens.

Brian Wilson: Testing … one, two, three, four, five, six, seven, eight, nine …

Brian's friend: Can you hear OK?

Brian: Yes.

Paul: OK. Ready?

Brian: Yeah.

Paul: Let's do it, brother. This is it.

(Paul sits at the grand piano at the back of his stage. Before him, Brian stands center stage. Paul McCartney and Brian Wilson sing Let It Be.*)*

Paul: This is Brian Wilson!

Brian: Thank you very much!

Paul: What'd you think? Was that alright?

Brian: I love it, man! I love it!

Paul: What do you wanna do? You wanna duet?

Brian: Let's go one more time.

Paul: Brian's got the option of either being here, being a little bit nearer to me, or there, which is cool.

Brian: I'd rather be here.

Paul: That's cool. I think that's good … you got a high stool?

Brian's friend: We have a stool that he sits on.

Paul: That's like a highish stool? Not a low one?

Brian's friend: Yeah.

Paul: Cool. Yeah, you had it right …

Brian: Let's do it!

Paul: Let's do it, man! He's bossing us around already. Bitchin'! OK, here we go. Second and final run-through.

(Paul McCartney and Brian Wilson sing Let It Be. *At the end of the song, Paul, Brian, and the band consult on stage. A piano is brought center stage for Brian, and they sing* God Only Knows.*)*

Brian: Right from the heart, Paul, right from the heart.

Paul: So we'll rehearse that with you guys tomorrow. And what about if you take the first verse …

Brian: Yeah.

Paul: I take the second verse … and then you repeat "If you should ever leave me."

Brian: Yeah.

Paul: Or how about if we split that verse. You do "If you should ever leave me" and then I take "Life would mean nothing to me."

Brian: OK … OK, sure, cool.

Paul: It's a beautiful song, Brian; you know I love it.

Brian: Wanna go one more time? One more from the top.

(Brian Wilson and Paul McCartney sing God Only Knows. *Brian's entourage huddle around Paul and Brian, producing various record sleeves for Paul to sign for them and their families. Paul signs them all.)*

Paul: Want us to run you one song just before you go? We're doing* She's Leaving Home.

Brian's friend: Oh God, are you kidding me?

Paul: Do you wanna hear it? We're showing off, man …

Brian: Let me hear it.

Paul: We're gonna show off, man.

Brian: Let's hear it right now.

Paul: Alright. Let's do *She's Leaving Home.*

Brian's friend: Oh good. Excellent.

Brian: They're doing *She's Leaving Home* for me.

Brian's friend: Just for you.

Brian: He's gonna do it for me, Goddamn it!

(Paul performs She's Leaving Home *for the first time to any audience since it was recorded for the* Sgt. Pepper *album in 1967.)*

BACKSTAGE IN MILWAUKEE BEFORE THE OPENING NIGHT OF THE SECOND LEG OF THE TOUR. *Paul is interviewed by the local* Milwaukee Journal Sentinel, *who quiz him about his support for the anti-land mine charity Adopt-A-Minefield, through which he and Heather actively campaign for the global abolition of land mines.*

Reporter: You just did the special event with Brian Wilson for the Adopt-A-Minefield thing. You've been so supportive with all these difficulties with the war going on. Is there a contradiction at all between that and the minefield thing?

Paul: With what? A contradiction with singing *Freedom,* that kind of thing?

Reporter: No, I mean mines are part of a war and there's a kind of righteous war going on here …

Paul: I don't agree. I think that mines shouldn't be part … they are part of a war … but children used to be part of chimney-sweeping … Pit ponies used to be part of mining.

Reporter: So you wanna see mines like mustard gas?

Paul: Yeah. Mines are like mustard gas, they're obsolete. What they do is they kill civilians and that's the sort of cowardly bit of it. The thing with land mines is that they are left behind after the war is over. It's like leaving the war behind you when the armies have gone. They hit women and children and the most vulnerable. I'm a pacifist … I really don't wanna come out in defense of war. My ideal scenario is no war ever. Make love, not war—you know, I still believe that. But if you do have to have war, like in defense or if like Hitler's invading, then I don't believe that land mines should be a part of it.

It Was Written

Out-of-body experience, uplifting …

FROM THE MORNING AFTER THE OPENING NIGHT, PRESS REVIEWS OF THE SHOW HAVE BEEN AMONG THE BEST, IF NOT THE BEST, OF PAUL'S CAREER SINCE THE DAYS OF THE BEATLES. *Despite the widespread praise, Paul refuses to let his publicists show him or read him the reviews.*

DJ, Cleveland: I haven't read a negative word about the concert. Did you expect to get this kind of reaction?

Paul: You never expect that, you know. It's tempting fate to expect really good reviews and, in truth, I don't read them. The guys all tell me and I get the buzz off them. But it is fantastic, and the main thing is that we are really enjoying the show, so that's like a review in itself for us. That's the best review, that we actually really love it and we can see the audiences loving it. If you read reviews, sometimes you … what it does for me is it makes me think about the next concert in terms of that review. I go, "Ah, so they said that about that; oh, well I'd better do it like that, then," and it's a bit unfree to start thinking like that. So I try and just forget and don't read the reviews—so I'm still just working instinctively.

Reporter: So you don't want me to read you part of this review I've got here. Do you mind?

Paul: I don't mind, no …

Reporter: OK … "Seeing Paul McCartney in concert will make you believe again in the redemptive power of rock-and-roll, in the curative value of visiting with old friends, in the pervading wonder that comes from seeing your heroes up close." Did you expect to evoke that kind of reaction?

Paul: No, but I wrote that. That's why it's so good, I wrote that one … *(Laughs.)*

"I said there was a serendipity around this tour, but, you know, it's not serendipity—there's a divine thing going on here. I don't mean that to mean it's deifying Paul, but it's as if God is putting balm on our lives through this show."

Jim McIntyre, Radio WDOK, Cleveland

"I had tears in my eyes when he came on because there was such a very good feeling there. I think it was the best show that I have ever seen."

Ray Connolly, Daily Mail *journalist*

"Probably no other artist can claim to have in one row a young man swaying to the rhythm while holding a sleeping child and, just behind him, a silver-haired businessman playing air-guitar along with the Band."

The Oklahoman

"That was an out-of-body experience; the show was beyond amazing."

Cameron Crowe, filmmaker

"That was the most incredible band I've seen since the Beatles. I was 14 years old again."

Alice Cooper, musician

"This is fucking history! This is what he should do all the time. Look at him! That's a fucking god up there!"

Ron Delsener, promoter

"And then he did one of my favorite songs that brought me to tears, man, *Blackbird*. I'm telling you, the guy is so goddamn uplifting! The guy is a saint! I love this guy. I gotta tell you, this is one of the best concerts I have ever heard. Go see McCartney, you're gonna dig him."

Howard Stern, radio broadcaster

"That fucking stuff at the start, what do you call it? What show? Pre? That is just so great! It was intellectual, it was arty, it was fucking more than all that! What a fucking vibe! And who did the lights? Your lot lit the Colosseum as part of the gig? *Fuck!*"

Bob Geldof, musician

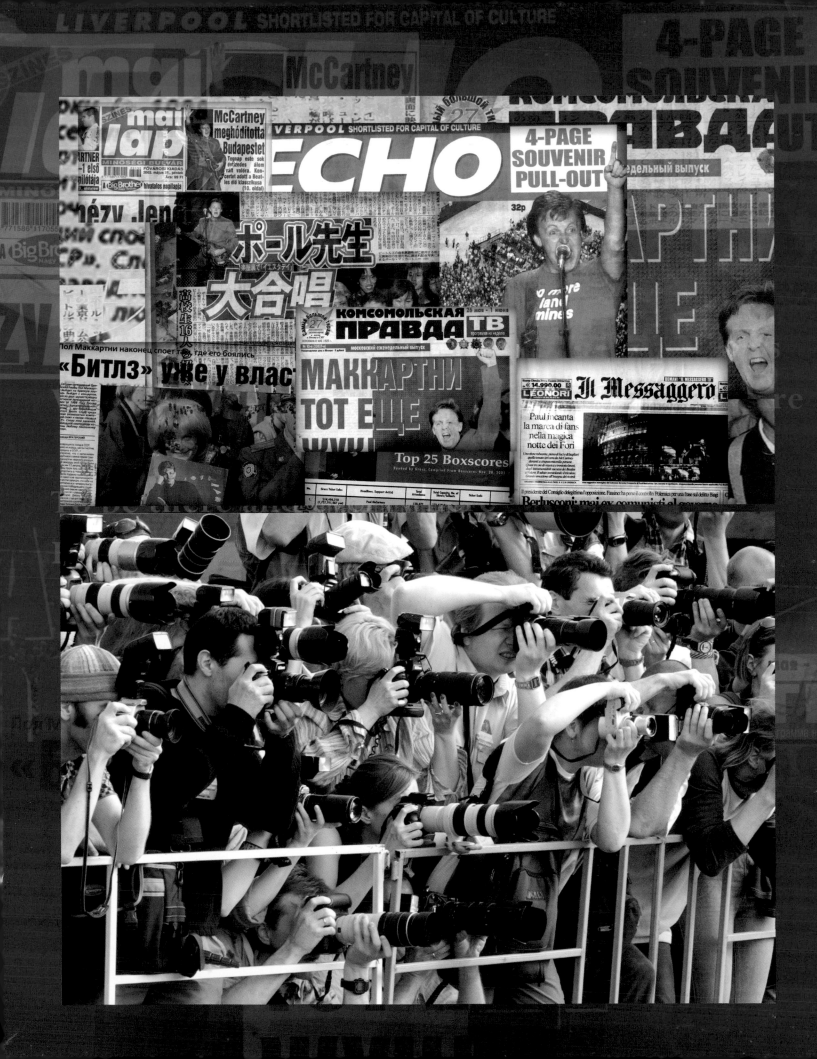

Carry Me Back

A sort of free feeling

BY MAKING MUSIC, HE MADE HISTORY. *But originally Paul McCartney wanted nothing more from his career than an escape from tedium. It's brought him much more than that, of course, but the magical thing is that the feeling of release is still there. And still inspiring him to play more music.*

Paul: Seriously, I just love it all. And I'm surprised that I'm not blasé. I really should be very jaded and very blasé and very fed up with the whole thing by now. But I'm not; I just get a lot of pleasure and excitement from all of this. It is very surprising because life is supposed to knock it out of you. But, touch wood, it doesn't seem to have gone that way with me and I don't know why. But it's mainly 'cos I love it. You know, I continue to love it. I was very enthusiastic in the Beatles; I really wanted the Beatles to continue when it ended. I was always the enthusiast … Well, I don't know about *the* enthusiast, the other guys were enthusiastic, but I was certainly an enthusiast. I've always been like that.

We got into music to try to get out of the routine of having a regular job. And that's the sort of thing I've always followed. In actual fact it can get like a very regular job. It can get worse than a regular job sometimes—but at least we fooled ourselves into thinking we were free, that we'd escaped all the irons of bondage of normal life. And I still feel like that, you know. If I fancy touring, I'll tour. If I don't, I won't. It does lead to you having a sort of free feeling about your life and a sort of artistic nature. I don't just go into work Monday to Friday, although often I do, and Saturday and Sunday as well.

What also happens is you get the business success—again, touch wood—and then suddenly it means you're a businessman, the very thing I was trying to avoid. But it's great and I'm very happy with how I do things. It seems to work. It's kind of made up, it's a bit of an ad-lib. I'm not a great sort of analyst or theorist. I'd consider doing anything, but it's a matter of what I fancy.

There was some guy who used to go to the art college when John went there, who was 24. And I thought he was over the hill. Huh. Mind you I was 17. 'Cos he had, like, dark shaving shadow, and I just thought, "God! I'd hate to get that old." But then you started to kind of get into your thirties and then it was, "Oh, don't feel too bad, you know." More recently, you look at people like Ray Charles and a lot of the blues guys. B.B. King—he's going on forever. I never think of beginnings or ends—I shall probably be touring when I get to 93. I've been lucky enough to do what I love. You know, I'm living my dream. This is it. And so, yeah, I feel very fortunate.

"HOW AM I GOING TO TOP THIS TOUR? I DON'T KNOW. IT'S THAT OLD BEATLES MOTTO AGAIN— 'SOMETHING WILL HAPPEN.'"

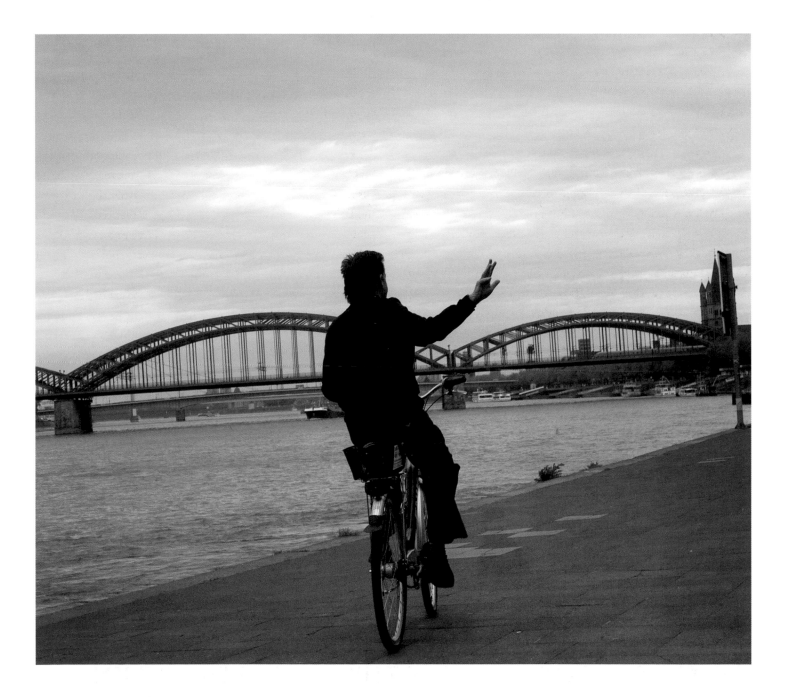

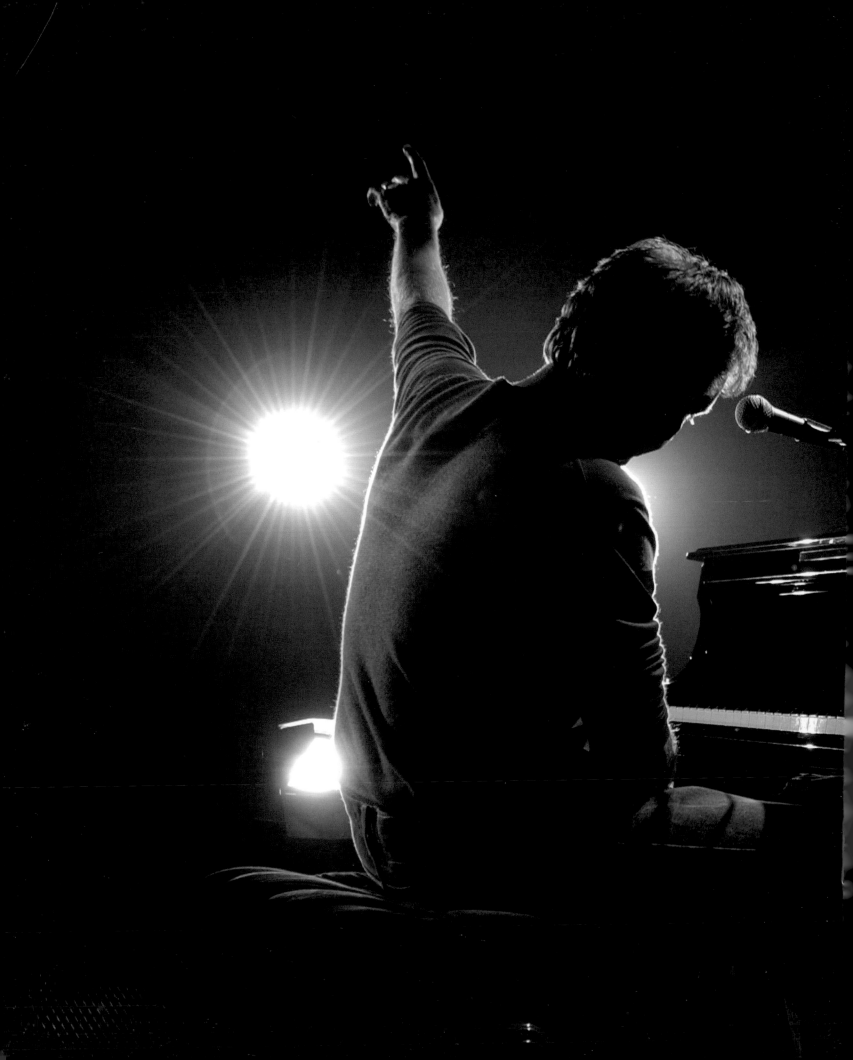

The Cast

BAND PARTY
Paul McCartney

Paul "Wix" Wickens
Rusty Anderson
Abe Laboriel Jr.
Brian Ray

John Hammel Personal Assistant to Paul McCartney
Mike Walley Travel Director
Paul B. Winn Financial Director, MPL Tours
Tom McCabe Chief Operating Officer, MPL Tours Inc.
Russell Willens Financial Controller, MPL Tours Inc.
Graham Jackson Financial Controller, MPL Tours Ltd.
Jenny Wyles Financial Accountant, MPL Tours Ltd.

Barrie Marshall Tour Director
Rachel Thomas Personal Assistant to Barrie Marshall
Phil Kazamias Tour Manager
Karen Gault Tour Manager
Frankie Enfield Tour Manager
Abigail Potter Tour Manager

Robby Montgomery Creative Consultant
Terry Pouchain Tour Accountant
Mark Aurelio Tour Accountant
David Kahne Musical Co-ordinator
Michele Lawley Travel Co-ordinator
Mark Hamilton Security Director
Missy O'Linn Security
Charles Bayford Security
Brian Riddle Security
Tony Christiana Advance Security
Ian Hopkins Advance Security
Danny Gilliland Advance Security
Shelley Lazar VIP Tickets Director
Zach Niles VIP Tickets Co-ordinator
Alia Ali VIP Tickets Co-ordinator
Roger Huggett Tour Graphics Co-ordinator
Bill Bernstein Tour Photographer
Paul Freundlich Tour Publicist
Geoff Baker Press Officer
Bill Porricelli Promotion Co-ordinator
Roy Bennett Lighting & Set Designer
Kim Hunt Pre-Tour Stylist
Rob Saduski Wardrobe Consultant

PRE-SHOW
Jeffrey Hornaday Pre-Show Director
Amy Tinkham Associate Director
Jenni Bolton Costume Designer
Patrice Miranda Make-up & Wigs
Sondra Nottingham Make-up & Wigs
Edward Jimenez Make-up & Wigs
Ann Thomas Wardrobe Supervisor
Chihiro Sugawara Wardrobe Assistant
Nicole Thomas Wardrobe Assistant

PERFORMERS
Trey Knight • Jamie Thompson • Dominic
Chaiduang • Brian Burt • Stella Choe
Catherine Sandell • Danielle Lewis
Chi Johnson • Victor Tang • Michael Pena
Heather Seybolt • Billy Bonsangue
Angela Stover • Michelle Lee • Claudia Velasco
Jhaemi Willens • Krishni Myers
Ayodhya Jones • Ryan Ashley • Carol Borjas

Lisa Byrnes • Kelly Cobuzio
Undarmaa Darihuu • Indrani Desouza
Jenn Eng • Hannah Feldner-Shaw
Anthony Johnson • Bonnie Morgan
Sarah Smith • Enkhee Tumendelger
Adrienne Wong • Chrissy Whitehead

PRODUCTION TEAM
Gerry Stickells Production Director
Sylvia Stickells Personal Assistant to Gerry Stickells
Mark Spring Production Manager
Diane Eichorst Production Co-ordinator
Tim McWilliams Production Accountant
Scott Chase Stage Manager
Paul Becher Video Director
Marcia Kapustin Assistant Video Director
Josh Worley Video Engineer
Dave Neugebauer Video Engineer
Richard Davis Video Crew Chief & Camera Operator
Mike Sienkiewicz Video Crew Chief & Camera Operator
Redo Jackson Camera Operator
Noel Wyatt Camera Operator
Dusty Cardaropoli Camera Operator
Dane Mustola Camera Operator
Skip Twitchell Camera Operator
Stan Pirini Camera Operator
Mark O'Herlihy Video Crew Chief & LED Technician
Stefaan Michaels Video LED Technician
Stefaan Desmedt Video LED Technician
Troy Bacchesschi Video LED Technician
Jim Johnston Video LED Technician
Leon Roll Video LED Technician
Michael Pentz Video LED Technician
Jeffrey Pentz Video LED Technician
Keith Smith Backline Crew Chief
Paul "Pab" Boothroyd FOH Sound Engineer
John Roden Monitors Engineer
Phil Romano Piano Technician
Sid Pryce Guitar Technician
Paul Davies Drum Technician
DJ Howes Keyboard Technician
Wally Lees Lighting Director
Robert Cooper Lighting Crew Chief
Chris Badger Lighting Crew
Paul Sadler Lighting Crew
Yasmine Kotb Lighting Crew
Bill McNamee Lighting Crew
Pete Feher Lighting Crew
Mike Flynn Lighting Crew
Jason Gangi Lighting Crew
Mike Parker Lighting Crew
Vivian Slodki Lighting Crew
James Spooner Lighting Crew
Kes Thornley Lighting Crew
Tom Cusimano Lighting Crew
Mike Gott Lighting Crew
Joseph Hug Lighting Crew
Gavin Tomkins Lighting Crew
Mike Farese Head Rigger
Tell Agerter Head Rigger
Bart Durbin Head Rigger
John Kinal Rigger
Danny Machado Rigger
Chuck Melton Rigger
John Williamson Rigger
Rick Wilmot Rigger

Arturo "Joey" Dickey Branam Rigger
Bjorn Melchert Branam Rigger
Dave Lowman Branam Rigger
Rockey Dickey Branam Rigger
Steve Davidson Branam Rigger

Sam First Head Carpenter
Alan Doyle Head Carpenter
Jorge Guadalupe Carpenter
Gino Cardelli Carpenter
Bob "Dusty" Madison Carpenter

Bob Hood Pyro
Richard Brisson Pyro

Alie Amato Ambience
Beth Springer Ambience

Phyllis Toney Wardrobe

John "Lug" Zajonc Electrician

Randy Willie Sound Crew Chief
Brandon Martin Sound Technician
Jason Vrobel Sound Crew
Joseph Manges Sound Crew
Kyle Vandegrift Sound Crew
Simon Bauer Sound Crew

SOUND (AUDIO RENTS)
Markus Meyer • Hanspeter Stumpf
Beat Allgaier

SOUND (CONCERT SOUND)
Andrew Davies • Adrian Fitzpatrick
Kerry Lewis • Matthew Manasse
Paul Swan

VIDEO (VLPS)
Keith Burgess • Simon Cox • Jonathon Wood
Gerald Mott • Feradou Lacoste

VIDEO (XL)
Klaas Eecloo • Frederic Derynck
Brecht Moreels • Guido Ruysschaert

EAT YOUR HEARTS OUT—CATERING
Mathew Jackson EYHO Catering Crew Chief
Jason Bright EYHO Caterer
Linda O'Brien EYHO Caterer
Nicola Gibbs EYHO Caterer
Janor Goddard EYHO Caterer
Sarah Swain EYHO Caterer
Pamela White EYHO Caterer
Toni Leen EYHO Caterer
Amy Derminer EYHO Caterer

TRANSPORT
Kevin Roach Freight Forwarding
Claus Jacob Lead Crew Bus Driver Europe
Oliver Freigang Crew Bus Driver Europe
Fritz Braun Crew Bus Driver Europe
Janosch Reithmayer Crew Bus Driver Europe
Stefan Haas Crew Bus Driver Europe
Basil O'Boyle Crew Bus Driver Europe
Andrea Wache Crew Bus Driver Europe
Bert Zemann Crew Bus Driver Europe

Vladimir Bottcher *Crew Bus Driver Europe*
David Reicherter *Crew Bus Driver Europe*
Chuck Coorts *Lead Crew Bus Driver US*
Dave Walters *Lead Crew Bus Driver US*
Craig Wall *Crew Bus Driver US*
Raymond Jacobs *Crew Bus Driver US*
Mike Mallatt *Crew Bus Driver US*
Bernie Thoren *Crew Bus Driver US*
Geoff Daubney *Crew Bus Driver US*
Tom Blauvelt *Crew Bus Driver US*
Mike Humphries *Crew Bus Driver US*
Geoff O'Connell *Band Bus Driver US*
Joe Folk *Band Bus Driver US*
Dave Morgan *Band Bus Driver US*
Kent Hardy *Pre-Show Bus Driver US*
Donny Leach *Pre-Show Bus Driver US*
Richard Lundeen *Pre-Show Bus Driver US*
Konrad Hoecker *Band Bus Driver Europe*
Mino Maier *Band Bus Driver Europe*
Dave Belton *Preshow Bus Driver Europe*
Roburt Pottgeiter *Preshow Bus Driver Europe*
Albert Sutton *Lead Truck Driver Europe*
Dave Harris *Truck Driver Europe*
Tyrone Bramwell *Truck Driver Europe*
Fred Addie *Truck Driver Europe*
Alistair Mackenzie *Truck Driver Europe*
Terry Dunn *Truck Driver Europe*
Mick Chester *Truck Driver Europe*
Chris Simcox *Truck Driver Europe*
Graham Potterton *Truck Driver Europe*
Barry Sadler *Truck Driver Europe*
Mike Levene *Truck Driver Europe*
Tipton Butler *Truck Driver Europe*
Simon Sargent *Truck Driver Europe*
Terry Denning *Truck Driver Europe*
Paul Slater *Truck Driver Europe*
Paul Carless *Truck Driver Europe*
Dave Arbon *Truck Driver Europe*
Graham Jobson *Truck Driver Europe*
Midge Mathieson *Truck Driver Europe*
Michael Shipley *Truck Driver Europe*
Wayne Hightower *Lead Truck Driver US*
Kelly Hightower *Truck Driver US*
Gregg Atkinson *Truck Driver US*
Sean Higgins *Truck Driver US*
Jim Freuck *Truck Driver US*
Ricky Bain *Truck Driver US*
Robert Berge *Truck Driver US*
Kevin Biggins *Truck Driver US*
Jack Crawford *Truck Driver US*
Patricia Galbraith *Truck Driver US*
Daryl Higgins *Truck Driver US*
Dave Jensvold *Truck Driver US*
Kevin Jeter *Truck Driver US*
Doug Lorenzana *Truck Driver US*
John Pyle *Truck Driver US*
Marianne Singer *Truck Driver US*
Paul Singer *Truck Driver US*
Paul Arnold *Truck Driver US*
Alan Taylor *Truck Driver US*
Terry Grenier *Truck Driver US*
Bob Westra *Truck Driver US*

SITE CO-ORDINATORS
Jay Schmit *Mexico/Japan/Europe*
Tom Rye *Europe*

STEEL CREW (EDWIN SHIRLEY STAGING)
Chris Stead *Steel Crew Chief*
Mataio Alefosio *Steel Crew*
Chris Beehan *Steel Crew*
Pete James *Steel Crew*
Rob Keetch *Steel Crew*
Bruce McKinlay *Steel Crew*
Greg Peach *Steel Crew*
Rick Staveley *Steel Crew*
Alex Walsh *Steel Crew*
Graeme Flemming *Steel Crew*
Ciaran O'Treasaigh *Steel Crew*
Jason Werner *Steel Crew*
John Hetherton *Steel Crew*
Matt Marshall *Steel Crew*
Shane Runge *Steel Crew*
Vince Sudlow *Steel Crew*
Pete Ashurst *Steel Crew*
Paul Bingham *Steel Crew*
Paul Breen *Steel Crew*
Hiro Brown *Steel Crew*
Phil Capon *Steel Crew*
Matt Gentle *Steel Crew*
Mike Goodwin *Steel Crew*
Ian Martin *Steel Crew*
Scott Seaton *Steel Crew*
Dan Tracy *Steel Crew*
Ade Turner *Steel Crew*
Simone Warner *Steel Crew*

LEGACY POWER
Henry Wetzel • Arturo Martinez
Dave Koopmans • Ulf Richter • Agnes McInnes
Ingolf Berger • Andy Morris

LIGHTS
Troy Eckerman *Advance Programmer*

LIGHTS (LSD UK)
Craig Robertshaw • Sean Burke
Blaine Dracup • David Prior • Ivan Morandi

MERCHANDISING
Les Midgley *Giant Merchandiser US*
Jeff O'Neill *Giant Merchandiser US*
Tim Ehrlich *Giant Merchandiser US*
Mike Prantis *Giant Merchandiser US*
Richard Carter *Giant Merchandiser US & Europe*
Andrew Scott *Giant Merchandiser Europe*
Amir Butt *Giant Merchandiser Europe*

MARK HAEFELI PRODUCTIONS—FILM CREW
Mark Haefeli *Director/Producer*
Craig Braden *Cameraman*
Bill Shackleton *Cameraman*
Jeff Grunther *Cameraman*

CLEAR CHANNEL ENTERTAINMENT
Brad Wavra *Vice President, Clear Channel
 Entertainment*
Dave Clarke *Clear Channel Production Co-ordinator*

CONCERTS WEST
Paul Gongaware *Co-CEO Concerts West*
Gord Berg *Concerts West Tour Co-ordinator*
Tom Rye *Concerts West Tour Production*

HOUSE OF BLUES
Lars Sorenson
Jeff Trisler

THANKS TO
*Heather, for being there and loving; all at MPL;
Marshall Arts Ltd; GLS Management Services Inc;
the Travel Company; Jay Karas and Andee Korda of
Kanpai Pictures Inc; Planview Inc; Showco; Light and
Sound Design Inc; Vari-Lite Inc; Nocturn Productions
Inc; Rock Steady Security Ltd.; Eat Your Hearts Out;
Upstaging Inc; Senators Coaches Inc; Rock-It Cargo;
Pyritz Pyrotechnics Inc; Legacy Power; Smart Art;
Otto Printing; Peter Lubin and Tom Donnell at Giant
Merchandising; Rick Steinberg at Quantum Color;
Capitol Records; Clear Channel Entertainment—
Touring Inc; Concerts West—An AEG Company; Branam
Enterprises; Sinc Design Consultants; Apache
Communications; Coach Services GmbH;
Edwin Shirley Staging and Trucking; Ant, Nick, and
Carlos at Outside Line; Caroline Grimshaw.*

THANKS TO THE PROMOTERS
Austria—*Wolfgang Klinger and Heimo Hanserl
 at Rock&More*
Belgium—*Herman Schueremans
 at Clear Channel Entertainment*
Denmark—*Flemmin Schmidt and Steen Mariboe
 at DKBmotor*
France—*Jackie Lombard at Interconcerts*
Germany (Hanover, Munich, Hamburg)—
 *Peter Schwenkow, Peter Prochnow, and Roland Temme
 at DeAG Entertainment*
Germany (Cologne and Gelsenkirchen)—
 *All at Peter Rieger Konzertagentur GmbH
 and Co.KG*
Holland—*Leon Ramakers at MOJO Concerts—
 a Clear Channel Entertainment Company*
Hungary—*Tim Dowdall at Multimedia International
 and Laszlo Hegedus at Multimedia Concerts*
Ireland—*Jim and Peter Aiken at Aiken Promotions Ltd*
Russia—*Nadia Solovieva, Eugeny Boldin and
 Alexander Gafin at SAV Entertainment*
Spain—*Neo Sala, Jorge Garcia, Jordi Mora and Jose
 Maria Llorens at Doctor Music Concerts and Pino
 Sagliocco, Paco Martinez, and Luis Rubira
 at Troubleshooter-Gamerco*
Sweden—*Thomas Johansson and Tor Nielsen at
 EMA Telstar: A part of Clear Channel Entertainment*
UK—*Barrie and Jenny Marshall, Doris Dickson,
 Mike Stewart at Marshall Arts Ltd.*
Italy—*Progetto Italia di Telecom Italia in association
 with Four One Music*

TOUR PROGRAM
Caroline Grimshaw, Roger Huggett,
David Hepworth, Paul Du Noyer,
Jerry Perkins, Geoff Baker, Lilian Marshall

www.paulmccartney.com
www.mplcommunications.com

The Tourasaurus

A guide to the private language of Paul McCartney's tour

AMBIENCE *Term given to the process conducted by Alie Amato and Beth Springer of decorating spartan rooms backstage into dressing rooms right out of an Indian fable.*

BACKLINE CREW *Modern term for the roadies who look after all the instruments, amps, and onstage sound.*

BAG TAGS *Plastic laminates that attach to each crew member's luggage, with numbers to identify who the luggage belongs to.*

BAGS *As in "Bags at Noon." Instruction given on the day sheet of the time at which porters will collect luggage from the hotel rooms of members of band parties A and B. The luggage is then transported ahead to the next city/country and is, by magic, in the designated room at arrival, some time in the small hours of the next morning.*

BAND PARTIES A AND B *Privileged members of the crew who escape getting their hands dirty effecting the load in/out, and who often travel with Paul and the band.*

CATERING *High-quality traveling restaurant operating solely for the benefit of the band and crew; provides hundreds of meals of top quality and variety daily and has never been known to be criticized for the quality or the warmth of the welcome.*

CLOWNS *Pre-Show role assigned to local volunteers in each city who agree to dress up in white satin clowns' uniforms and masks in order to parade through the audience and onto the stage at the beginning of the Pre-Show event. Huge helium balloons, painted to resemble planets, are attached to their wrists. On occasion, the clowns' roles are taken by crew members, scared witless by the idea of a stage debut.*

DAY OFF *Mythical concept invented by Tour Director Barrie Marshall on the premise that there will be time during the whistlestop trek to reacquaint with life outside the "bubble."*

DAY SHEET *List of instructions issued by Tour Managers Phil Kazamias and Karen Gault, informing band party members where they are going next and how/when to get there.*

DOING THE RUNNER *Instruction given to members of band parties A and B, meaning that it is essential that all bags (laptops, cameras, etc.) are deposited on Coach B before the end of the show, and that you also deposit yourself aboard Coach B immediately after Paul boards Coach A. Being "On the Runner" necessarily involves tearing at slices of huge pizzas (provided in the galley) and helping yourself to the vast variety of champagne, whiskey, Jack Daniel's, gin, vodka, wine, beer, and soft drinks that are traditionally raised in a toast to the success of that night's show. During the "Runner," the show is discussed, dissected, and celebrated in voices shouting as loud as possible.*

DOORS *As in "Doors at Six." The time when the sound check ends and the stage is vacated so that concert-goers can enter the building to rush at beer stalls and merchandise venues before taking their seats for the show. Doors are rarely opened at the published time due to the enjoyment of the sound check.*

EXTRAS *Hotel charges above the cost of the room and breakfast paid for by the tour. Extras typically comprise personal telephone calls, additional room service, laundry charges, and, in Germany and Scandinavia, a flurry of interest in adult TV channels.*

FLOAT *Generous advance of cash issued by Tour Accountant Terry Pouchain on the understanding that the money advanced is to be spent and properly receipted on tour business. Highly abused in Amsterdam.*

LAMINATE *Access All Areas pass, given to all crew and a few favored family/friends, the loss of which incurs a fine and general ridicule.*

LOAD IN/OUT *Demi-miraculous process whereby the contents of several huge trucks (several hundred roadcases) are manhandled off the trucks in order to build and equip the stage and backstage offices in a matter of a few hours (in), and then remanhandled back into the trucks in even fewer hours after the show (out).*

MAGIC PIANO *The multi-colored upright piano played by Paul during his solo section and at the end of the shows. It was christened the Magic Piano by Paul on his 1990 tour when it rose up and revolved 20 feet in the air as he played it.*

MEET-AND-GREET *Pejorative term given to pre-agreed backstage "meetings" between Paul and various guests prior to the show. Meet-and-greets tend to be held for record company executives, show sponsors, competition winners, celebrities who "just popped by," and others who—to a person—seem solely set on shaking Paul's hand and posing for a photograph with him. M & Gs (as they are known) are generally detested by those empowered to schedule backstage activity in the interest of getting Paul on stage at the arranged time.*

MERCH *Tour-associated merchandise, ranging from T-shirts to key-rings to jackets and programs. Known to the crew as "swag."*

NEWSLETTER *Designed to be a day-to-day information sheet written and published by the press officer for the intention of giving the crew and band parties a digest of concert reviews, tour-associated news (such as box office records broken), and the timings and details of a show day's schedule of interviews, meetings, and show times. In effect, however, this degenerates into invented gossip, lewd insinuation, and the lunatic ravings of a maverick with no regard for either reverence, rules, or responsibility.*

PASSES *Stick-on backstage passes that allow the wearer to be not quite as backstage as he/she would like (a geographical privilege allowed only to wearers of laminates).*

PER DIEM *Pocket money, basically. The payment additional to tour salary to cover "living expenses"; e.g., the cost of meals not eaten at the shows (an improbable concept given the standard of Catering), personal telephone calls, and an unexplainable number of tobacco-paper packets. The total per diem paid to each "tourist" for pretty much just being there throughout the tour exceeded $10,500.*

PRE-SHOW *Highly attractive troupe of young dancers gathered to perform a trippy tableau, which acted as the audience attention awakener for 17 minutes immediately prior to Paul taking the stage.*

PYRO *Abbreviation for "pyrotechnics department"; Bob Hood's explosive concern that punctuates the performance of* Live and Let Die *with mortar-like bangs and flames.*

RADIO SHOUT *Name given by Paul to the practice of telephoning a local radio station en route to the gig in order to chat as he approaches the show.*

RADIOS *Walkie-talkies for keeping in touch with other crew while working on a show in vast arenas, or to call out to Catering.*

THE RUNNER *Executive coach that transports Paul, Heather, the band, and key personnel (Mike Walley, John Hammel, and Mark Hamilton) from the backstage area to the hotel or airport immediately following the end of the show, in order to get away before the crowds snarl up the traffic. The coach is led by police outriders and followed by a convoy of a second coach, plus vans and security cars, containing various members of band parties A and B.*

SCREENS *Huge video screens that relay the onstage action to members of the audience too far back to see it with normal eyesight.*

SOUND CHECK *Ostensibly a period of some three hours before show time during which Paul and the band rehearse on the various instruments they will be using for the show. This is done in order for Front-of-House Sound Engineer Paul "Pab" Boothroyd and Monitors Engineer John Roden to reach and mark the right sound levels. In practice, however, sound check invariably takes on the proportions of another concert entirely; it is usual for Paul to lead the band through up to a 90-minute set of standards, favorites, jams, and occasionally new compositions for their own enjoyment. Typical sound-check songs include:* Matchbox, Honey Don't, Midnight Special, Honey Hush, Celebration, C-Moon, Bring It to Jerome, *and on one fabulous occasion that brought rehearsals to a standstill in Culver City, Paul McCartney and Brian Wilson together perform* God Only Knows *and* Let It Be. *Sound check begins with* Coming Up *and ends with* Lady Madonna. *It also frequently features the* Gerry Stickells' Jam, *a song composed to tease Gerry in his attempts to get the band off stage so that the doors can open.*

STAGE RIGHT/STAGE LEFT *On the face of it a location, but frequently a confusion to members of band parties A and B, many of whom fail to remember during the 14-month tour whether "right" or "left" is determined by looking from the stage or at it. Replaced for the purposes of clarity by the embarrassed mutter of "Brian's side" or "Rusty's side."*

SWOOP or **HUDDLE** *American football-style ring formed by Paul and the band in order to take a moment for a prayer immediately before going on stage.*

TOUR BUBBLE *The feeling of isolation from and inoculation against the world while one is on tour, where the generally agreed parameters of reality cease to exist.*

TOUR MODE *Bizarre pathological state whereby one on tour believes that all that matters in life is one's life on the tour. As exampled by one who, on reading the* Los Angeles Times *during Paul's concerts in California in 1989, exclaimed, "I didn't know the Berlin Wall came down three days ago."*

TOUR VIRGIN *Crew member who has never toured before.*

TRANSLATION SESSION *Process whereby Paul McCartney learns a variety of phrases in the local foreign tongue in less than an hour in order to converse colloquially with the crowd during the show.*

TWIRLEES *Catering girls' affectionate nickname for the frequently spinning Pre-Show.*

WARDROBE *Designerwear "store" in which wardrobe mistress Phyllis Toney dresses Paul and the band.*

Paul McCartney: The World Tour

DRIVING USA SCHEDULE 2002

Month	Date	Venue	City
April	1	Oakland Arena	Oakland
April	3	San Jose Arena	San Jose
April	5	MGM Grand	Las Vegas
April	6	MGM Grand	Las Vegas
April	10	United Center	Chicago
April	11	United Center	Chicago
April	13	Air Canada Center	Toronto
April	16	First Union Center	Philadelphia
April	17	Continental Arena	East Rutherford
April	19	FleetCenter	Boston
April	21	Nassau Coliseum	Long Island
April	23	MCI Center	Washington, DC
April	24	MCI Center	Washington, DC
April	26	Madison Square Garden	New York City
April	27	Madison Square Garden	New York City
April	29	Gund Arena	Cleveland
May	1	Palace at Auburn Hills	Detroit
May	4	Staples Center	Los Angeles
May	5	Arrowhead Pond	Anaheim
May	7	Pepsi Center	Denver
May	9	Reunion Arena	Dallas
May	10	Reunion Arena	Dallas
May	12	Philips Arena	Atlanta
May	13	Philips Arena	Atlanta
May	15	Ice Palace	Tampa
May	17	National Car Rental Center	Fort Lauderdale
May	18	National Car Rental Center	Fort Lauderdale

BACK IN THE US SCHEDULE 2002

Month	Date	Venue	City
Sept	21	Bradley Center	Milwaukee
Sept	23	Excel Center	Minneapolis
Sept	24	United Center	Chicago
Sept	27	Civic Center	Hartford
Sept	28	Boardwalk Hall	Atlantic City
Sept	30	FleetCenter	Boston
Oct	1	FleetCenter	Boston
Oct	4	Gund Arena	Clevelend
Oct	5	Pacers Sports Entertainment Center	Indianapolis
Oct	7	Entertainment and Sports Center	Raleigh
Oct	9	Savvis Center	Saint Louis
Oct	10	Schottenstein Center	Columbus
Oct	12	New Orleans Arena	New Orleans
Oct	13	Compaq Center	Houston
Oct	15	Ford Center	Oklahoma
Oct	18	Rose Garden	Portland
Oct	19	Tacoma Dome	Tacoma
Oct	21	Arco Arena	Sacramento
Oct	22	Compaq Center	San Jose
Oct	25	Arrowhead Pond	Anaheim
Oct	26	MGM Grand	Las Vegas
Oct	28	Staples Center	Los Angeles
Oct	29	America West Arena	Phoenix
Nov	2	Sports Palace	Mexico City
Nov	3	Sports Palace	Mexico City

DRIVING JAPAN SCHEDULE 2002

Month	Date	Venue	City
Nov	*11*	*Dome*	*Tokyo*
Nov	*13*	*Dome*	*Tokyo*
Nov	*14*	*Dome*	*Tokyo*
Nov	*17*	*Dome*	*Osaka*
Nov	*18*	*Dome*	*Osaka*

BACK IN THE WORLD SCHEDULE 2003

Month	Date	Venue	City
March	*25*	*Bercy*	*Paris*
March	*28*	*Palau Sant Jordi*	*Barcelona*
March	*29*	*Palau Sant Jordi*	*Barcelona*
April	*1*	*Sports Palais*	*Antwerp*
April	*2*	*Sports Palais*	*Antwerp*
April	*5*	*Hallam Arena*	*Sheffield*
April	*9*	*MEN Arena*	*Manchester*
April	*10*	*MEN Arena*	*Manchester*
April	*13*	*NIA*	*Birmingham*
April	*14*	*NIA*	*Birmingham*
April	*18*	*Earl's Court*	*London*
April	*19*	*Earl's Court*	*London*
April	*21*	*Earl's Court*	*London*
April	*22*	*Earl's Court*	*London*
April	*25*	*Gelredome Stadium*	*Arnhem*
April	*27*	*Köln Arena*	*Cologne*
April	*28*	*Köln Arena*	*Cologne*
April	*30*	*Preussag Arena*	*Hanover*
May	*2*	*Parken*	*Copenhagen*
May	*4*	*Globe Arena*	*Stockholm*
May	*5*	*Globe Arena*	*Stockholm*
May	*8*	*König Pilsner Arena*	*Oberhausen*
May	*10*	*Colosseum*	*Rome—indoor*
May	*11*	*Colosseum*	*Rome—outdoor*
May	*14*	*Stadthalle*	*Vienna*
May	*15*	*Budapest Sport Arena*	*Budapest*
May	*17*	*Königsplatz*	*Munich*
May	*18*	*Königsplatz*	*Munich*
May	*21*	*AOL Stadium*	*Hamburg*
May	*24*	*Red Square*	*Moscow*
May	*27*	*RDS Stadium*	*Dublin*
May	*29*	*Hallam Arena*	*Sheffield*
June	*1*	*King's Dock*	*Liverpool*

SCENE TITLES ARE EXTRACTED FROM THE FOLLOWING SONGS:

Foreword Never Quite Like This *(I'VE JUST SEEN A FACE)*
Prelude This Moment to Arise *(BLACKBIRD)*
Scene 1 Easy Game to Play *(YESTERDAY)*
Scene 2 We Could Always Sing *(HERE TODAY)*
Scene 3 See the World Spinning *(THE FOOL ON THE HILL)*
Scene 4 Filling Me Up *(GETTING BETTER)*
Scene 5 Out of Sight *(I'VE JUST SEEN A FACE)*
Scene 6 Unpack My Case *(BACK IN THE U.S.S.R.)*
Scene 7 Always There with a Smile *(HERE TODAY)*
Scene 8 Très Bien Ensemble *(MICHELLE)*
Scene 9 Funny Paper *(CARRY THAT WEIGHT)*
Scene 10 Remember Their Funny Faces *(JET)*
Scene 11 Middle of Something *(MAYBE I'M AMAZED)*
Scene 12 My Dreams Tonight *(THE END)*
Scene 13 Clutching Her Handkerchief *(SHE'S LEAVING HOME)*
Scene 14 See It Your Way *(WE CAN WORK IT OUT)*
Scene 15 See How They Run *(LADY MADONNA)*
Scene 16 Keeping Perfectly Still *(THE FOOL ON THE HILL)*
Scene 17 Ride in the Sky *(JET)*
Scene 18 Out of My Head *(EVERY NIGHT)*
Scene 19 I Can't Tell You *(LET ME ROLL IT)*
Scene 20 Each One Believing *(HERE THERE AND EVERYWHERE)*
Scene 21 Shine on 'Til Tomorrow *(LET IT BE)*
Scene 22 My Heart Can Stay *(MY LOVE)*
Scene 23 In Times of Trouble *(LET IT BE)*
Scene 24 Thoughts of You *(LONELY ROAD)*
Scene 25 As We Fell into the Sun *(BAND ON THE RUN)*
Scene 26 You Can Be the One *(YOUR LOVING FLAME)*
Scene 27 The Movement You Need *(HEY JUDE)*
Scene 28 It Was Written *(CALICO SKIES)*
Scene 29 Carry Me Back *(MULL OF KINTYRE)*

My Love; Let Me Roll It; Band On the Run; Jet *(Paul and Linda McCartney)* © *Paul and Linda McCartney*
Calico Skies; Lonely Road *(Paul McCartney)* © *MPL Communications Ltd*
Mull of Kintyre *(McCartney / Laine)* © *MPL Communications Ltd*
Maybe I'm Amazed; Every Night *(Paul McCartney)* © *Northern Songs-Sony / ATV Music Publishing Limited*
Getting Better; Carry That Weight; The End; We Can Work It Out; She's Leaving Home; Let It Be; I've Just Seen a Face; Blackbird; Yesterday; The Fool on the Hill; Back in the U.S.S.R.; Michelle; Lady Madonna; Here There and Everywhere; Hey Jude; Here Today *(Lennon / McCartney)* © *Northern Songs-Sony / ATV Music Publishing Limited*

Index